ENDICOTT COLLEGE

LIBRARY

Beverly, Massachusetts

Digital Design

The New Computer Graphics.

Digital Design, The New Computer Graphics.

► **First published in the United States of America by:**
Rockport Publishers, Inc.
33 Commercial Street
Gloucester, Massachusetts 01930-5089
Telephone: (508) 282-9590
Fax: (508) 283-2742

► **Distributed to the book trade and art trade in
the United States by:**
North Light Books,
an imprint of F & W Publications
1507 Dana Avenue
Cincinnati, Ohio 45207
Telephone: (800) 289-0963

► **Other Distribution by:**
Rockport Publishers, Inc.
Gloucester, Massachusetts 01930-5089

ISBN 1-56496-372-1

10 9 8 7 6 5 4 3 2 1

► **Designer:**
The Design Company
► **Cover Illustration:**
Alison Scheel

Printed in Hong Kong

Digital Design

The New Computer Graphics.

Rockport Publishers
Gloucester, Massachusetts
Distributed by North Light Books
Cincinatti, Ohio

Table Of Contents

▶ **Introduction** **6**

▶ **Corporate Identity** **8**

▷ **Event** **56**

▷ **Fine Art** **76**

▷ **Promotion** **94**

▷ **Product** **110**

▶ **Index/Directory** **158**

Colors			▶100%

Solid

None

PANTONE S 164-3

Black

100Y

PANTONE S 293-3

100Y100M RED

PANTONE S 220-1

PANTONE S 251-1

PANTONE S 164-3

PANTONE S 42-5

PANTONE S 5-2

PANTONE S 19-1

PANTONE S 164-3

| X: 1.257" | W: 8.5" | W: 0 | |
| Y: 3.407" | H: 11" | cols: 4 | |

Introduction

Digital design. What exactly is this? In the case of this book, it means any design created digitally; this volume includes letterheads, brochures, labels, interfaces, and illustrations. The limitations of the book format may restrict it from showing the full range of possibilities, but what this book does present is a sampling of the immense potential.

▶ Comparing this current volume with earlier books showcasing computer-assisted designs reveals great leaps and strides in the industry. When illustration software first became mainstream, all computer-generated images looked like they were created by a computer. But now, advancements in software allow the designers to replicate very closely the look and feel of a hand crafted article. It is now an option rather than a necessity to have that computer-generated look. It is assured that improvements in such software will continue to change the look and feel of digital illustration.

The software currently being developed and produced is more accessible, easier to understand, and certainly more affordable than its predecessors. The world of computer design has moved eons away from its beginnings; it is not so uncommon for a home to have multiple personal computers, and children are being taught computer skills in grade school. The unlimited access and the increased aptitude of a larger group of people means that an increased amount of people have the opportunity and potential to be "desktop publishers."

▶ These improvements and advancements in software and hardware have had a huge effect on the graphic design world in a number of ways, some good and some not so good. This has had a profound effect on the graphic design industry as a whole. The influx of

desktop publishers with excellent computer skills has left the designers with formal design training bitter. The computer can somewhat compensate for but will never replace talent and artistry. The evolution of the computer has shown just that: it can help but will never replace skill and a good eye.

▶ The computer is a tool; its use needs to be optimized. It can be used in two ways: it can simplify the existing processes for creating a layout, or it can be pushed to do and create things much greater than could be possibly be done without the computer. By simplifying and speeding up basic layouts and pre-press work, the newly created free time allows time for experimenting, trying, optimizing the computer.

▶ The computer has already changed a great deal about the graphic design industry, and it will continue to do so. The recent proliferation of multimedia formats will force even another radical change in the industry. The interactive potential of many formats introduces an entirely new element; it no longer suffices to have a static design. Plus, the designers must compensate for changes in options and computer settings by the end user. It is no longer guaranteed the exact product created will be what the end user will see. A good computer design will take all these factors into consideration. There is still room for improvement in this field indefinitely.

▶ This book is a wonderful source of information now, and will serve as an important bookmark in the continuing development of computer-assisted design later.

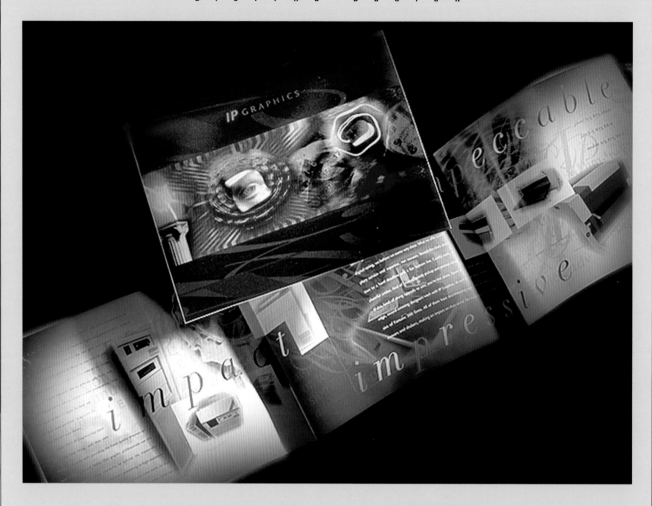

▶ This piece was designed to promote the capabilities of IP Graphics, a local output provider. The type plays on the initials IP and reinforces the themes of impact/impressive/impeccable service. The main goal was to have a piece that would be an effective leave-behind or mailer for IP's sales staff.

Corporate Identity

Design Firm
Marcolina Design, Inc.
All Design
Sean McCabe
Project
IP Graphics promotional brochure
Client
IP Graphics
Purpose or Occasion
Capabilities brochure
Software
Adobe Photoshop, Adobe Illustrator, QuarkXPress
Hardware
Power Macintosh 8100

CORPORATE IDENTITY

Design Firm
McElveney and Palozzi Design Group Inc.
Art Director
William McElveney
Designers
Erika S. White, Ellen Johnson
Illustrator
Ellen Johnson
Project
Great Western Chardonnay Champagne
Client
Canandaigua Wineries
Purpose or Occasion
Label redesign
Software
Macromedia FreeHand, Adobe Photoshop

▶ This label was undergoing a redesign to relaunch the client's classic line of champagne. The new label's design needed to maintain a traditional feel while encompassing two seemingly opposite themes: on one hand a new chardonnay grape was being used, on the other, a traditional method of fermentation was being used. The illustration was created traditionally, scanned in Adobe Photoshop, and then placed in FreeHand as the backdrop for the label. The label has a matte-varnish finish with foil stamping for a dramatic effect.

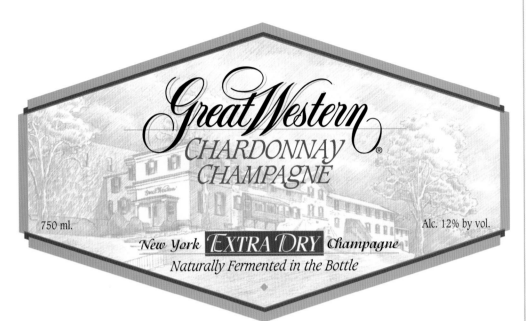

Design Firm
Corporate Visions, Inc.
Art Director/Illustrator
Micki Francis
Designers
Daniel Boris, Micki Francis,
Rachel Faulise
Project
DEA drug-prevention booklet
Client
Drug Reinforcement Administration
Purpose or Occasion
DEA brochure
Software
Fractal Design Painter, Adobe
Photoshop, QuarkXPress
Hardware
Power Macintosh

▶ With the theme of "get it straight," this piece was selected as the cover of a drug-education brochure. The DEA wanted to create a booklet that would appeal to adolescents, so cartoon teenagers were created that had style and realism to them. The characters were first drawn with pen and ink on paper and then brought into Adobe Photoshop and saved. The file was opened in Painter, where color modeling was added to the image of the kids. The file was again opened in Adobe Photoshop, where the brick wall and sidewalk were added as the background.

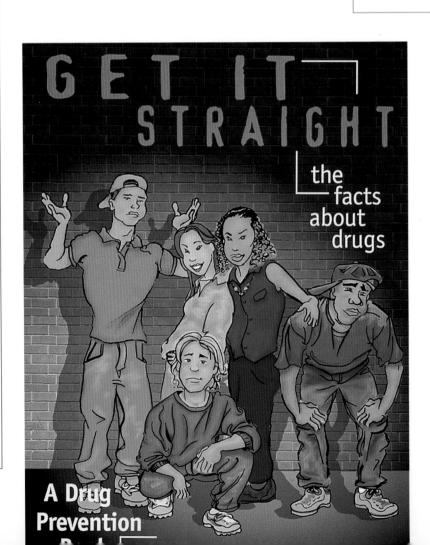

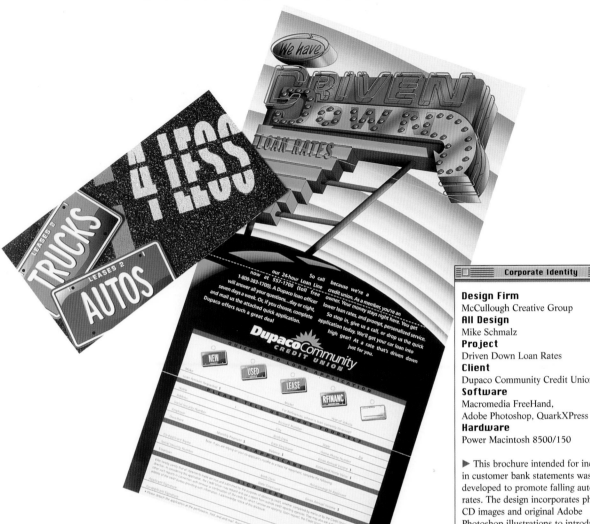

Design Firm
McCullough Creative Group
All Design
Mike Schmalz
Project
Driven Down Loan Rates
Client
Dupaco Community Credit Union
Software
Macromedia FreeHand,
Adobe Photoshop, QuarkXPress
Hardware
Power Macintosh 8500/150

▶ This brochure intended for inclusion
in customer bank statements was
developed to promote falling auto loan
rates. The design incorporates photo
CD images and original Adobe
Photoshop illustrations to introduce
new rates to a young market.

Design Firm
Erbe Design
Art Director/Designer
Maureen Erbe
Photographer
Henry Blackham
Project
Monrovia advertisement
Client
Monrovia Nursery Co.
Purpose or Occasion
Increase customer awareness
Software
QuarkXPress
Hardware
Macintosh

▶ The purpose of the advertisement
was to impart information about the
company's history of integrity and the
quality of products offered to
the consumer.

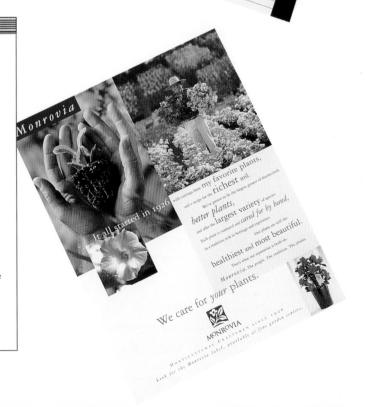

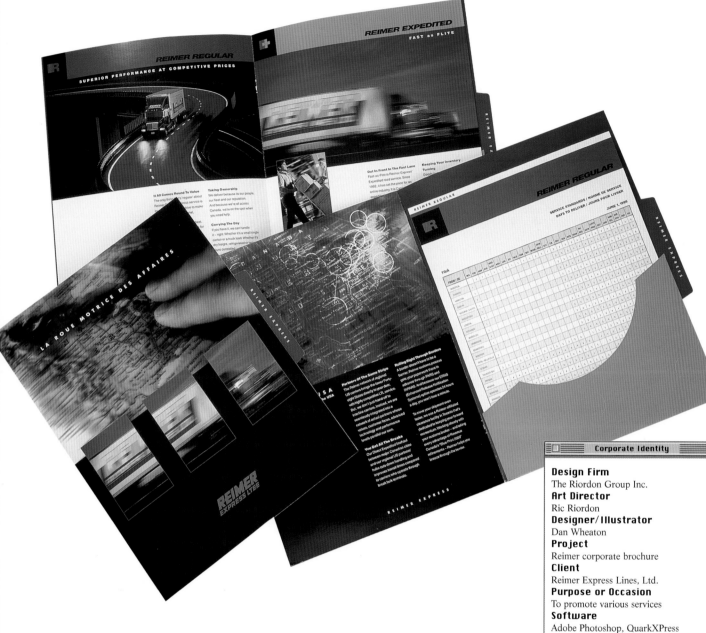

Corporate Identity

Design Firm
The Riordon Group Inc.
Art Director
Ric Riordon
Designer/Illustrator
Dan Wheaton
Project
Reimer corporate brochure
Client
Reimer Express Lines, Ltd.
Purpose or Occasion
To promote various services
Software
Adobe Photoshop, QuarkXPress
Hardware
Power Macintosh

▶ The most impressive feature of this brochure is the creative use of Adobe Photoshop throughout the piece. The images are believable, even though each shot represents a combination of stock images and custom photography. For example, the image on the upper left (the truck coming down a winding road) is made up of three shots. The background is a stock image. The truck was shot from the top of Reimer's building in their parking lot and replaced over the stock truck image. Angles were matched and lighting and color enhancement completed the illusion.

Corporate Identity

Design Firm
Design Guys
Art Director/Designer
Steven Sikora
Project
Business cards
Client
Sheryl Sikora
Software
Adobe Photoshop, QuarkXPress
Hardware
Macintosh 7100

▶ The client wanted some attention-grabbing business cards. To achieve this, it was suggested that a lock of wig hair and a bag be added along with the card.

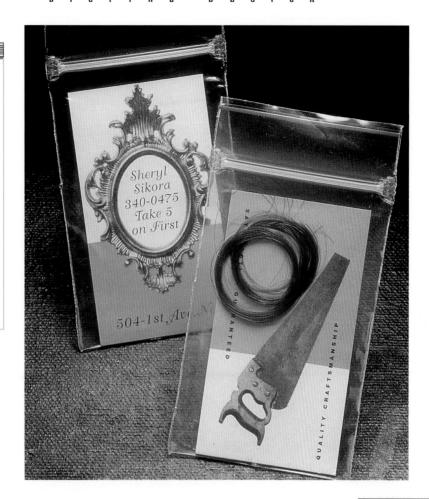

Corporate Identity

Design Firm
The Riordon Design Group, Inc.
Art Director
Ric Riordon
Designers
Dan Wheaton, Sharon Pece
Illustrator
Dan Wheaton
(Adobe Photoshop montages and enhancement)
Project
Minacs corporate brochure and folder
Client
The Minacs Group
Purpose or Occasion
New identity/corporate promotion
Software
Adobe Photoshop, QuarkXPress
Hardware
Power Macintosh, Quadra 950

▶ An all-digital piece, each photo image was either enhanced or composed as part of a Photoshop montage. There were four such montages in the piece. The folder features a subtle headset image created in Adobe Photoshop as a mezzotint. The montages were compiled from high-resolution scans and presented as Tektronic color proofs for color approval prior to running out film.

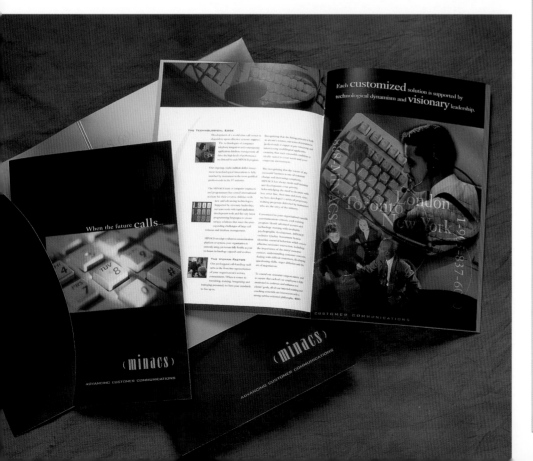

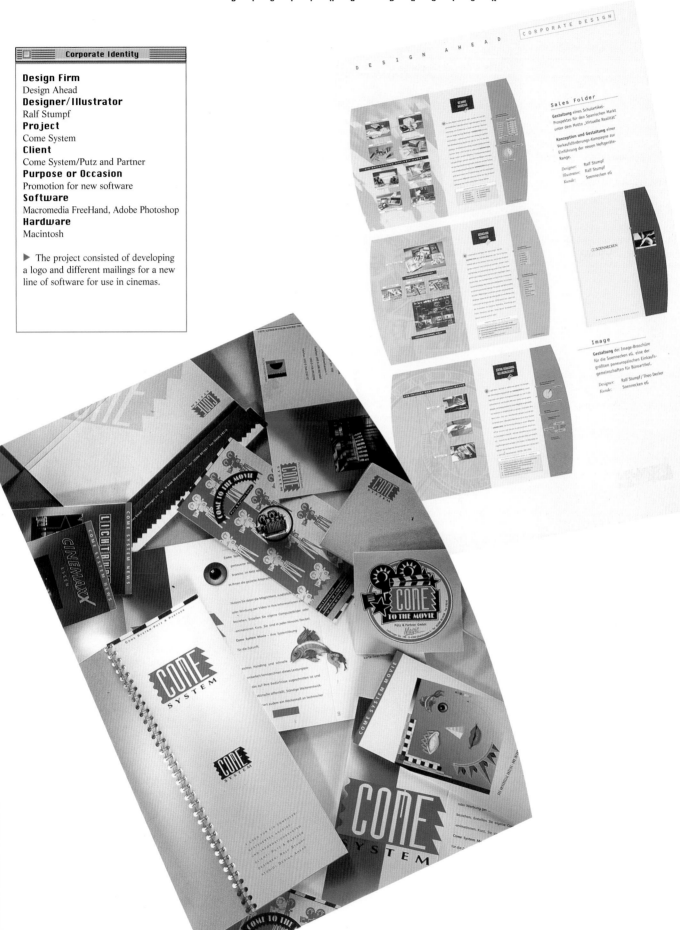

Corporate Identity

Design Firm
Design Ahead
Designer/Illustrator
Ralf Stumpf
Project
Come System
Client
Come System/Putz and Partner
Purpose or Occasion
Promotion for new software
Software
Macromedia FreeHand, Adobe Photoshop
Hardware
Macintosh

▶ The project consisted of developing a logo and different mailings for a new line of software for use in cinemas.

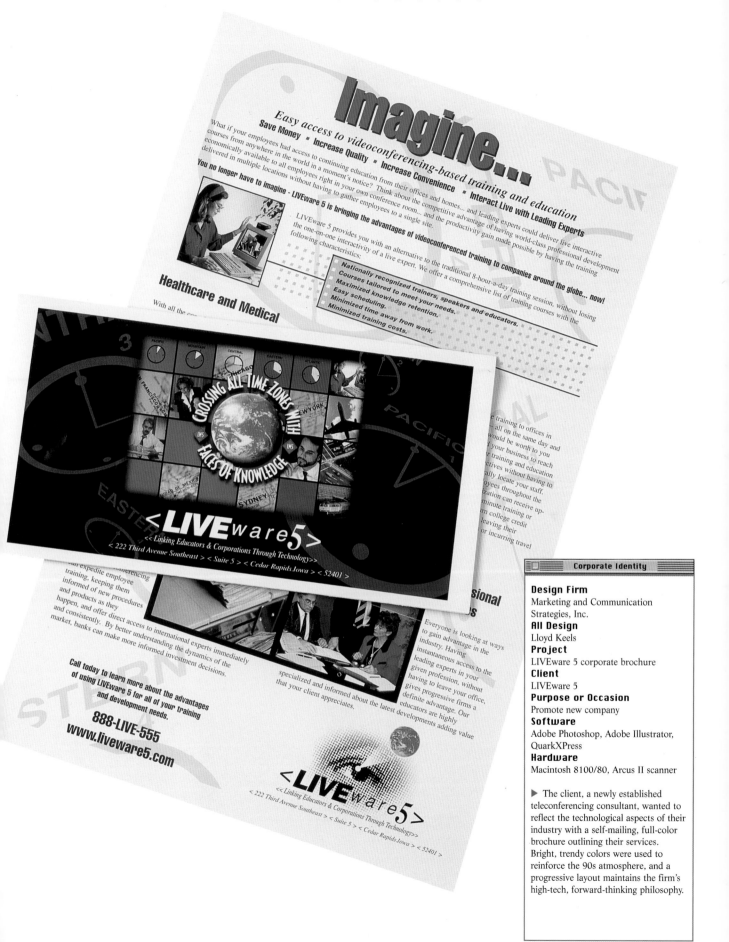

Corporate Identity

Design Firm
Marketing and Communication
Strategies, Inc.
All Design
Lloyd Keels
Project
LIVEware 5 corporate brochure
Client
LIVEware 5
Purpose or Occasion
Promote new company
Software
Adobe Photoshop, Adobe Illustrator,
QuarkXPress
Hardware
Macintosh 8100/80, Arcus II scanner

▶ The client, a newly established
teleconferencing consultant, wanted to
reflect the technological aspects of their
industry with a self-mailing, full-color
brochure outlining their services.
Bright, trendy colors were used to
reinforce the 90s atmosphere, and a
progressive layout maintains the firm's
high-tech, forward-thinking philosophy.

Corporate Identity

Design Firm
Louis Nelson Associates Inc.
Designer/Architects
Frank Gaylord, Cooper-Lecky
Architects; Louis Nelson Associates
Project
Korean War Veterans Memorial
mural wall
Client
Korean War Veterans Memorial
Advisory Board
Software
Adobe Photoshop
Hardware
Macintosh Quadra 950,
Microtek IIXE scanner

▶ Standing on the Mall in Washington,
DC, the mural wall of the Korean War
Veteran's Memorial is a powerful
164-foot-long mural etched in forty-one
black granite panels. A newly advanced
process of grit-blasting was used to etch
the images onto the highly polished
surface of the stone. The images were
digitally reshadowed and repositioned
from thousands of archival photographs
using Adobe Photoshop.

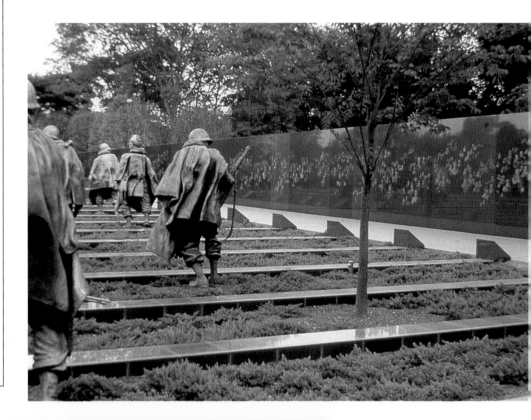

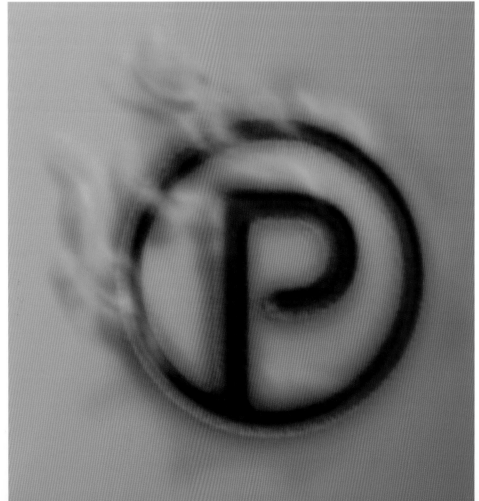

Corporate Identity

Design Firm
Love Packaging Group
Art Director
Tracy Holdeman
Designers
Brian Miller, Tracy Holdeman
Project
Pardners logo
Client
Pardners Unlimited, Inc.
Purpose or Occasion
Logo for Pardners packaging and
corporate identity
Software
Macromedia FreeHand, Adobe Photoshop
Hardware
Power Macintosh Quadra 950

▶ For the Pardners logo, a branding-
iron visual was pursued. The logo
began with the simplest of pencil
sketches. This served as reference and
the basic P-letterform brand was
worked out in FreeHand. The paths
were then exported to Adobe Illustrator
and copied to the clipboard. Adobe
Photoshop was opened and the paths
were pasted in.

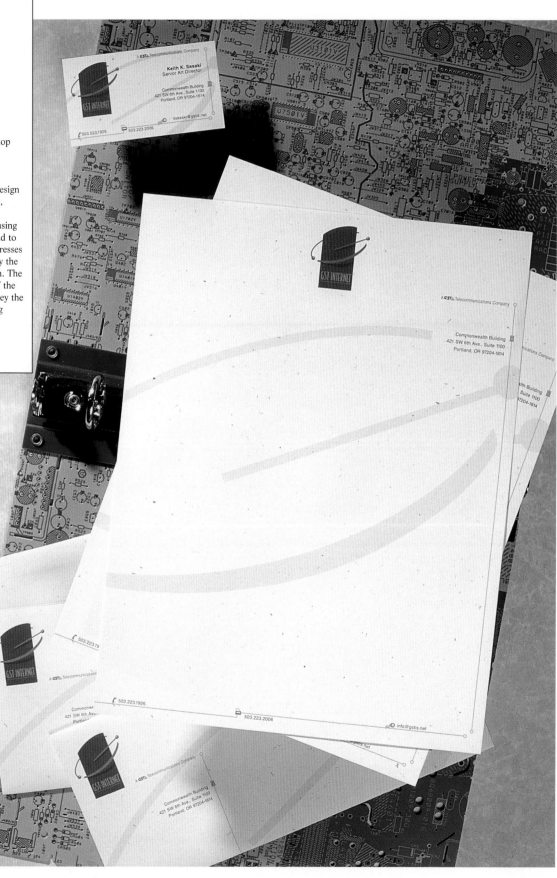

Corporate Identity

Design Firm
GST Internet
All Design
Keith Sadaki
Project
Corporate identity system
Client
GST Internet
Purpose or Occasion
Stationery
Software
Adobe Illustrator, Adobe Photoshop
Hardware
Macintosh 8500/150

▶ The GST Internet stationery design premise extends the sophisticated, high-tech look and feel of the company's corporate identity by using circuit board-like runners that lead to various contact numbers and addresses on the page. Original icons signify the various means for communication. The letter G is shaded at the center of the letterhead and positioned to convey the motion, energy, and ever-changing nature of an Internet company.

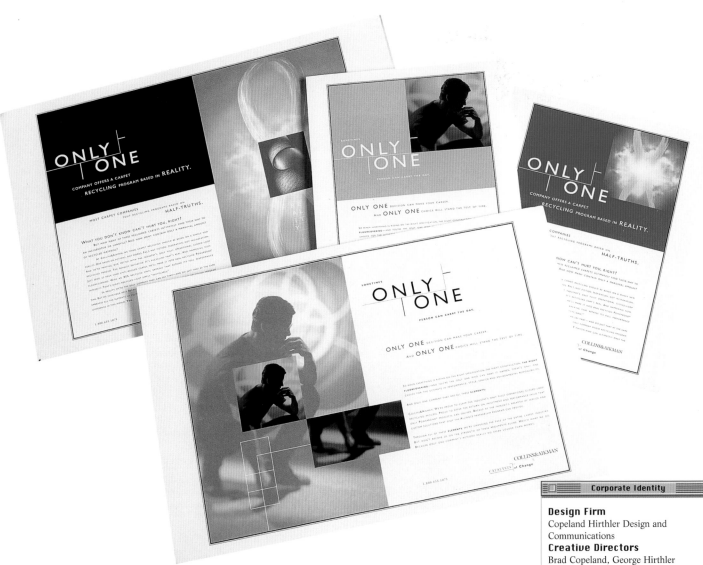

Corporate Identity

Design Firm
Copeland Hirthler Design and Communications
Creative Directors
Brad Copeland, George Hirthler
Art Director
Raquel C. Miqueli
2D Designers
Raquel C. Miqueli, Lea Nichols
Copywriter
Melissa James Kemmerly
Photographer
Jerry Burns
Project
Collins and Aikman recycle and elements advertisements
Client
Collins and Aikman
Purpose or Occasion
Advertising campaign for Collins and Aikman floor coverings

▶ This campaign was designed to elevate brand awareness and presence for Collins and Aikman floor coverings among interior designers as well as promote the company's competitive advantages.

Corporate Identity

Design Firm
Mark Selfe Design
Art Director/Designer
Mark Selfe
Illustrator
Adam Cohen
Project
Mouse pad/tote bag
Client
Global Star
Purpose or Occasion
Self promotion
Software
Adobe Photoshop
Hardware
Power Computing Power Tower 180

▶ Global Star is a new cellular phone company with advanced cellular technology. The artwork will be used for Global Star's promotional campaign on mouse pads, tote bags, and other promotional materials.

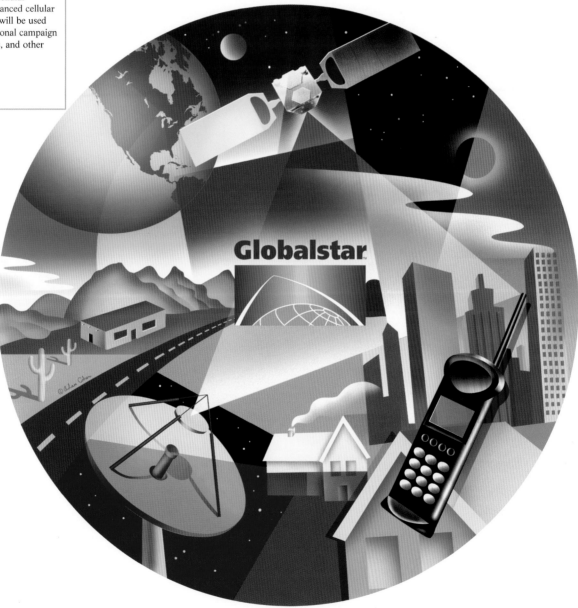

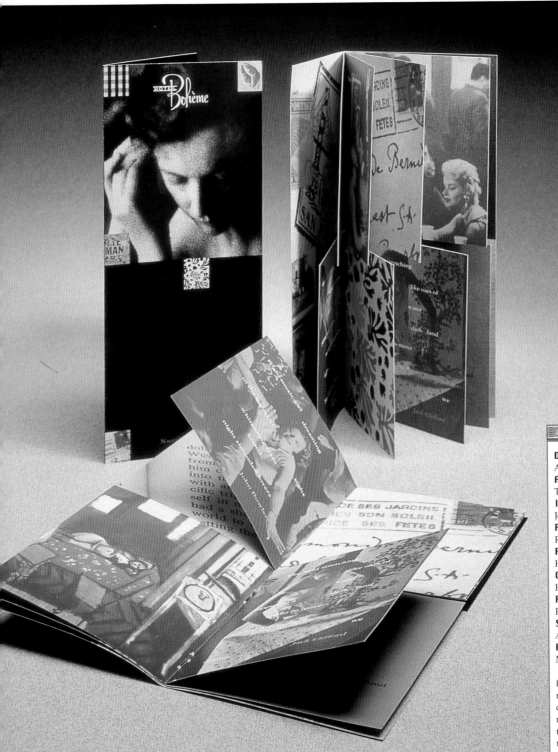

Corporate Identity

Design Firm
Aerial
Art Director/Designer
Tracy Moon
Illustrator
Jerry Stoll
Photographer
R. J. Muna
Project
Hotel Boheme brochure
Client
Hotel Boheme
Purpose or Occasion
Promotion
Software
Adobe Photoshop, QuarkXPress
Hardware
Macintosh 8500

▶ This brochure produced for the renovation of a small hotel in the heart of Old North Beach, San Francisco relies on the theme of the beat artists of the fifties who at one time frequented the area near the hotel. The hotel's name, logotype, and materials were based on a highly visual, poetic theme and the brochure gives the viewer a sense of actually being inside the hotel.

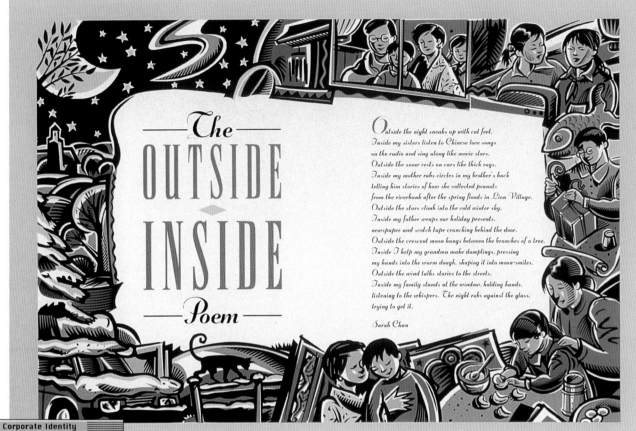

Design Firm
Mires Design
Art Director
John Ball
Illustrator
Tracy Sabin
Project
The Outside Inside Poem
Client
Harcourt Brace
Purpose or Occasion
Illustration for a poem
Software
Adobe Illustrator
Hardware
Macintosh 9500

▶ This spread for an elementary-level literature textbook accompanies a poem written by Sarah Chan.

Design Firm
McElveney and Palozzi Design Group, Inc.
Art Director
William McElveney
Designer
Dennis DeSilva
Illustrator
Ellen Johnson
Project
Logo design
Client
Fieldbrook Farms
Purpose or Occasion
Logo redesign
Software
Macromedia FreeHand

▶ Fieldbrook Farms was looking for a logo that was both graphically bold and inviting. The final logo needed to be a two-color solution that would be easy to implement across their entire line of packaging. The resulting logo was created entirely in FreeHand.

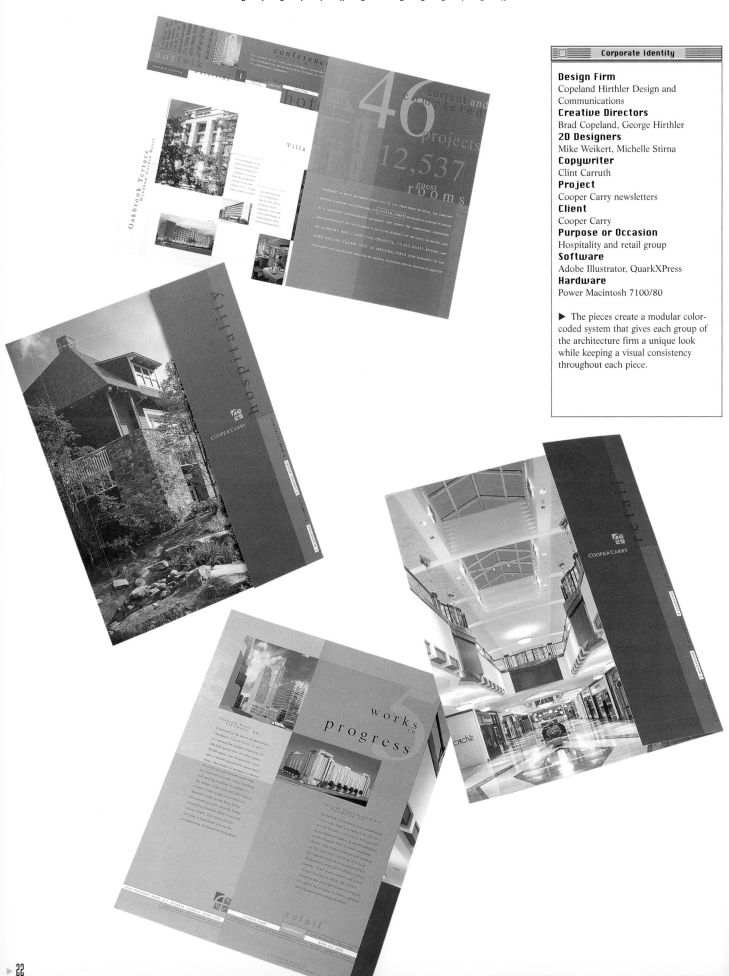

Corporate Identity

Design Firm
Copeland Hirthler Design and
Communications
Creative Directors
Brad Copeland, George Hirthler
2D Designers
Mike Weikert, Michelle Stirna
Copywriter
Clint Carruth
Project
Cooper Carry newsletters
Client
Cooper Carry
Purpose or Occasion
Hospitality and retail group
Software
Adobe Illustrator, QuarkXPress
Hardware
Power Macintosh 7100/80

▶ The pieces create a modular color-
coded system that gives each group of
the architecture firm a unique look
while keeping a visual consistency
throughout each piece.

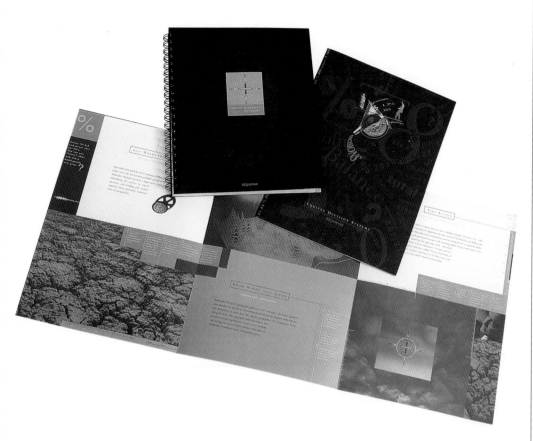

Corporate Identity

Design Firm
Copeland Hirthler Design and
Communications
Creative Directors
Brad Copeland, George Hirthler
Art Director
Melanie Bass Pollard
2D Designers
Melanie Bass Pollard, David Woodward,
Shawn Brasfield, Lea Nichols
Copywriters
Melissa James Kemmerly,
Diana Thorington
Account Executive
Leslie Blair
Photographers
Fredrik Broden, Jerry Burns,
Mark Shelton, John Grover
Producers
Laura Perlee, Donna Harris,
Tor Gunderson
Project
Equifax corporate identity
Client
Equifax
Purpose or Occasion
Collateral material for marketing,
trade shows, and forums

▶ This collateral and advertising
system provided Equifax with unique
and flexible materials for promoting
products and services across diverse
markets and divisions within Equifax.
All pieces are created to fit within a
sized-pocket system. This flexible
imaging system was extended through
a range of print and environmental
graphics ranging from brochures to
trade-show materials to advertising.
Most of the photography was
conceptualized in the studio with tight
comps created in Adobe Photoshop,
QuarkXPress, and Adobe Illustrator.

Corporate Identity

Design Firm
Erbe Design
Art Director/Designer
Maureen Erbe
Photographer
Scott Streble
Project
Ask a Friend — newspaper insert
Client
Huntington Memorial Hospital
Campaign
Purpose or Occasion
Image campaign for hospital
Software
QuarkXPress
Hardware
Macintosh

▶ The purpose of the piece was to
communicate to the community that the
hospital is not only the best in the area
but also the most compassionate for
people of all ages and ethnic groups.
The square format, die-cut friendly
faces and warm colors were chosen
to make the piece inviting to the
reader and stand out among other
newspaper inserts.

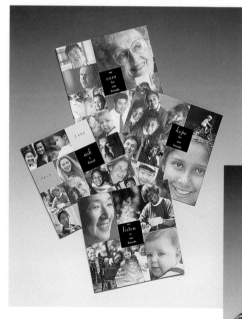

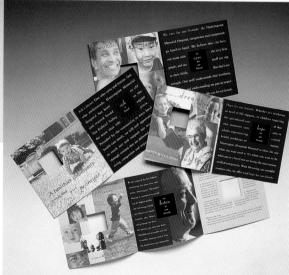

Design Firm
Whitney Edwards Design
Art Director/Designer
Charlene Whitney Edwards
Project
Corporate brochure
Client
TransWeb.LLC
Purpose or Occasion
Corporate brochure
Software
Adobe Photoshop, Adobe Illustrator,
QuarkXPress
Hardware
Macintosh 8500

▶ The abstract Photoshop collages
used in this brochure were well-suited
for this product—a fibrous material
used for filtration. The illustrations
were done in Adobe Photoshop and
Adobe Illustrator. Some of the filtration
materials were scanned at low resolution
on a desktop scanner. They were
much more interesting than the high-
resolution scans that showed too
much detail and proved confusing.

Photo credit: Jordon Photography

Corporate Identity

Design Firm
Love Packaging Group
All Design
Brian Miller
Project
Elogen logo
Client
Elogen, Inc.
Purpose or Occasion
Logo for skin-care product
Software
Macromedia FreeHand, Adobe Photoshop
Hardware
Power Macintosh Quadra 950

▶ The logo originated from a pencil sketch that was done to refine the initial concept. The product is a skin-care line developed by a cellular biologist who was engineering the ingredients of his product on a molecular level. As a unique niche, the molecular concept was solidified into a visual by taking the ingredients of the product and mapping them onto two molecules linked by the initial of the name (Elogen). To achieve the different colors for different uses of the logo, the information palette in Adobe Photoshop was closely monitored.

Corporate Identity

Design Firm
Love Packaging Group
All Design
Brian Miller
Project
Homestar logos
Client
HOC Industries
Purpose or Occasion
Product logos
Software
Macromedia FreeHand,
Adobe Dimensions, Adobe Photoshop
Hardware
Macintosh Quadra 950

▶ The two logos were created as loose pencil sketches that were taped to the monitor to serve as reference as they were fleshed out in FreeHand. The banners were rendered in Dimensions and composited in FreeHand with the type and shape paths.

Corporate Identity

Design Firm
Love Packaging Group
All Design
Brian Miller
Project
Backpacks to briefcases logo
Client
Wichita Public Schools/Wichita Area
Technical College
Purpose or Occasion
Cooperative education banquet
thanking employees
Software
Macromedia FreeHand, Adobe Photoshop
Hardware
Macintosh Quadra 950

▶ After a pencil sketch resolved the basics of the logo, the sketch was scanned and put on its own layer in FreeHand to serve as reference. The line art was traced and fine-tuned and then exported to Adobe Illustrator where it was copied to the clipboard and then pasted into Adobe Photoshop as paths. Each airbrushed section got its own layer and the paths were turned to selections and offset to serve as airbrushing friskets. When the logo was completed, it was flattened and saved as a high-resolution file and imported into FreeHand where the transparent option could then be used to lay the logo over color.

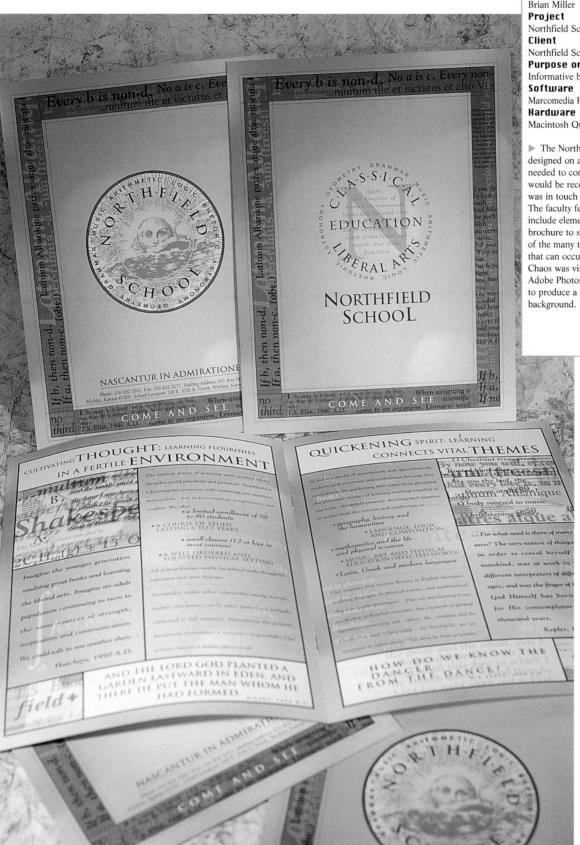

Corporate Identity

Design Firm
Love Packaging Group
All Design
Brian Miller
Project
Northfield School brochure
Client
Northfield School
Purpose or Occasion
Informative brochure for parents
Software
Marcomedia FreeHand, Adobe Photoshop
Hardware
Macintosh Quadra 950

▶ The Northfield School brochure was designed on a very low budget and needed to convey to the parents who would be receiving it that the school was in touch with the student body. The faculty felt it was important to include elements of chaos within the brochure to show that they were aware of the many thoughts and problems that can occupy a student's mind. Chaos was visually represented using Adobe Photoshop's lighting effects filter to produce a partially illuminated background.

Corporate Identity

Design Firm
Multimedia Asia, Inc.
Art Director
G. Lee
Illustrator
J. E. Jesus
Project
Corporate identity
Client
Multimedia Asia, Inc.
Purpose or Occasion
Corporate identity
Software
Adobe Photoshop, Adobe Illustrator
Hardware
Macintosh

▶ Since it is a multimedia company, it is important that the logo says what the company can do and who they are. The map represents how important it is for companies today to become part of the global market, and the icons show the services offered. The map was based on an antique map and was worked on in Adobe Illustrator. The image was then exported to Adobe Photoshop for added effects and filtering.

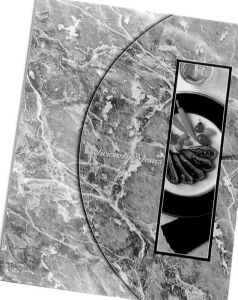

Corporate Identity

Design Firm
Eastern Edge Media Group, Inc.
Art Director/Designer
M. J. Pressley-Jones
Illustrator
Robert J. Jones
Project
PA Convention Center catering menu
Client
Aramark Corporation
Software
Adobe Photoshop, QuarkXPress
Hardware
Power Macintosh 9500, Quadra 950

▶ The client wanted the cover to reflect the marble interior of the PA Convention Center's grand hall. Background art that complemented the hall's interior was located and used in the piece. The die-cut business card slits adds a creative surprise.

Corporate Identity

Design Firm
Parham Santana, Inc.
Art Directors
Loriann Reinig
Creative Director
Elisa Feinman/USA Network
Digital Design
Derek Beecham
Copywriters
Kimberly A. Hemphill, Allison Villone
Project
US/French Open sales kit folder
Client
USA Network
Software
Adobe Photoshop, Adobe Illustrator,
QuarkXPress
Hardware
Macintosh

▶ The objective of the sales kit folder was to announce that USA Networks is featuring two grand-slam tennis events. The goal was to create a sense of the competition and excitement found in tennis. This was accomplished by adding movement to the images and by highlighting with hot colors the latest, greatest personalities in tennis. Research included various tennis magazines and books as well as sports-video packaging.

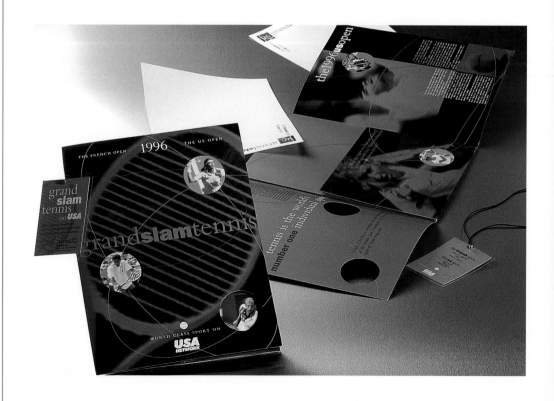

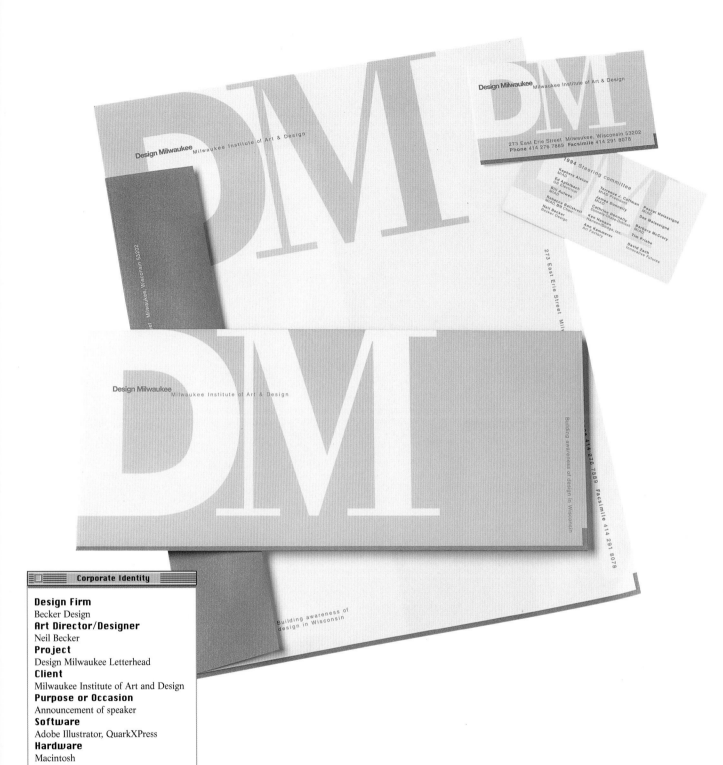

Corporate Identity

Design Firm
Becker Design
Art Director/Designer
Neil Becker
Project
Design Milwaukee Letterhead
Client
Milwaukee Institute of Art and Design
Purpose or Occasion
Announcement of speaker
Software
Adobe Illustrator, QuarkXPress
Hardware
Macintosh

▶ Design Milwaukee, operating in conjunction with the Milwaukee Institute of Art and Design, is an organization that reaches the entire design community of Milwaukee. Not only was the challenge to design a look that would be appropriate for a wide range of disciplines, but to make it innovative and timeless.

Corporate Identity

Design Firm
Becker Design
All Design
Neil Becker
Project
Winter Park Pub identity
Client
Winter Park Pub
Purpose or Occasion
Corporate identity
Software
Adobe Illustrator, QuarkXPress
Hardware
Macintosh

▶ This identity system was created for a pub in downtown Winter Park.

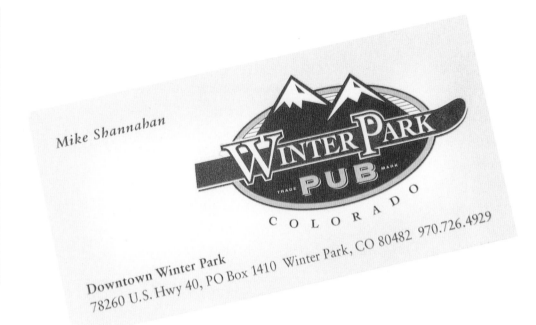

Corporate Identity

Design Firm
Marcolina Design, Inc.
All Design
Dermot Mac Cormack
Project
Bentley corporate brochure
Client
Bentley Systems, Inc.
Purpose or Occasion
Corporate overview of products/services
Software
Adobe Photoshop, Specular Collage, Infini-D, QuarkXPress, Adobe Illustrator
Hardware
Power Macintosh 9500

▶ Bentley Systems, Inc., a leader in the world of CAD software, required a corporate brochure that would position their company in a global market as well as describe their products and services to customers and investors. Images were assembled in Collage to keep track of the many elements as well simplify comping in a low-resolution format.

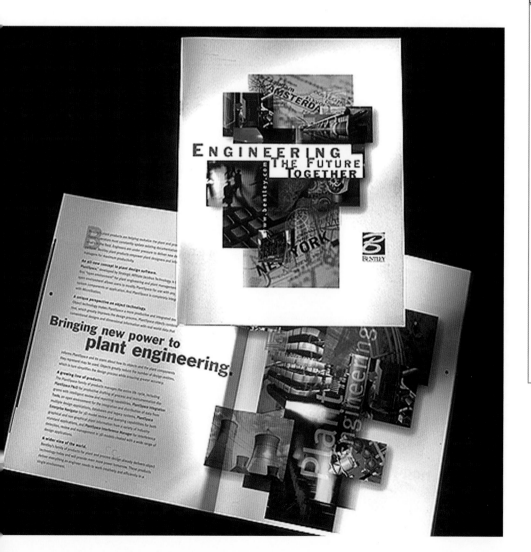

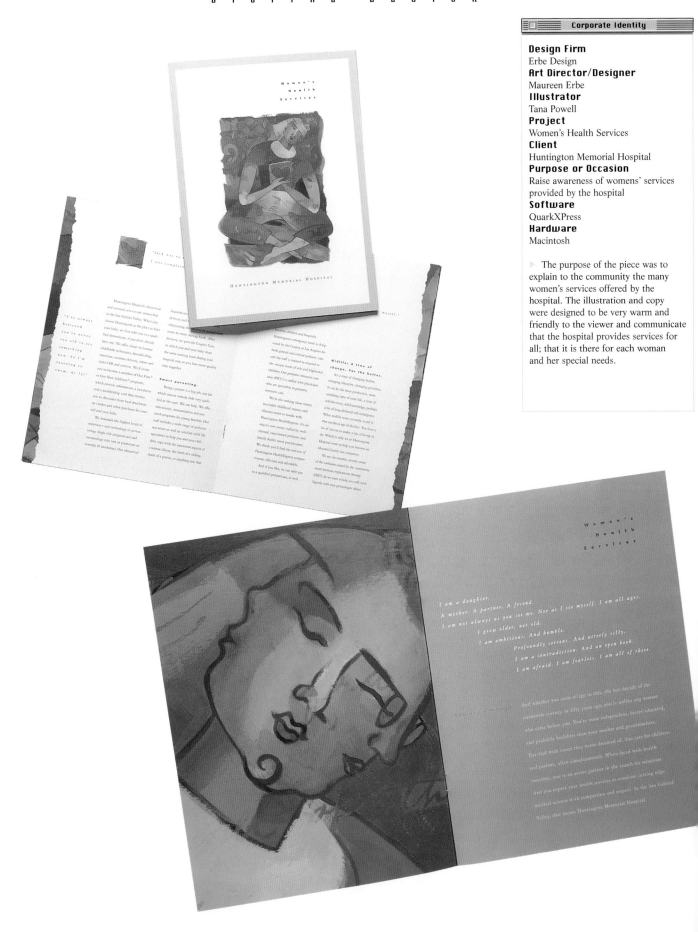

Design Firm
Erbe Design
Art Director/Designer
Maureen Erbe
Illustrator
Tana Powell
Project
Women's Health Services
Client
Huntington Memorial Hospital
Purpose or Occasion
Raise awareness of womens' services
provided by the hospital
Software
QuarkXPress
Hardware
Macintosh

▶ The purpose of the piece was to
explain to the community the many
women's services offered by the
hospital. The illustration and copy
were designed to be very warm and
friendly to the viewer and communicate
that the hospital provides services for
all; that it is there for each woman
and her special needs.

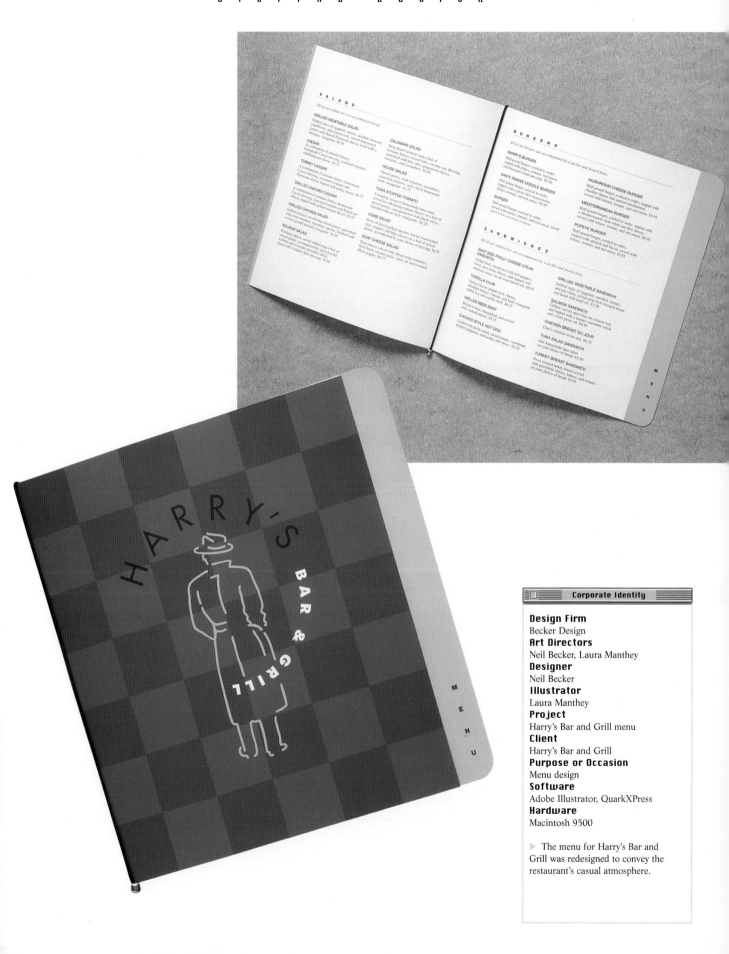

Corporate Identity

Design Firm
Becker Design
Art Directors
Neil Becker, Laura Manthey
Designer
Neil Becker
Illustrator
Laura Manthey
Project
Harry's Bar and Grill menu
Client
Harry's Bar and Grill
Purpose or Occasion
Menu design
Software
Adobe Illustrator, QuarkXPress
Hardware
Macintosh 9500

▶ The menu for Harry's Bar and
Grill was redesigned to convey the
restaurant's casual atmosphere.

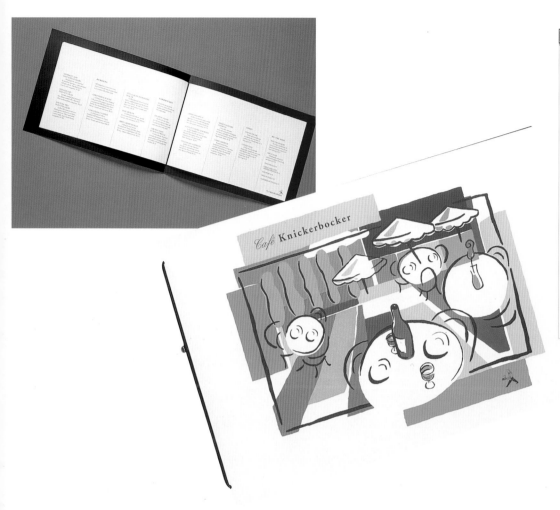

Corporate Identity

Design Firm
Becker Design
Art Director/Designer
Neil Becker
Illustrator
David Cyetan
Project
Café Knickerbocker menu
Client
Café Knickerbocker
Purpose or Occasion
Menu redesign
Software
Adobe Photoshop, QuarkXPress
Hardware
Power Macintosh 9500, 7100

▶ The Café Knickerbocker menu was redesigned to better represent the menu of an upscale restaurant.

Corporate Identity

Design Firm
Hornall Anderson Design Works
Art Director
Jack Anderson
Designers
Jack Anderson, Julie Lock,
Alan Florsheim, Joy Miyamoto
Project
Scandia racing brochure
Client
Scandia
Purpose or Occasion
Promotional brochure
Software
Marcomedia FreeHand, QuarkXPress
Hardware
Macintosh

▶ This piece served as an introductory/ sponsorship recruitment brochure for an Indy-car racing team. Stock photos were used throughout the brochure to emphasize the excitement and success of the team.

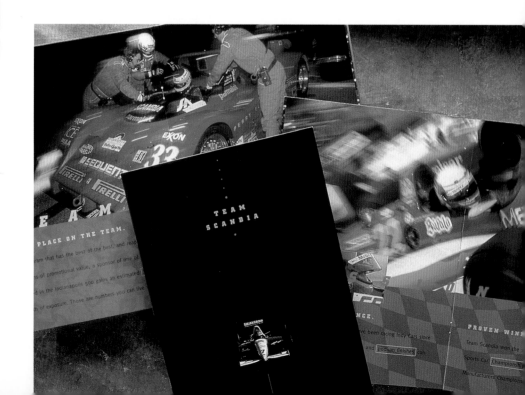

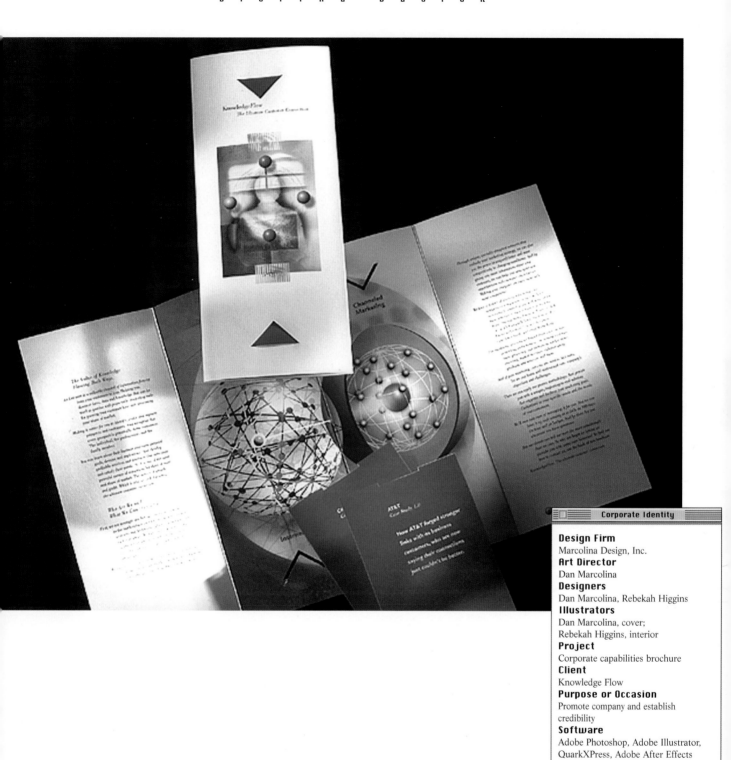

Corporate Identity

Design Firm
Marcolina Design, Inc.
Art Director
Dan Marcolina
Designers
Dan Marcolina, Rebekah Higgins
Illustrators
Dan Marcolina, cover;
Rebekah Higgins, interior
Project
Corporate capabilities brochure
Client
Knowledge Flow
Purpose or Occasion
Promote company and establish
credibility
Software
Adobe Photoshop, Adobe Illustrator,
QuarkXPress, Adobe After Effects
Hardware
Genesis MP

▶ The hard-line graphics were created
in Adobe Illustrator then embellished
in Adobe Photoshop. Cover illustration
was created in Adobe After Effects with
extensive layering and masking. The
brochure was designed to be modified
by the addition of printed cards that
fit in the triangular dies.

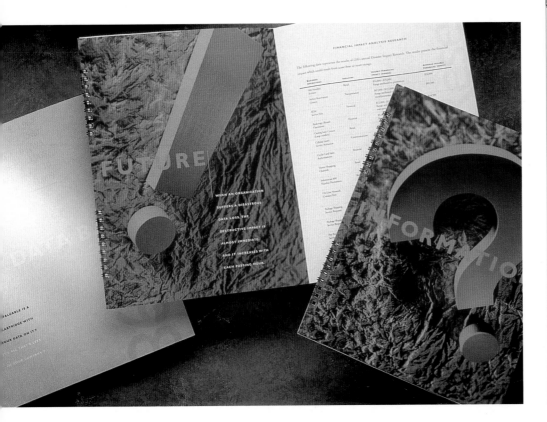

Corporate Identity

Design Firm
Hornall Anderson Design Works
Art Director
John Hornall
Designers
John Hornall, Debra Hampton,
Heidi Favour
Client
Data Base
Purpose or Occasion
Capabilities brochure
Software
Adobe Photoshop, QuarkXPress
Hardware
Macintosh

▶ The client's main objective was to create a brochure that would describe their company's capabilities in data security and protection. Large, colorful type treatments were used to play down the large blocks of text that are frequently found in technical literature. For security reasons the client chose not to use any facility shots. Feature symbols representing metal, three-dimensional letter forms were chosen to emphasize copy points.

Corporate Identity

Design Firm
Hornall Anderson Design Works
Art Director
Jack Anderson
Designers
Jack Anderson, Jana Wilson
Project
Koehler McFadyen capabilities brochure
Client
Koehler McFadyen
Purpose or Occasion
Capabilities brochure
Software
Adobe Illustrator, Adobe Photoshop,
QuarkXPress
Hardware
Macintosh

▶ The design objectives were to update and humanize the existing capabilities brochure and incorporate existing project sheet inserts. With an eye on keeping the piece cost effective, the solution was a structured grid with the emphasis on a centered square element. A one-color cover sheet ties in existing project sheets.

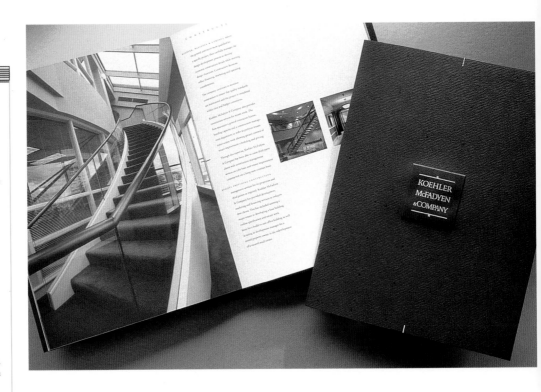

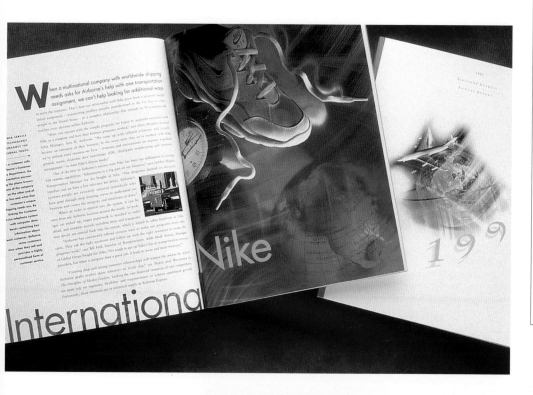

Corporate Identity

Design Firm
Hornall Anderson Design Works
Art Director
John Hornall
Designers
John Hornall, Lisa Cerveny, Heidi
Favour, Bruce Branson-Meyer
Project
Airborne Express annual report
Client
Airborne Express
Purpose or Occasion
Annual report
Software
Macromedia FreeHand, QuarkXPress
Hardware
Macintosh

▶ Not only was this designed to be an
annual financial report, it was also used
to tell the client's stories. The domestic
sections consisted of information about
the clients, while the logistics sections
consisted of technological information.

Corporate Identity

Design Firm
Hornall Anderson Design Works
Art Director
Jack Anderson
Designers
Jack Anderson, Lisa Cerveny, Jana Wilson,
Alan Florsheim, Michael Brugman
Project
Frank Russell Company defined
contribution services kit
Client
The Frank Russell Company
Purpose or Occasion
Capabilities kit
Software
Adobe Photoshop, Macromedia FreeHand,
QuarkXPress
Hardware
Macintosh

▶ This modular brochure package
focuses on different defined-contribu-
tions companies. Up to four different
parts of the client's company can be
chosen to be presented based on which
company service is being highlighted.
The kit includes four brochures and a
small, square overview brochure.

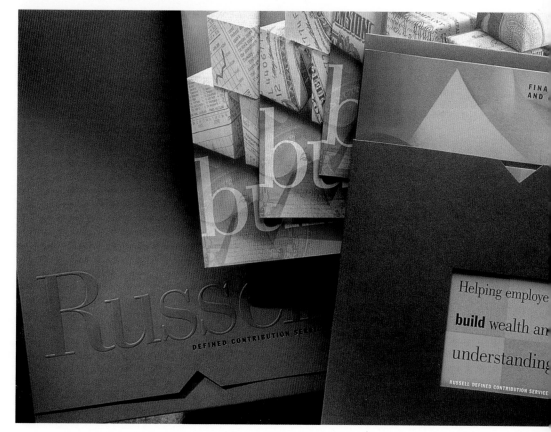

Corporate Identity

Design Firm
Hornall Anderson Design Works
Art Director
Jack Anderson
Designers
Jack Anderson, Heidi Favour,
Mary Hermes, Mary Chin Hutchison,
Julia LaPine
Project
Quebecor Integrated Media stationery
program
Client
Quebecor Integrated Media
Purpose or Occasion
Stationery
Software
Macromedia FreeHand
Hardware
Macintosh

▶ The client's stationery program uses
the same four colors as the company's
previous identity. These colors were
special match inks, and not actual
PMS colors.

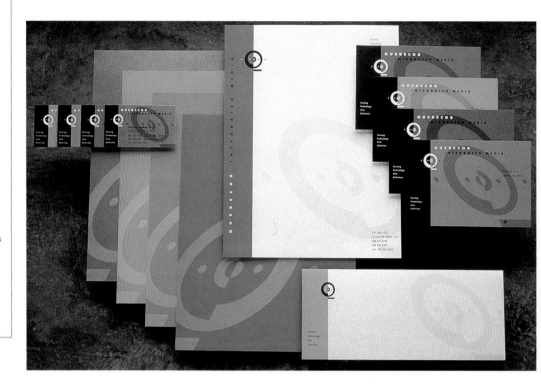

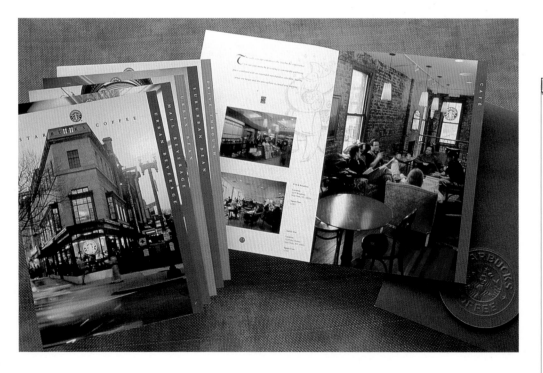

Corporate Identity

Design Firm
Hornall Anderson Design Works
Art Director
Jack Anderson
Designers
Jack Anderson, Julie Lock
Project
Starbucks real estate kit
Client
Starbucks Coffee Company
Purpose or Occasion
Sales kit
Software
Adobe Photoshop, QuarkXPress
Hardware
Macintosh

▶ This piece was used as a means of
leasing retail area for new Starbucks
stores. Photographs were used to
highlight the available areas and show
examples of current establishments.

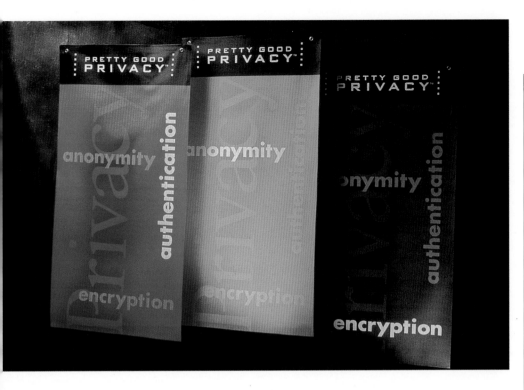

Corporate Identity

Design Firm
Hornall Anderson Design Works
Art Director
Jack Anderson
Designers
Jack Anderson, Debra Hampton,
Heidi Favour, Jana Wilson,
Katha Dalton, Michael Brugman
Project
PGP capabilities brochure
Client
PGP (Pretty Good Privacy)
Purpose or Occasion
Capabilities brochure
Software
QuarkXPress
Hardware
Macintosh

▶ Pretty Good Privacy (PGP) is an
encryption software company that
scrambles digital correspondence so
it can't be intercepted over the Internet.
The word "Privacy" on the front cover
becomes lost in type when opened to
the front page (symbolic of the company's
scrambling encryption capabilities).

Corporate Identity

Design Firm
Held Diedrich
Art Directors
Doug Diedrich, Megan Snow
Designer
Megan Snow
Photographers
Dan Francis, Patty Lindley
Project
Facility brochure
Client
Kendrick Memorial Hospital
Purpose or Occasion
Lead generation/fulfillment
Software
QuarkXPress
Hardware
Macintosh Power PC

▶ This piece was designed to capture
the warm and friendly feeling of the
facility. QuarkXPress was used to
create the file, and the brochure was
printed using four-color process.

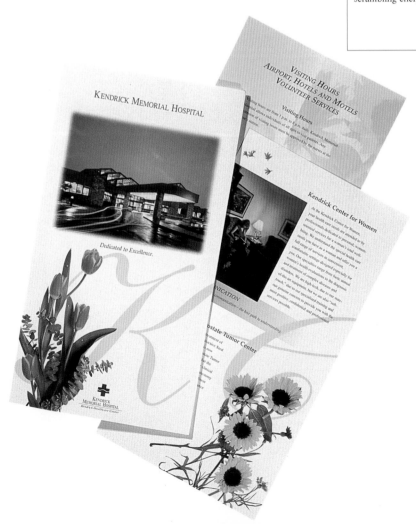

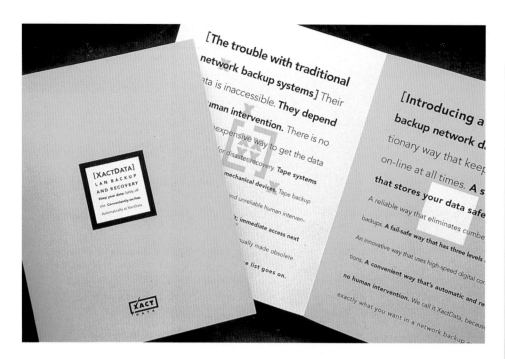

Corporate Identity

Design Firm
Hornall Anderson Design Works
Art Director
Jack Anderson
Designers
Jack Anderson, Lisa Cerveny,
Jana Wilson, Julie Keenan
Project
XactData capabilities brochure
Client
XactData Corporation
Purpose or Occasion
Capabilities brochure
Software
Macromedia FreeHand, QuarkXPress
Hardware
Macintosh

▶ XactData, a distributive system
back-up company, which uses
high-speed back-up lines, needed a
capabilities brochure. A vault idea was
represented throughout the brochure by
making use of the logo as a focal point
(an X in a square, or vault.) Small Xs
are used to identify the user information
throughout the brochure, as well. The
end of the brochure reinforces the
concept of backing-up data through
placement of the X logo.

Corporate Identity

Design Firm
Melissa Passehl Design
Art Director
Melissa Passehl
Designers
Melissa Passehl, Charlotte Lambrects,
David Stewart, Christopher Passehl
Project
Product brochure and folder
Client
Viewmate
Software
Adobe Illustrator, Adobe Photoshop,
QuarkXPress
Hardware
Power Macintosh 9500

▶ The design objective was to create
an overall new identity and product
brochure that conveyed the company's
commitment to quality color monitors.
The company's attention to detail in
precision and color were used as design
elements in the folder.

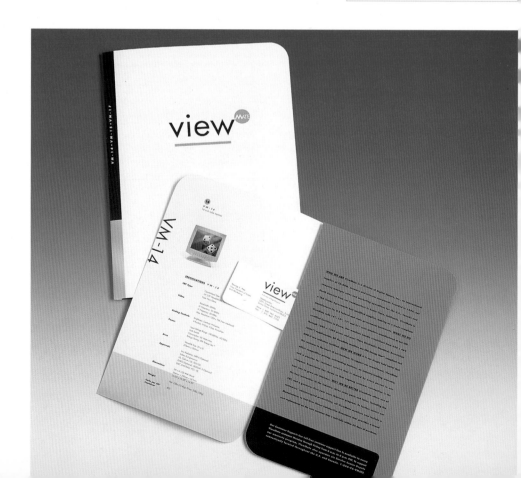

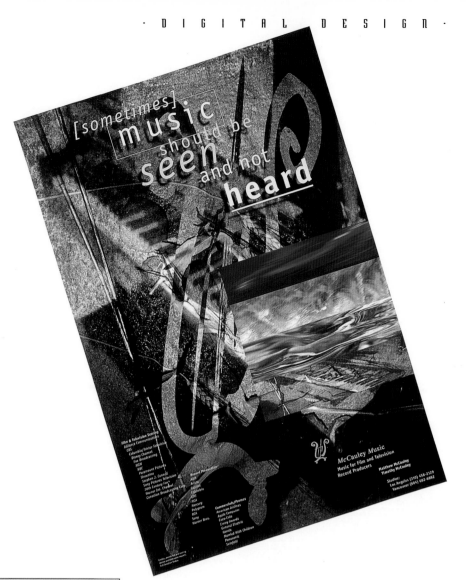

Corporate Identity

Design Firm
Design Art, Inc.
Art Director/Designer
Norman Moore
Project
McCaulley music poster
Client
Mathew McCaulley
Purpose or Occasion
Music company promotion
Software
Adobe Photoshop, Adobe Illustrator,
QuarkXPress
Hardware
Macintosh 9500/150

▶ The background is a combination of three photographs composited in layers in Adobe Photoshop with the piano given the most prominence. The diagonal lyre illustration was imported from Adobe Illustrator and brightly colored abstract photos were later pasted in using Quark. The type shadow was screen captured from Quark and blurred using Adobe Photoshop.

Corporate Identity

Design Firm
Hornall Anderson Design Works
Art Director
Jack Anderson
Designers
Jack Anderson, Heidi Favour
Project
Pacific Place newsletter
Client
Pacific Place
Purpose or Occasion
Newsletter for new development
Software
Macromedia FreeHand, QuarkXPress
Hardware
Macintosh

▶ The newsletter for a development needed to attract prospective clients to this newly constructed Seattle development. The gatefold includes existing and new downtown attractions to highlight the area.

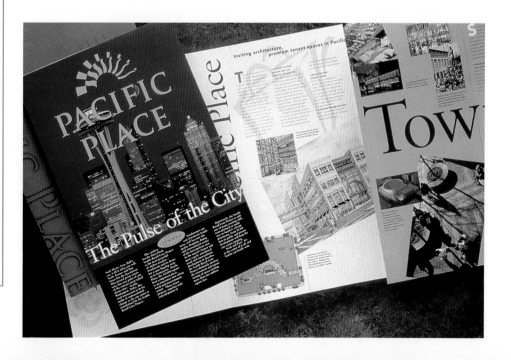

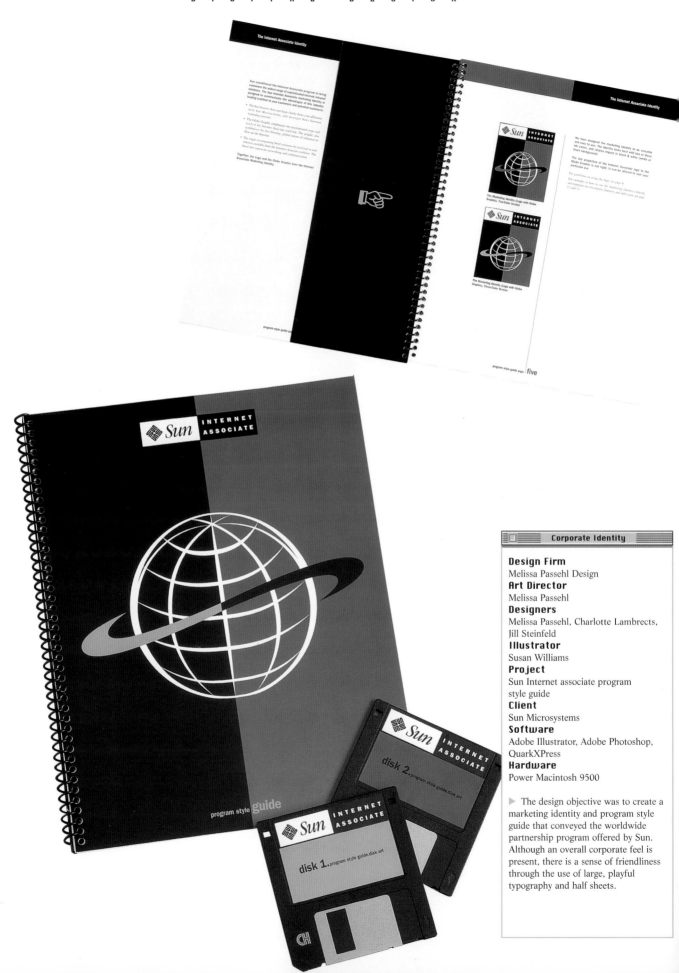

Corporate Identity

Design Firm
Melissa Passehl Design
Art Director
Melissa Passehl
Designers
Melissa Passehl, Charlotte Lambrects,
Jill Steinfeld
Illustrator
Susan Williams
Project
Sun Internet associate program
style guide
Client
Sun Microsystems
Software
Adobe Illustrator, Adobe Photoshop,
QuarkXPress
Hardware
Power Macintosh 9500

▶ The design objective was to create a
marketing identity and program style
guide that conveyed the worldwide
partnership program offered by Sun.
Although an overall corporate feel is
present, there is a sense of friendliness
through the use of large, playful
typography and half sheets.

Corporate Identity

Design Firm
Heart Graphic Design
Art Director/Designer
Clark Most
Software
Adobe Photoshop, QuarkXPress,
Fractal Design Painter
Hardware
Power Macintosh 8100

▶ This newsletter design and all the elements in it were created or manipulated digitally. The newsletter will be used by Tannoy, a speaker manufacturer, to communicate new-product information, talk about technology, and generally promote their quality-oriented identity.

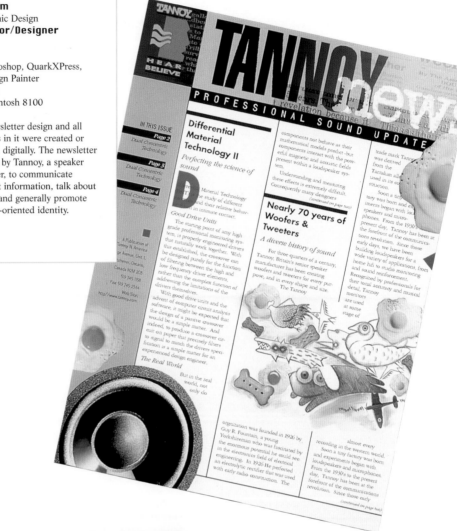

Corporate Identity

Design Firm
Toni Schowalter Design
Art Director/Designer
Toni Schowalter
Project
Radio Advertising Bureau folder
Client
Radio Advertising Bureau
Purpose or Occasion
Identity piece
Software
Adobe Photoshop, QuarkXPress
Hardware
Power Macintosh 6100, 7600

▶ Playing up the theme "For Your Ears Only" by using photographic images that evoke different aspects of radio communications, an identity was developed for the Radio Advertising Bureau that subscribers could begin to recognize. Adobe Photoshop was used to modify the color, and montages were created in QuarkXPress. Photo costs were kept down by using stock images from a photo CD.

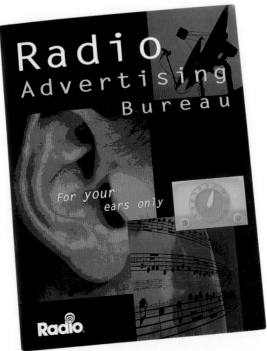

Corporate Identity

Design Firm
The Identica Partnership
Art Director
Carole Langier
Designers
Carole Langier, Simon Drew
Project
National Power system on CD-ROM
Client
National Power (UK)
Software
Macromedia Director

► This dual-platform showpiece/ reference guide was created to be used by design agencies and National Power's Corporate Communications department. It showcases the National Power style created by Identica.

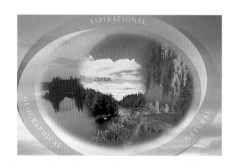

Corporate Identity

Design Firm
The Identica Partnership
Art Director
Carole Laugier
Designers
Carole Laugier, Simon Drew
Project
Promotional CD-ROM
Client
The Identica Partnership
Purpose or Occasion
Sales tool
Software
Macromedia Director

► This CD-ROM is a tool geared towards the sales and marketing staff at Identica that explains seven very different case studies. There are several virtual-reality screens and interesting programming/videos to explain the cases more thoroughly. This program was developed as a new business promotional piece to be presented by Identica's sales and marketing staff on Macintosh PowerBooks.

Corporate Identity

Design Firm
Greteman Group
Art Director
Sonia Greteman
Designers
Sonia Greteman, James Strange
Project
Kansas Health Foundation
annual report
Client
Kansas Health Foundation
Software
Macromedia FreeHand,
Adobe Photoshop
Hardware
Macintosh Power PC

▶ The annual report uses a combination of embossing, striking photography, and bold typography. All photos were scanned through Photoshop and then put in duotones. Franklin Gothic makes up the interactive headlines with Garamond used in the body copy.

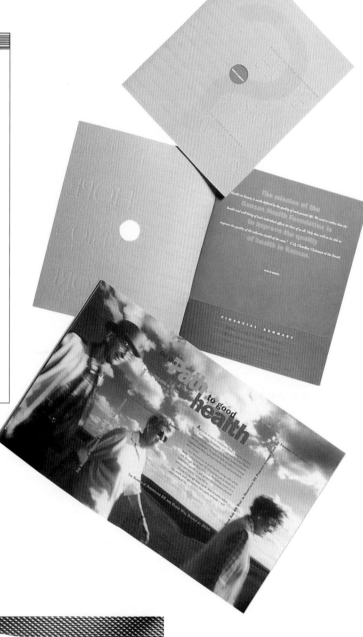

Corporate Identity

Design Firm
Greteman Group
Art Director/Designer
Sonia Greteman, James Strange
Illustrator
James Strange
Project
WISB brochure and annual report
Client
Wichita Industries and Services for the Blind
Purpose or Occasion
Annual report and fund raiser
Software
Macromedia FreeHand
Hardware
Macintosh Power PC

▶ All illustrations were created in FreeHand with embossing and die-cutting created on one template to save on costs. Simple graphics and type emphasize the powerful and moving message—the day-by-day struggle of the visually impaired.

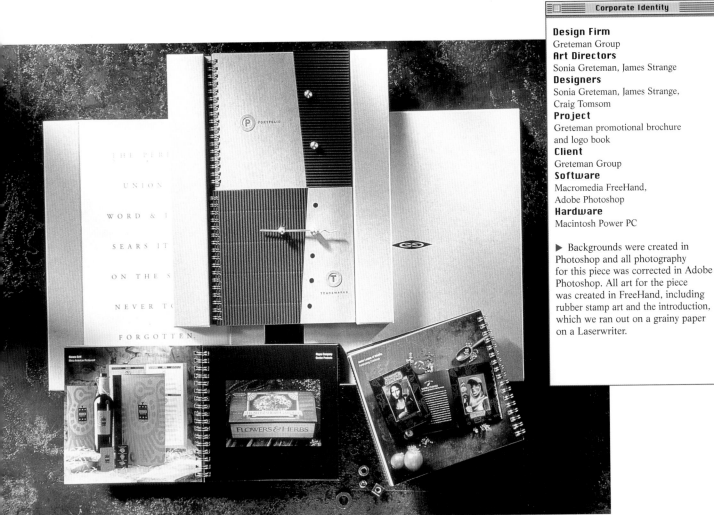

Corporate Identity

Design Firm
Greteman Group
Art Directors
Sonia Greteman, James Strange
Designers
Sonia Greteman, James Strange,
Craig Tomsom
Project
Greteman promotional brochure
and logo book
Client
Greteman Group
Software
Macromedia FreeHand,
Adobe Photoshop
Hardware
Macintosh Power PC

▶ Backgrounds were created in Photoshop and all photography for this piece was corrected in Adobe Photoshop. All art for the piece was created in FreeHand, including rubber stamp art and the introduction, which we ran out on a grainy paper on a Laserwriter.

Corporate Identity

Design Firm
Design Works Studio, Ltd.
All Design
Jason Vaughn
Project
Eyes of Time
Client
Moore Visions
Purpose or Occasion
Corporate identity
Software
Adobe Photoshop
Hardware
Umax 5-900

▶ The client needed a dream-like appearance that conveyed the endless sight and depth into their business future. Cutting-edge, out-of-the-ordinary concepts were pursued in this design. KPT, GE, and other filters were used to make this look happen.

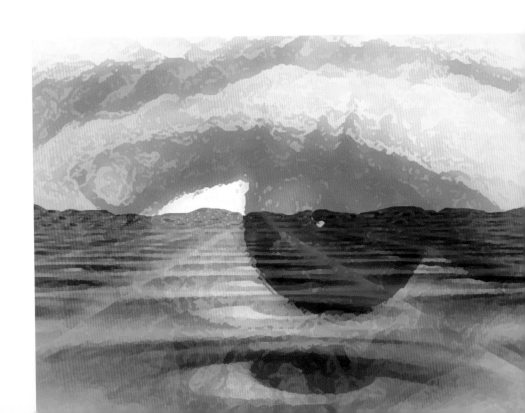

Corporate Identity

Design Firm
Steve Trapero Design
All Design
Steve Trapero
Project
Corporate identity
Client
Capitol Hill Seventh-Day
Adventist Church
Purpose or Occasion
Corporate identity
Software
Adobe Illustrator, QuarkXPress
Hardware
Power Macintosh 7100

▶ This new and dynamic identity system was created to reflect the congregation's youthfulness and vitality, along with the denomination's central message of Jesus and the three angels' messages found in *Revelation 14*. The brushstroke figures are both the three angels and the three crosses of Calvary, with Christ in the center.

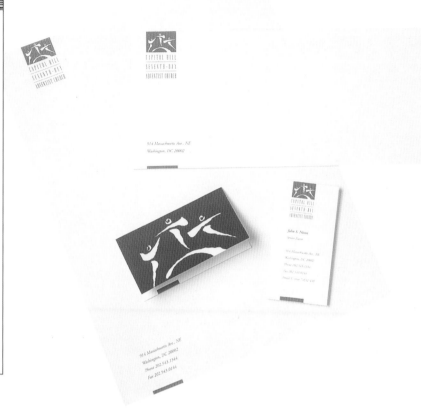

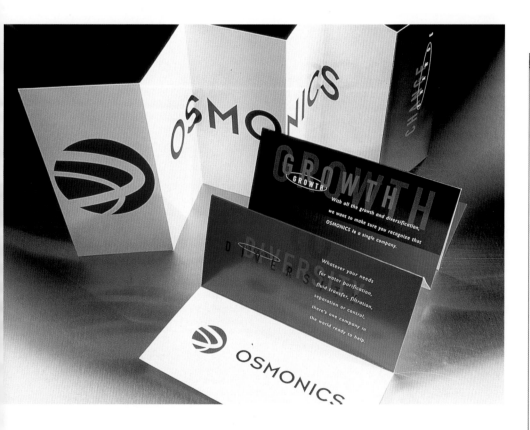

Corporate Identity

Design Firm
Larsen Design and Interactive
Art Director
Tim Larsen
Designer
Sascha Boecker
Project
Osmonics identity program
Client
Osmonics
Software
Macromedia FreeHand
Hardware
Macintosh

▶ Osmonics, a market leader in the field of fluid handling, was experiencing rapid growth through recent acquisitions. Osmonics' twenty-five-year-old logo and corporate identity needed an updating that would reflect the new diversity of the firm's multiple businesses. The resulting logo and identity program projects a consistent and focused public image. The Osmonics logo was created on a Macintosh computer system using FreeHand.

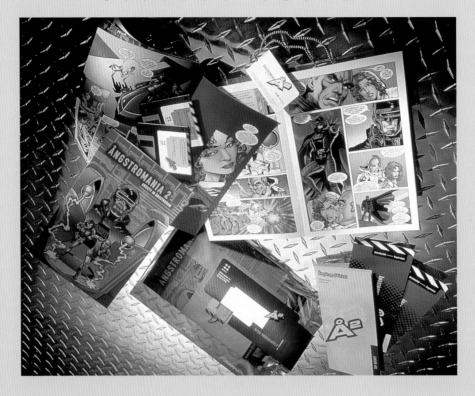

▶ Novellus was hosting an event that coincided with the an upcoming trade show, and needed an innovative theme and eye-catching materials to grab the attention of trade show attendees. Reprising the previous year's theme of "Angstromania," this year's theme was "Angstromania 2." The printed invitation materials and the interactive diskette invitations were created on Macintosh using QuarkXPress, FreeHand, Photoshop, Director, and Illustrator.

Event

Design Firm
Larsen Design and Interactive
Art Directors
Tim Larsen, Donna Root
Designers
Peter de Sibour, Sascha Boecker (print);
Sean McKay, Jon Wettersten (interface)
Illustrators
Dan Jurgens, Joe Rubinstein
Project
Angstromania 2 invitation materials
Client
Novellus Systems
Purpose or Occasion
Trade show event
Software
Marcomedia FreeHand, QuarkXPress,
Adobe Photoshop, Macromedia
Director, Adobe Illustrator
Hardware
Macintosh

Event

Design Firm
Perfectly Round Productions and
Insight Design Communications
All Design
Sherrie Holdeman, Tracy Holdeman
Project
Vocational brochure
Client
Catholic diocese of Wichita
Purpose or Occasion
Recruitment for priesthood
Software
Macromedia FreeHand, Adobe Photoshop
Hardware
Macintosh 7500

▶ Developing a brochure targeted at
recruiting priests became easy once the
concept — "Real People Make Real
Priests" — was finalized. The inside of
the brochure that focuses on statement,
and to emphasize this point, well-known
priests were asked to dig up childhood
photos of themselves. These photos are
actual evidence that priests indeed
come from the same place we all do.
The concept helps to demystify the
thought and communicates to each
reader on a personal level.

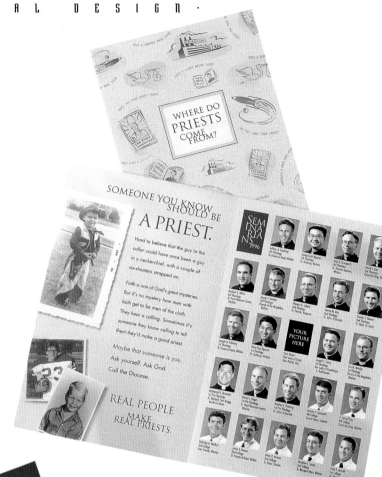

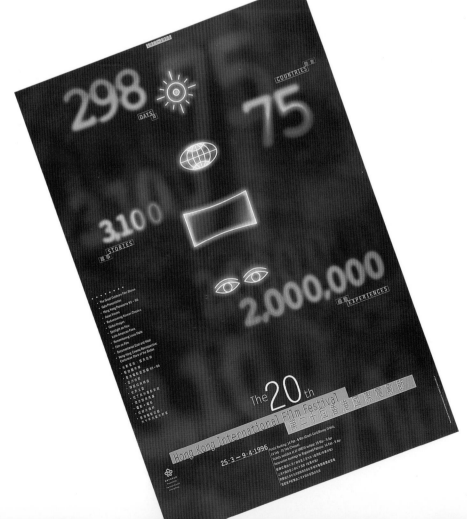

Event

Design Firm
Kan and Lau Design Consultants
Art Director
Freeman Lau Siu Hong
Designers
Freeman Lau Siu Hong, Fanny Ng Wai Ha
Project
The Twentieth Hong Kong
International Film Festival
Client
Urban Council
Software
Adobe Photoshop, Macromedia FreeHand
Hardware
Power Macintosh

Event

Design Firm
Mirko Ilić Corporation
Art Director/Designer
Mirko Ilić
Project
Poster for album release and tour
Client
Helidon-Liubljana
Purpose or Occasion
Announcement of band release
and tour
Software
Adobe Photoshop, Adobe Illustrator,
QuarkXPress
Hardware
Macintosh 8500

▷ To pull together the themes of
democracy and the suffering of parts of
the former Yugoslavia, stock photos,
type, and shapes were combined in
QuarkXPress. Stock photos are used to
suggest the Slovenian sky and earth.

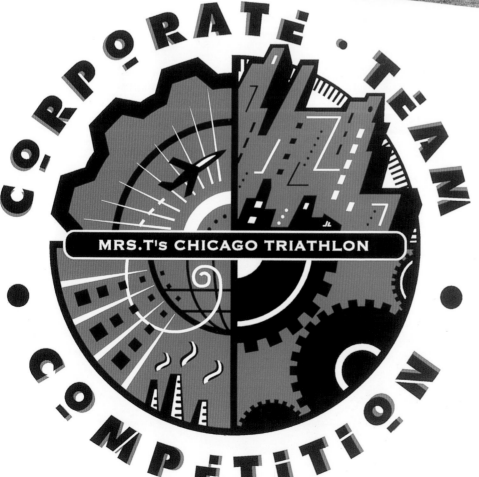

Event

Design Firm
Jim Lange Design
Art Director
Jan Caille
Designer/Illustrator
Jim Lange
Project
Corporate team competition logo
Client
Mrs. T's Chicago triathlon
Purpose or Occasion
Team event
Software
Adobe Illustrator
Hardware
Macintosh

▷ The focus of this piece dealt with
reinforcing the concept of the team,
represented by parts working together.
A circle reinforced the unity concept
and the lines, squares, and blips suggest
hi-tech business running efficiently.

Event

Design Firm
Design Guys
Art Director
Steven Sikora
Designer
Richard Boynton
Project
Target cashier triathlon posters
Client
Target
Purpose or Occasion
Promoting improved cashier performance
Software
Adobe Photoshop, Adobe Illustrator, QuarkXpress
Hardware
Macintosh Quadra 950

▶ The Target cashier triathlon was a speed and service program for store cashiers. The series of six posters comprised three teaser posters before the program's introduction and three monthly reminder posters after the program's launch.

Event

Design Firm
Insight Design Communications
All Design
Sherrie Holdeman, Tracy Holdeman
Project
AIGA Macintosh workshop
Client
AIGA
Purpose or Occasion
Workshop
Software
Macromedia FreeHand, Adobe Photoshop
Hardware
Macintosh 7500

▶ The AIGA "How to do-it-yourself" Macintosh workshop is a twist on the theme of a home workshop — specifically the workshop of the 1950s home handyman as depicted in the many do-it-yourself repair books and encyclopedias of the time. In the design of the AIGA piece, the mission was to make the piece look like it was not done on a computer. The cover is an obscure illustration of a computer. The headline is almost unreadable, and the subheads are incorporated into a piece of blueprint collage that wraps over the fold. All items used for collage purposes came from old how-to books. For the finishing touch, torn pieces of duct tape were used as a closure tab.

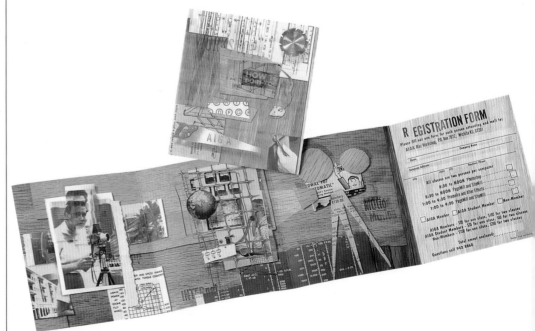

▶ The Target cashier triathlon was a speed-and-service program for store cashiers. The series of six posters comprised three teaser posters before the program's introduction and three monthly reminder posters after the program's launch.

▶ This illustration was created to promote a non-profit outdoor summer jazz concert series. The illustration was first sketched and scanned to use as a template when rendering the final illustration in Adobe Photoshop.

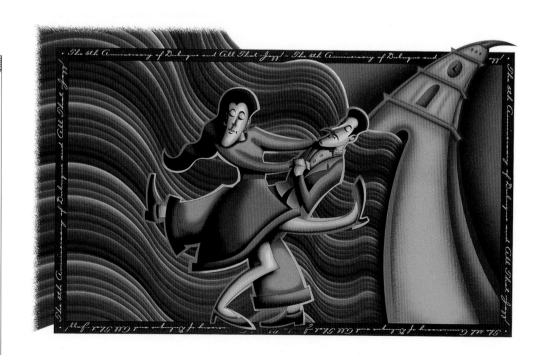

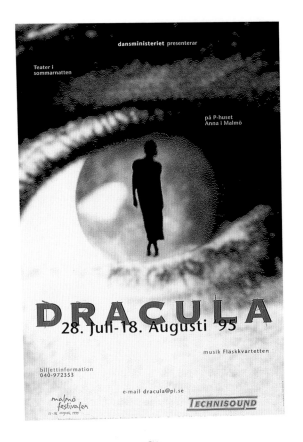

Event

Art Directors/Designers
Lars Busekist, Vibeke Nodskov
Project
Dracula
Client
Dansministeriet, Sweden
Purpose or Occasion
Poster for a modern performance
of *Dracula*
Software
Adobe Photoshop, QuarkXPress
Hardware
Macintosh 800 Quadra

▶ The poster consists of three
elements — a photo of an eye, a full
moon, and a hand-drawn human
figure. The elements were reconfigured
using Adobe Photoshop so that the
moon became the eyeball and the
figure became the pupil of the eye. The new
composition was then bitmapped using
a diffusion dither.

Event

Design Firm
Marketing and Communication
Strategies, Inc.
Art Director
Lloyd Keels
Designer/Illustrator
Eric Dean Freese
Project
Milestones Trade show booth
Client
Milestones Adult Day Health Center
Purpose or Occasion
Booth for upcoming trade show
Software
Adobe Photoshop, Adobe Illustrator,
QuarkXPress
Hardware
Power Macintosh 8100/80,
Arcus II scanner

▶ Milestones is an adult day health
center that stresses education, humanities,
and health care within a pleasant
environment. The redesign of the
Milestones booth included a "Our Loved
Ones are Treasures" theme. Utilizing
the existing backdrop, one 56" x 80"
and three 28" x 40" photographic
illustrations were created, each
incorporating treasure map imagery.
Additionally, a treasure-chest and red
"x marks the spot" are used with the booth.

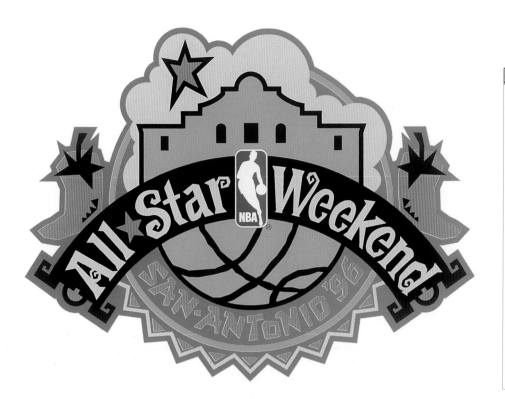

Event

Design Firm
Jim Lange Design
Art Director
Tom O'Grady
Designer/Illustrator
Jim Lange
Project
NBA All-Star Weekend logo
Client
NBA
Purpose or Occasion
NBA All-Star Weekend
Software
Adobe Illustrator
Hardware
Macintosh

▶ The main elements of this logo were pulled from various aspects of the weekend's events—player's uniforms, audience banners, and floor detailing.

Event

Design Firm
Insight Design Communications
All Design
Sherrie Holdeman, Tracy Holdeman
Project
Special-event material
Client
The Mid-Kansas Clubs of Printing House Craftsmen
Purpose or Occasion
Craftsman Club printing competition
Software
Macromedia FreeHand, Adobe Photoshop
Hardware
Macintosh 7500

▶ The print material used to promote the client's event include: direct-mail poster/call for entries, invitations, awards, and a program. With the theme "It's the People that Make the Difference," the background simulates a press sheet that explains offset printing. The poster was left uncropped to show the printers color bars and crop marks. The make-ready look of overprinted inks in the hand and lower-left corner was created in FreeHand and Photoshop and the type was set in FreeHand and pasted into Photoshop. The solid type was converted into halftone dots of various degrees by changing the mode from grayscale to bitmap where the dot size can be selected by number.

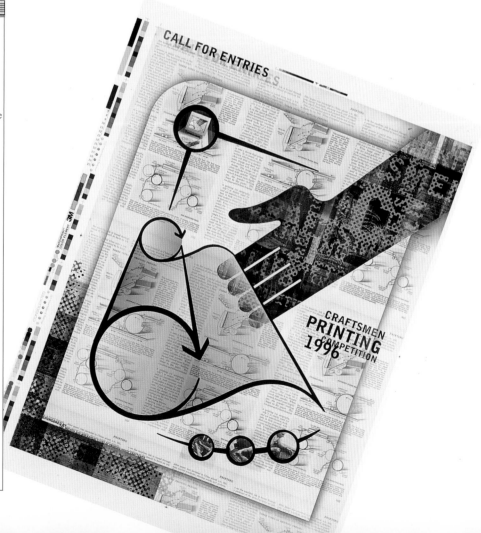

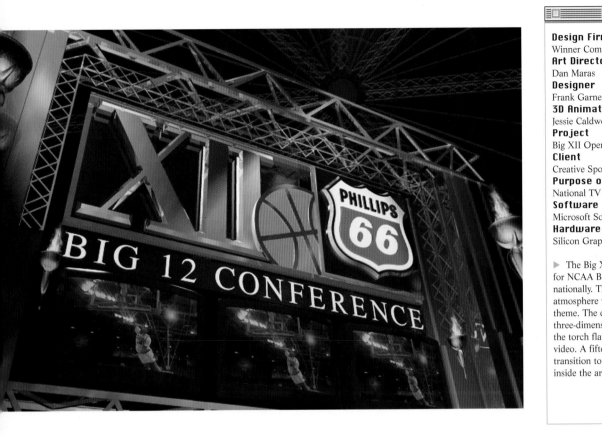

Event

Design Firm
Winner Communications, Inc.
Art Director
Dan Maras
Designer
Frank Garner
3D Animator
Jessie Caldwell
Project
Big XII Open
Client
Creative Sports
Purpose or Occasion
National TV advertising campaign
Software
Microsoft SoftImage 3D
Hardware
Silicon Graphics, Quantel Hal

▶ The Big XII Open was designed for NCAA Basketball games that air nationally. The idea was to create a big atmosphere with basketball as the main theme. The elements created are all three-dimensional models, except the torch flames and the basketball video. A fifteen-second opener uses a transition to get to the live video inside the arena.

Event

Design Firm
Winner Communications
Art Director
Dan Maras
Designer
Frank Garner
3D Animation
Frank Garner, Jason Madding
Project
Conference USA Open
Client
Creative Sports
Purpose or Occasion
NCAA basketball open that airs nationally
Software
Microsoft Softimage 3D
Hardware
Silicon Graphics, Quantel Hal

▶ Conference USA is an upbeat animation using a combination of different layered effects. After Effects and light filters composited with two- and three-dimensional elements add an exciting touch to this NCAA opener.

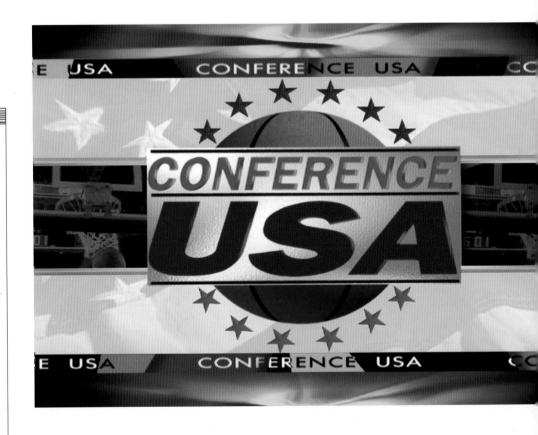

Event

Design Firm
Copeland Hirthler Design and
Communications
Creative Directors
Brad Copeland, George Hirthler
Art Director/2D Designer
Todd Brooks
**3D Designers/Illustrators/
Photographers**
Glenn Gyssler, stock photos
Copywriter
Melissa James Kemmerly
Project
Riverwood Next Wave campaign
Client
Riverwood International
Purpose or Occasion
Employee campaign
Software
Adobe Illustrator, Adobe Photoshop,
QuarkXPress
Hardware
Macintosh 8550

▶ The Riverwood Next Wave project
was a series of pieces created for an
internal employee-awareness campaign.

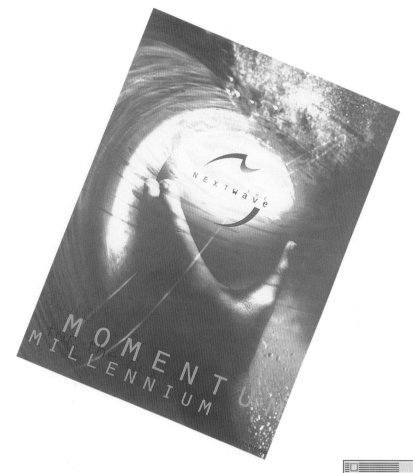

Event

Design Firm
Metropolis Corporation
Creative Director
Denise Davis
Assistant Creative Director
Lisa DiMaio
Illustrator
Karen Ross
Project
ITG Scarves
Client
Booz, Allen and Hamilton, Inc.
Purpose or Occasion
Information Technologies Conference
Software
Adobe Illustrator

▶ Each scarf was made up of extracted
mobile images. In their original mobile
form, they represent the uniting of
complex business and operational
activities to provide flexible information
for effective decision making.

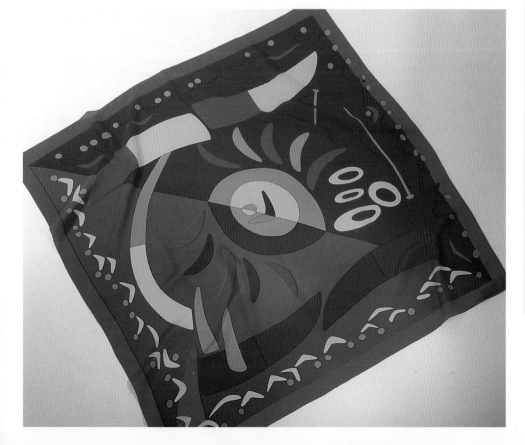

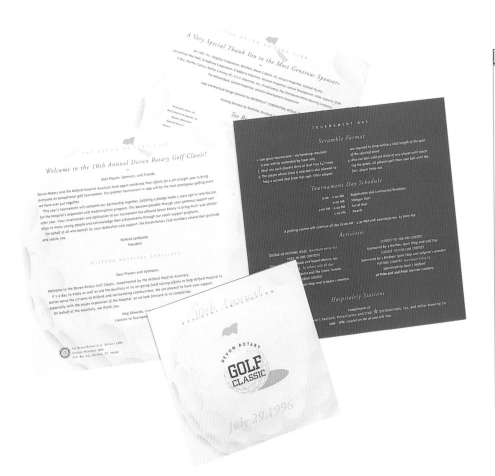

Event

Design Firm
Metropolis Corporation
Creative Director
Denise Davis
Assistant Creative Director/Illustrator
Lisa DiMaio
Project
Devon Rotary golf classic
Client
Devon Rotary Club
Purpose or Occasion
Golf tournament
Software
Macromedia FreeHand

▶ This prestigious golfing event brings together the Rotary, Milford Hospital Auxiliary, and others to fulfill a pledge made five years ago to raise $50,000 for the hospital's expansion and modernization program. The invitations were designed and printed pro bono to support the Rotary Club in its efforts.

Event

Design Firm
Kan and Lau Design Consultants
Art Director/Designer
Kan Tai-keung
Computer Illustrator
Benson Kwun Tin Yau
Project
Second Computer Art Biennale Rzeszow '96—Poland
Client
The Voivode of Rzeszow
Purpose or Occasion
Call for entries
Software
Adobe Photoshop, Macromedia FreeHand
Hardware
Power Macintosh

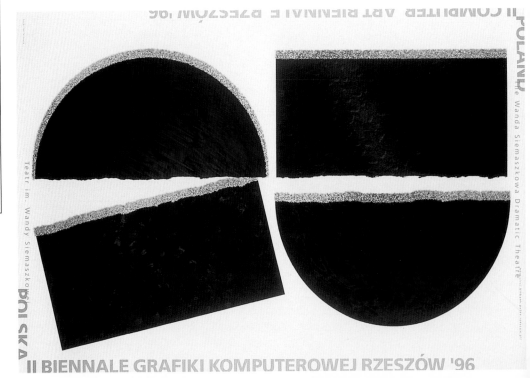

Event

Design Firm
Eastern Edge Media Group, Inc.
Art Director/Designer
M. J. Pressley-Jones
Illustrator
Robert J. Jones
Project
Philadelphia flower show menu and guide
Client
Aramark Corporation
Purpose or Occasion
Flower show
Software
Adobe Photoshop, QuarkXPress
Hardware
Power Macintosh 9500, Quadra 950

▶ Using an original illustration of a sunflower, the image was scanned and then a ghosted version was produced for the inside of the piece. The legend and map directs the crowds to the eateries, cafés, and food courts within the Philadelphia Convention Center.

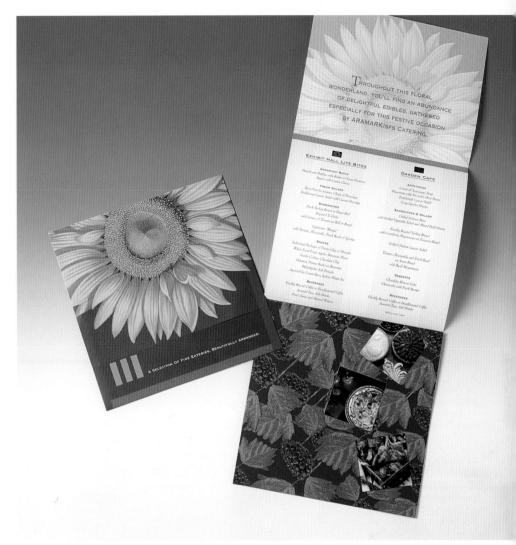

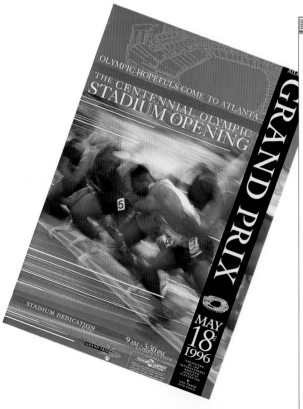

Event

Design Firm
Copeland Hirthler Design and Communications
Creative Directors
Brad Copeland, George Hirthler
Art Directors/2D Designers
David Butler, Mark Ligameri
Copywriters
IAAF
Account Executives
Greg Daney, Jenny Prutz
Photographer
Chris Hamilton
Producers
Laura Perlee, Donna Harris, Tor Gunderson
Project
Grand prix poster
Client
IAAF
Purpose or Occasion
Event promotion

▶ This poster promoted the grand opening of Centennial Olympic Stadium as well as serving as a promotional vehicle for the track-and-field event known as the Grand Prix.

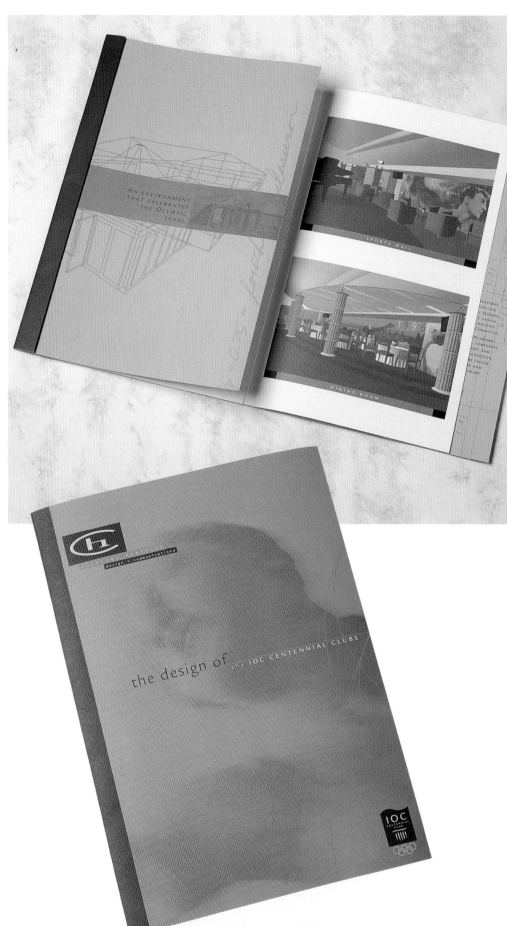

Event

Design Firm
Copeland Hirthler Design and
Communications
Creative Directors
Brad Copeland, George Hirthler
Art Directors
Sarah Huie, Melanie Bass Pollard
2D Designers
Melanie Bass Pollard, Sean Goss
3D Designers
Sarah Huie, David Park
Copywriters
George Hirthler, Blair Birdsey
Account Executives
Sarah Huie, Ward Copeland
Photographers
Don Freeman,
IOC Library, Allsport
Producers
Laura Perlee, Donna Harris
Project
IOC Hospitality Club invitation and
brochure
Client
International Olympic Committee
Purpose or Occasion
Centennial Olympic Hospitality Club

▶ The brochure was created to serve
as a thank you to sponsors and to
recognize those involved in the creation
of the hospitality club for the IOC
during the Atlanta Centennial Olympic
Games. Using only two colors to meet a
limited budget, this brochure highlights
the creation and purpose for visitors to
the club. It showcases the SGI renderings
created during the development of the
club along with the visuals that were
used to pay homage to the Centennial
Games. This design reflects the concepts
and ideas behind the hospitality club's
design through the use of the ancient-
Greek art elements from the original
Games montaged with photos of
outstanding athletes from the last
100 years.

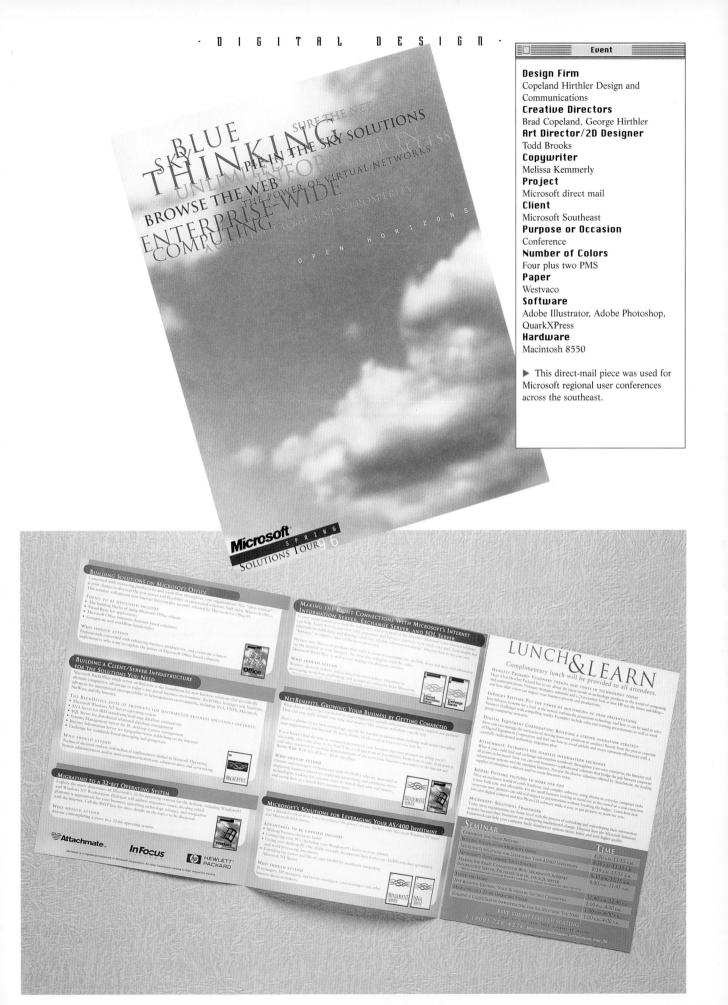

Design Firm
Copeland Hirthler Design and
Communications

Creative Directors
Brad Copeland, George Hirthler

Art Director/2D Designer
Todd Brooks

Copywriter
Melissa Kemmerly

Project
Microsoft direct mail

Client
Microsoft Southeast

Purpose or Occasion
Conference

Number of Colors
Four plus two PMS

Paper
Westvaco

Software
Adobe Illustrator, Adobe Photoshop,
QuarkXPress

Hardware
Macintosh 8550

▶ This direct-mail piece was used for
Microsoft regional user conferences
across the southeast.

Event

Design Firm
Love Packaging Group
Art Director
Brian Miller
Designer/Illustrator
Chris West
Project
FBA direct mail
Client
Fibre Box Association
Purpose or Occasion
Annual meeting
Software
Macromedia FreeHand, Adobe Photoshop
Hardware
Power Computing Power Tower Pro 225

▶ This teaser/mailer establishes the graphic vocabulary used in all subsequent pieces in the series. The puzzle piece that detaches from the corrugated portion is taken to the event and redeemed for the meeting program. The puzzle piece fits into an identical die-cut in the program's cover.

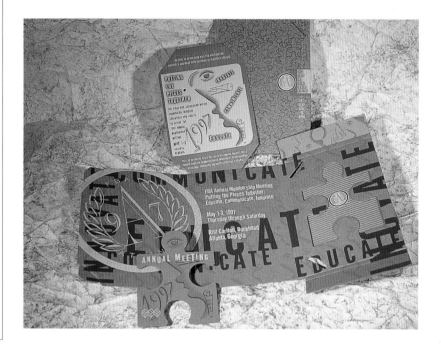

Event

Design Firm
Mirko Ilić Corporation
Art Director/Designer
Mirko Ilić
Project
Poster for lecture
Client
Syracuse University
Purpose or Occasion
Lecture announcement
Software
Adobe Photoshop, Adobe Illustrator
Hardware
Macintosh 8500

▶ Since the lecture was mostly about computer-generated design and illustration, artwork already used for other purposes was included in the piece.

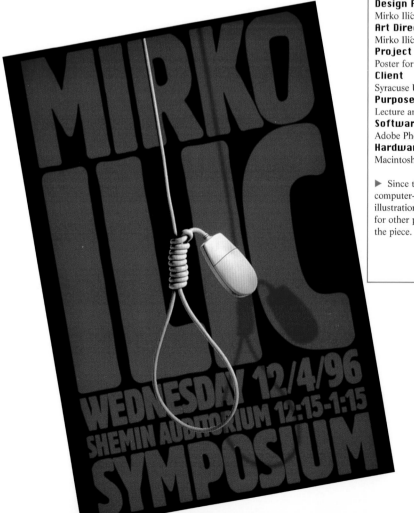

Event

Design Firm
MartinRoss Design
Art Directors/Designers
Martin Skoro, Ross Rezac
Illustrator
Martin Skoro
Project
Big Brothers and Sisters materials logo,
annual report, invitation, banners
Client
Big Brothers and Sisters of Minneapolis
Purpose or Occasion
Seventy-fifth anniversary
Software
Adobe Photoshop, QuarkXPress
Hardware
Macintosh 7100

▶ For the seventy-fifth year anniversary
of the Minneapolis Big Brothers and
Sisters, the designers created a festive
logo and invitation. For the annual
report, a number of great photos that
were further enhanced in Photoshop
were pulled from their archives.

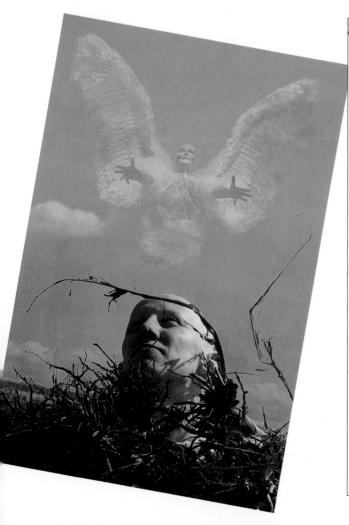

Event

Design Firm
Sommese Design
Art Directors
Kristin Breslin Sommese, Chemi
Montes
Photographers
Kristin Breslin Sommese, Steven
Arnold
Client
Pennsylvania State University
Purpose or Occasion
Performance Art Symposium
Software
Adobe Photoshop, Adobe PageMaker
Hardware
Power Macintosh 7100/80

▶ This poster was designed for a
performance-art symposium that
examines the historical, theoretical, and
experiential significance of performance
art as it relates to art education. The
designers wanted to use an image of
Rachel Rosenthal, a well-known
performance artist and educator who
was a speaker at the symposium. They
also felt that it was also important to
show Rachel somehow interacting with
or influencing a student. The photo of
Rachel was donated to the project by
the Steven Arnold Trust. The type on
the back was designed in PageMaker
using a flexible format that allowed for
on-the-fly changes.

Event

Design Firm
Toni Schowalter Design
Art Director/Designer
Toni Schowalter
Illustrator
Anthony Ranieri
Project
CBS golf kit
Client
CBS Television
Purpose or Occasion
Affiliate marketing promotion
Software
Adobe Illustrator
Hardware
Power Macintosh 6100 and 7600

▶ The image was created in Illustrator and applied to several pieces using different aspects of the illustration for the folder, masthead, and schedule. The die-cut for the folder could also be recreated from the unique shape of the logo/illustration. Repro for the names of the various station affiliates was easily created on the computer, but required twenty plate changes at the printer when the pieces were run.

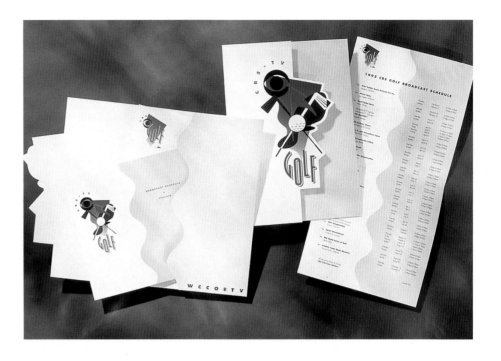

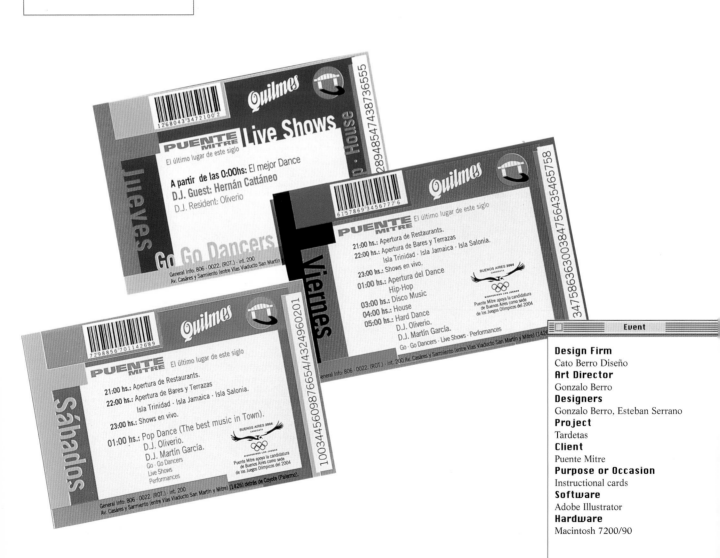

Event

Design Firm
Cato Berro Diseño
Art Director
Gonzalo Berro
Designers
Gonzalo Berro, Esteban Serrano
Project
Tardetas
Client
Puente Mitre
Purpose or Occasion
Instructional cards
Software
Adobe Illustrator
Hardware
Macintosh 7200/90

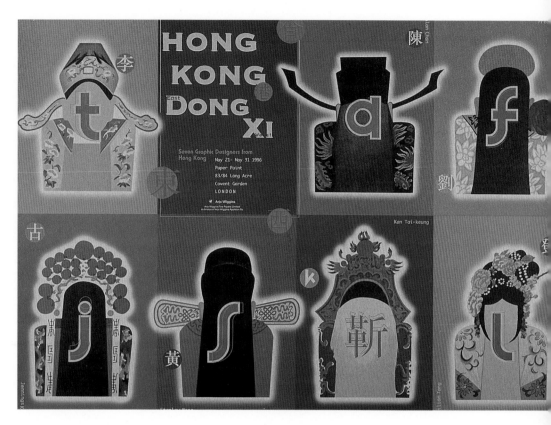

Design Firm
Kan and Lau Design Consultants
Art Director
Freeman Lau Siu Hong
Designers
Freeman Lau Siu Hong, Joseph Leung
Computer Illustrator
John Tam Mo Fai
Project
Hong Kong Dong Xi—exhibition poster
Client
Wiggins Teape (Hong Kong), Ltd.
Purpose or Occasion
Design exhibition
Software
Adobe Photoshop, Macromedia FreeHand
Hardware
Power Macintosh

▶ This piece was designed to announce the Hong Kong designers exhibition in London.

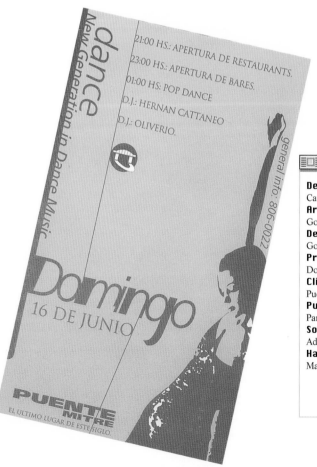

Design Firm
Cato Berro Diseño
Art Director
Gonzalo Berro
Designers
Gonzalo Berro, Esteban Serrano
Project
Domingo
Client
Puente Mitre
Purpose or Occasion
Party
Software
Adobe Illustrator
Hardware
Macintosh 7200/90

Event

Design Firm
Copeland Hirthler Design and
Communications
Creative Directors
Brad Copeland, George Hirthler
Art Director/2D Designer
David Butler
Project
Delta Olympic invitation package
Client
Delta Airlines

▶ This package served as a VIP
invitation to guests of Delta for the
1996 Olympic Games. The client
wanted a formal announcement/
invitation that would not appear too
extravagant. The two-color pieces
were developed in QuarkXPress and
produced on a limited budget using a
variety of papers and printers.

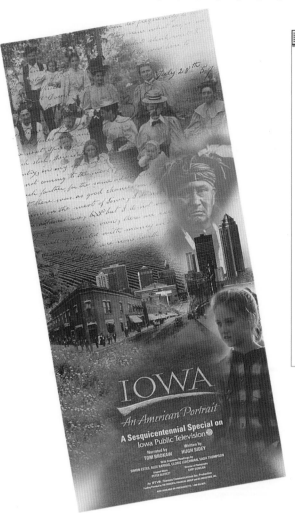

Event

Design Firm
Stamats Communications
Art Director/Designer
Tim Greeneweig
Project
Poster
Client
Iowa Public Television
Purpose or Occasion
Iowa sesquicentennial
Software
Adobe Photoshop, QuarkXPress
Hardware
Power Macintosh 7100/66

▶ This poster was created to promote an hour-long special on Iowa Public Television about the state's 150th anniversary. Photos of differing quality were used from a variety of sources and various filters in Adobe Photoshop were used to bring them all together.

Event

Design Firm
Kan and Lau Design Consultants
Art Director
Kan Tai-keung
Designers
Kan Tai-keung, Eddy Yu Chi Kong
Computer Illustrator
Benson Kwun Tin Yau
Project
Design in China 2001
Client
The Center for International Arts
Education Exchange of the Central
Institute of Fine Arts
Purpose or Occasion
Design course
Software
Live Picture, Adobe PageMaker

▶ A calligraphic Chinese character was transformed into a color bar and a modern sans serif type. With the combination of a pair of chopsticks, it formed to represent the twenty-first century. This poster bears the message that Chinese modern design has evolved from traditional culture.

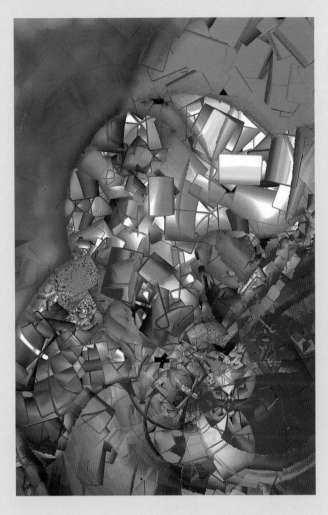

▶ The artist's overall objective is to create fine art for both individuals and companies that brings the viewer to the piece and allows some form of personal discovery in the process. Artistically, McGlothlin strives to create abstracts that are visually striking as well as inviting, and works with a broad color palette to achieve this. In addition, the computer has taken on a new role as a dynamic tool in the creation of original fine art. In an artist's hands, the blank monitor screen becomes a canvas, the mouse, a paint brush. It's a unique marriage of technology and creativity that gives the artist new tools, new options, and a whole new range of visual possibilities.

Fine Art

Design Firm
McGlothlin Associates, Inc.
Illustrator
Gordon Edward McGlothlin
Clients
Private and corporate art collectors
Project
Metropolis
Software
Fractal Design Painter, Adobe Photoshop, Adobe Gallery Effects, Xaos Paint Alchemy, Xaos Terrazzo, Kai's Power Tools, KPT Convolver
Hardware
Power Macintosh 9500/150

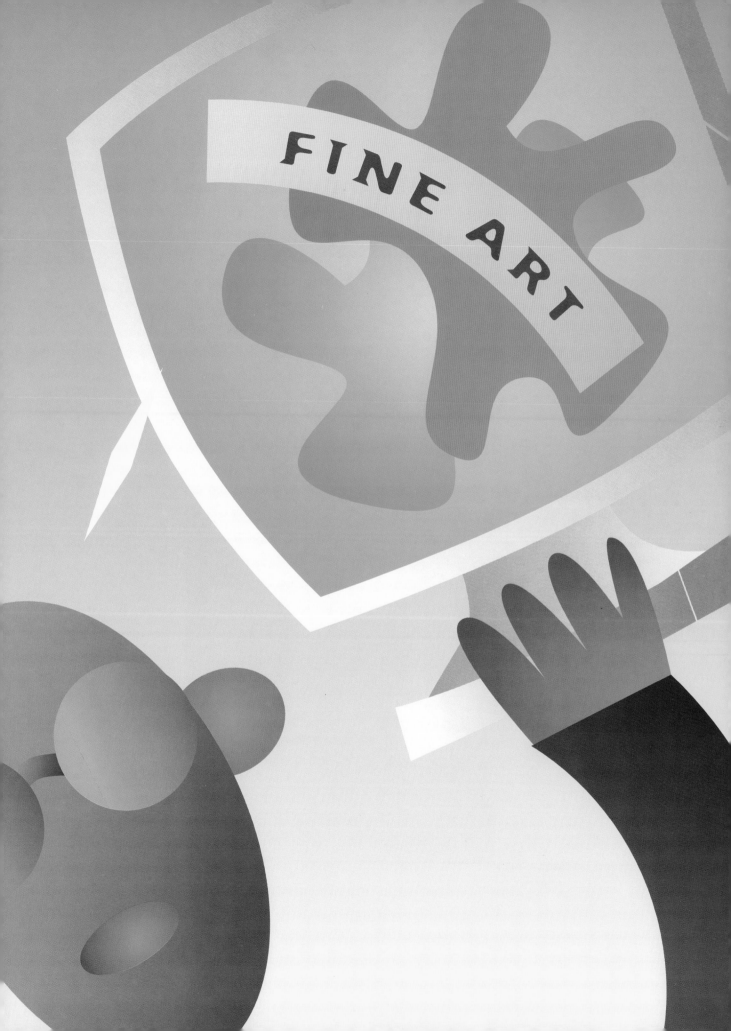

Fine Art

Design Firm
McGlothlin Associates, Inc.
Illustrator
Gordon Edward McGlothlin
Clients
Private and corporate art collectors
Project
Egg Rolls
Software
Fractal Design Painter, Adobe Photoshop, Adobe Gallery Effects, Xaos Paint Alchemy, Xaos Terrazzo, Kai's Power Tools, KPT Convolver
Hardware
Power Macintosh 9500/150

I worry for Leo in all the dry
singing the streets clean
and emerald grass

I am taken up by the tornado
the sky is pink, the desert fill
my nostrils in dark clo

Everything is up in the air.

I want to settle like

dus

Fine Art

Designer
Michelle Bowers
Project
Clicking My Heels
Software
Adobe Photoshop, Macromedia FreeHand
Hardware
Power Macintosh 7200/120

▶ "Clicking My Heels" refers to Dorothy's adventures in Oz as an allusion to the artist's own feelings of transience. The work is a portrayal of geographic alienation that conveys a sense of longing for permanence. The primary objective of this series is a seamless marriage of visual and textural metaphor. The work's arrangement metaphorically suggests a house being lifted by the twister. The works are electronically generated Inkjet output on Lexan, a vellum-like, semi-transparent plastic, suspended from above by clear monofilament.

Fine Art

Design Firm
McGlothlin Associates, Inc.
Illustrator
Gordon Edward McGlothlin
Clients
Private and corporate art collectors
Project
Autumn Seashore
Software
Fractal Design Painter, Adobe
Photoshop, Adobe Gallery Effects,
Xaos Paint Alchemy, Xaos Terrazzo,
Kai's Power Tools, KPT Convolver
Hardware
Power Macintosh 9500/150

Fine Art

Illustrator
Ira Altshiller
Project
Fine-art print
Purpose or Occasion
Gallery print
Software
Fractal Design Painter, Adobe Photoshop
Hardware
Macintosh 8100/80, Wacom Art 2

▶ This pen-and-ink series titled
Interior Landscape #1, #2, #3 was first
scanned and brought into Painter. It
was then imported into Photoshop
where several filters were used for the
final adjustment. Output was done on a
300 dpi Iris printer on archival paper.

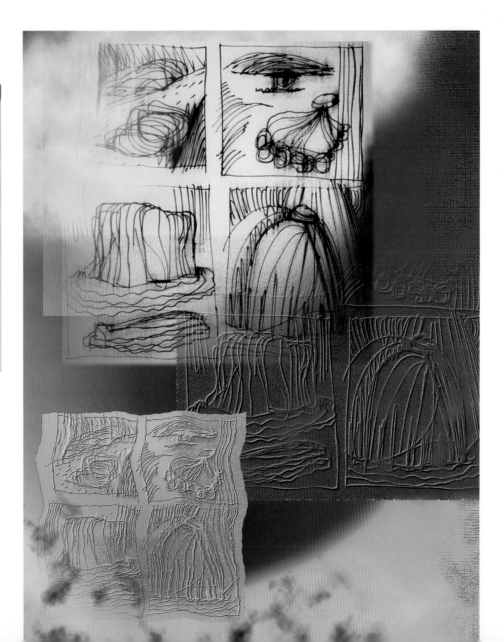

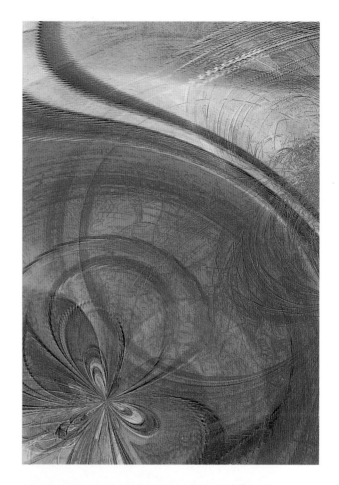

Fine Art

Design Firm
McGlothlin Associates, Inc.
Illustrator
Gordon Edward McGlothlin
Clients
Private and corporate art collectors
Project
Santa Fe Diversions
Software
Fractal Design Painter, Adobe
Photoshop, Adobe Gallery Effects,
Xaos Paint Alchemy, Xaos Terrazzo,
Kai's Power Tools, KPT Convolver
Hardware
Power Macintosh 9500/150

Fine Art

Design Firm
McGlothlin Associates, Inc.
Illustrator
Gordon Edward McGlothlin
Clients
Private and corporate art collectors
Project
Reflections
Software
Fractal Design Painter, Adobe Photoshop,
Adobe Gallery Effects, Xaos Paint
Alchemy, Xaos Terrazzo, Kai's Power
Tools, KPT Convolver
Hardware
Power Macintosh 9500/150

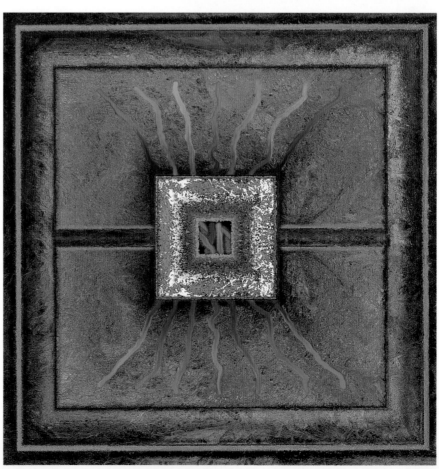

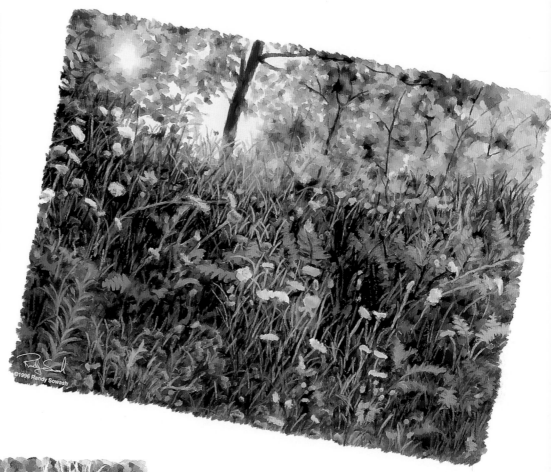

Fine Art

Illustrator
Randy Sowash
Project
Arrival of a New Day
Purpose or Occasion
Fine art
Software
Fractal Design Painter
Hardware
Macintosh IIsi, Hitachi drawing tablet

▶ *Arrival of a New Day* seeks to capture the mood of a sunrise during the late-summer months. Using a Hitachi drawing tablet, this image was hand rendered using the oil pastel and water tools in Painter.

©1996 Randy Sowash

Fine Art

Ilustrator
Randy Sowash
Project
Birch Trees
Purpose or Occasion
Fine art
Software
Fractal Design Painter
Hardware
Macintosh IIsi, Hitachi drawing tablet

▶ This image was hand-rendered using a Hitachi drawing tablet. The oil pastel and water tools in Painter were used to create a painted, impressionistic style.

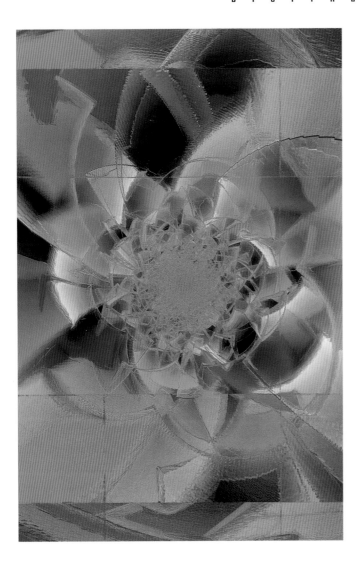

Fine Art

Design Firm
McGlothlin Associates, Inc.
Illustrator
Gordon Edward McGlothlin
Clients
Private and corporate art collectors
Project
Lauren B.
Software
Fractal Design Painter, Adobe Photoshop, Adobe Gallery Effects, Xaos Paint Alchemy, Xaos Terrazzo, Kai's Power Tools, KPT Convolver
Hardware
Power Macintosh 9500/150

Fine art

Illustrator
Randy Sowash
Project
27 East Third Street
Purpose or Occasion
Fine art
Software
Fractal Design Painter
Hardware
Macintosh IIsi, Hitachi drawing tablet

▶ The different shapes and angles of this building created an interesting composition that was hand-rendered using a Hitachi drawing tablet and the oil pastel and water tools in Fractal Design Painter.

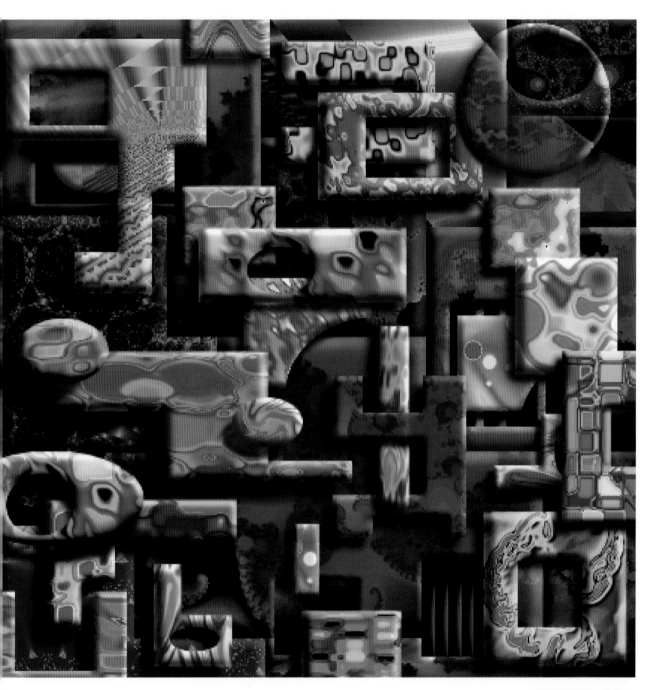

Fine Art

Illustrator
Richard A. Bucci
Project
Wild Card II
Software
NIH Image, Mandella, Adobe Photoshop
Hardware
Macintosh

▶ This two-dimensional graphic is currently the basis for an upcoming interactive version of the work. Textures were created in NIH Image and Mandella with shading added using Adobe Photoshop.

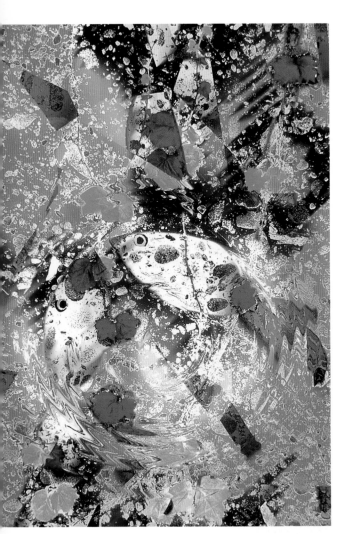

Fine Art

Illustrator
Arlene Rhoden
Project
Two Fish
Purpose or Occasion
Fine art
Software
Adobe Photoshop, KPT Kodak CD
Hardware
Macintosh 8500/120, Wacom Art 2 tablet

▶ An image of a stone wall with climbing red vines was chosen from a photo CD and imported into Photoshop. The contrast was altered and the vines were isolated. On a new layer, two KPT textures were added to the rest of the image using the difference and procedural modes. This process was used to create the two fish you see made up from the stone wall. Using a layer mask, the red vines were brought back for color and design. The dodge tool was used for the finishing highlights.

Fine Art

Design Firm
Imaginings Computer Graphics
Art Director/Designer
Gene R. Edwards
Project
Eggs III
Software
Digiview, Pixmate
Hardware
Amiga

▶ The third in a series of three, the original black-and-white image was raised to a new level using a reduced and altered palette.

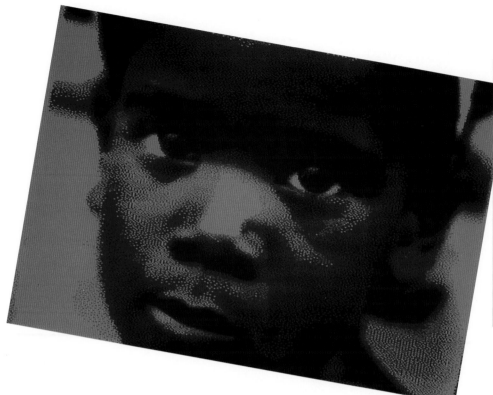

Fine Art

Design Firm
Imaginings Computer Graphics
Art Director/Designer
Gene R. Edwards
Project
North Philly Girl
Software
Digiview, Adpro, Deluxe Paint
Hardware
Amiga

▶ The original black-and-white image was enhanced with Digiview, Adpro, and Deluxe Paint. A Floyd-Steinberg dither was used when reducing the palette and the resulting grayscale image was then tinted.

Fine Art

Illustrator
Arlene Rhoden
Project
Africa
Purpose or Occasion
Fine art for portfolio
Software
Adobe Photoshop, Paint Alchemy, MetaTools Power Photos
Hardware
Power Macintosh 8500/120, Wacom Art 2 tablet

▶ Starting with a stock photo, *Africa* was created in Photoshop. With color establishing the mood of the piece, the picture's curves were adjusted for higher contrast and the wave distort filter was used to create more of a collaged look. Paint Alchemy was used to provide a texture that further enhanced the subject matter. The type was given the same brush look and was layered on top using the darken mode.

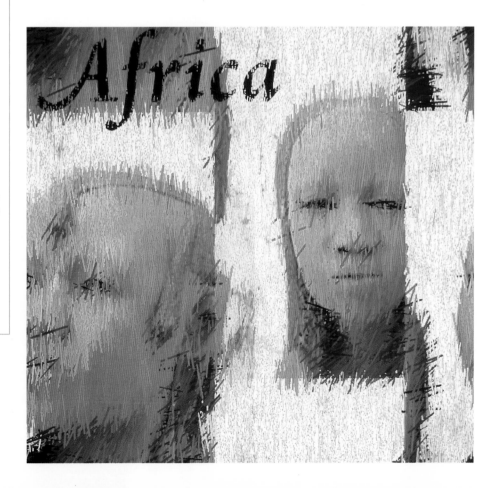

Fine Art

All Design
Chip Taylor
Project
Media Head
Purpose or Occasion
Art
Software
Adobe Photoshop, Strata StudioPro
Hardware
Macintosh 8500/120,
Microtex 1/XE scanner

▶ Media Head is intended to serve
as a metaphor of the massive
bombardment of media on our society.
As the multitude of media grows,
we find ourselves becoming more
device-like in our filtering out of the
numerous forms media takes.

Fine Art

Design Firm
Gary Glover Illustration
Art Director
Larry Roach
Designer/Illustrator
Gary Glover
Project
Halloween Hauntings
Client
San Manuel Casinos
Purpose or Occasion
Print, T-shirts, mugs
Software
Adobe Photoshop
Hardware
Macintosh 8500

▶ These two images were part of a
series for the San Manuel bingo
casinos. The poker chip and bingo
ball were used as reoccuring themes
throughout the project. Both were
created in Photoshop using custom
brushes and layers.

Fine Art

Design Firm
Insight Design Communications
All Design
Sherrie Holdeman, Tracy Holdeman
Project
Computer User cover illustration
Client
MSP Communications
Purpose or Occasion
Magazine cover illustration
Software
Macromedia FreeHand, Adobe Photoshop
Hardware
Macintosh 7500

▶ This illustration was designed to
accompany a magazine article about
starting your own small business.
Since the magazine's primary audience
consists of individuals who are
leaving the corporate workplace, the
illustration's main element combines
the image of the small-business owner
and the two worlds of corporate and
small business.

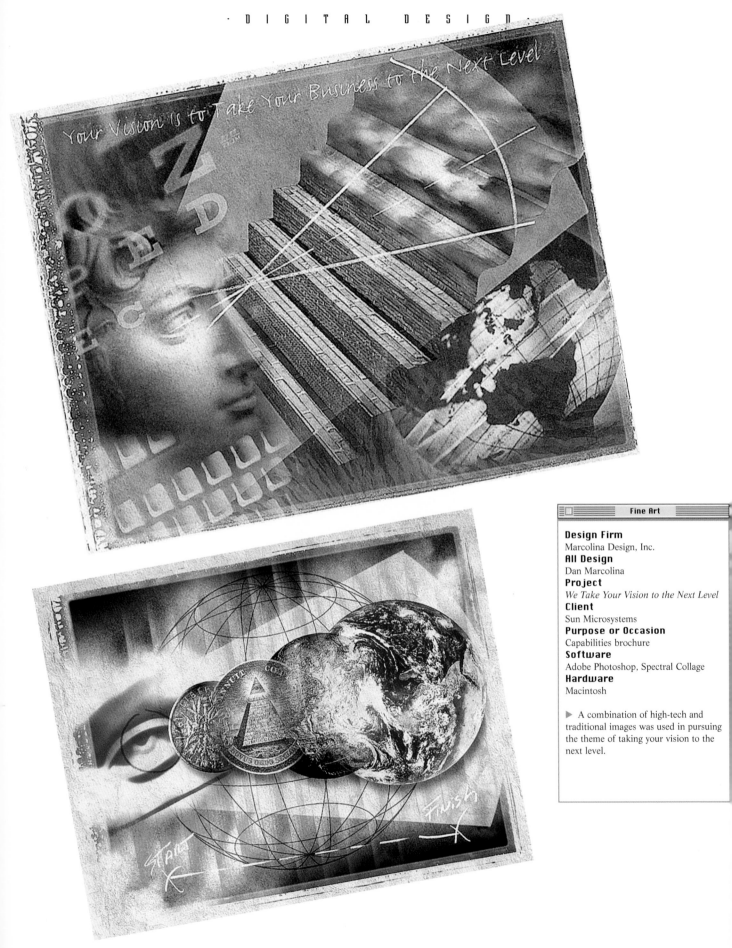

Your Vision is to Take Your Business to the Next Level

Fine Art

Design Firm
Marcolina Design, Inc.
All Design
Dan Marcolina
Project
We Take Your Vision to the Next Level
Client
Sun Microsystems
Purpose or Occasion
Capabilities brochure
Software
Adobe Photoshop, Spectral Collage
Hardware
Macintosh

▶ A combination of high-tech and traditional images was used in pursuing the theme of taking your vision to the next level.

Design Firm
Heart Graphic Design
All Design
Clark Most
Client
Tannoy North America
Purpose or Occasion
Newsletter illustration
Software
Adobe Photoshop, Fractal Design Painter
Hardware
Power Macintosh 8100

▶ This digital illustration used for a newsletter supports an article entitled "70 Years of Woofers and Tweeters—A Diverse History of Sound." Fractal Design Painter and Adobe Photoshop were both used to create this illustrative montage.

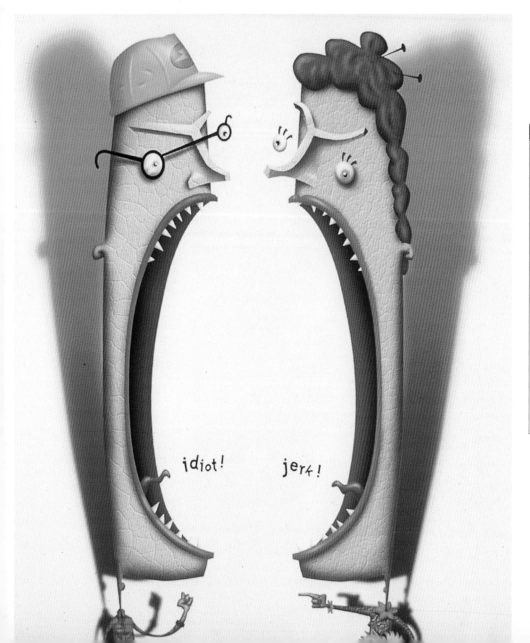

Design Firm
Anchorage Daily News
Art Director/Illustrator
Lance Lekander
Project
Bad Manners
Client
Anchorage Daily News
Purpose or Occasion
Illustration for newspaper article
Software
Fractal Design Painter, Adobe Photoshop
Hardware
Macintosh 9500/132 80

▶ This illustration was done for an article on declining social behavior. The illustration was done in both Painter and Photoshop with all textures added using Painter.

Fine Art

Design Firm
Heart Graphic Design
All Design/Photographer
Clark Most
Software
Adobe Photoshop
Hardware
Power Macintosh 8100

▶ One in a series of three, this piece proved to be an enjoyable experiment. Multiple-exposure medium format transparencies were scanned into the computer on a drum scanner and manipulated with layer masks, filters, opacity changes.

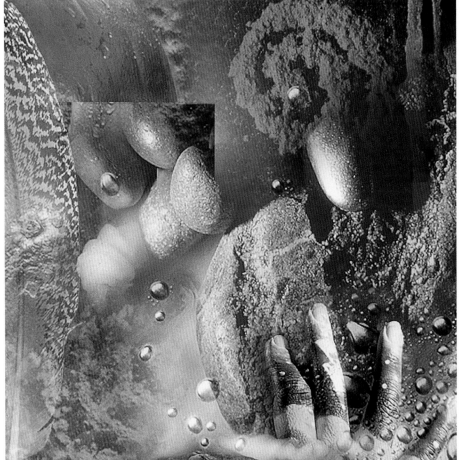

Fine Art

Design Firm
Heart Graphic Design
All Design/Photographer
Clark Most
Software
Adobe Photoshop
Hardware
Power Macintosh 8100

▶ This piece is part of an experiment in pursuit of new brochure formats and designs. Multiple-exposure medium format transparencies were scanned into the computer on a drum scanner and manipulated with layer masks, filters, and opacity changes.

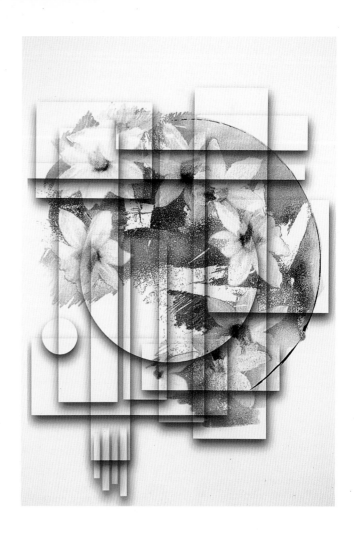

Fine Art

Design Firm
McCullough Creative Group
All Design
Mike Schmalz
Project
Sturgis print
Client
Sturgis Limited Editions
Purpose or Occasion
Fine-art print
Software
Macromedia FreeHand
Hardware
Power Macintosh 8500/150

▶ This illustration was a limited-edition print commemorating the fifty-fifth annual Sturgis motorcycle rally. The illustration was sketched traditionally, scanned, and enhanced with FreeHand on the Macintosh.

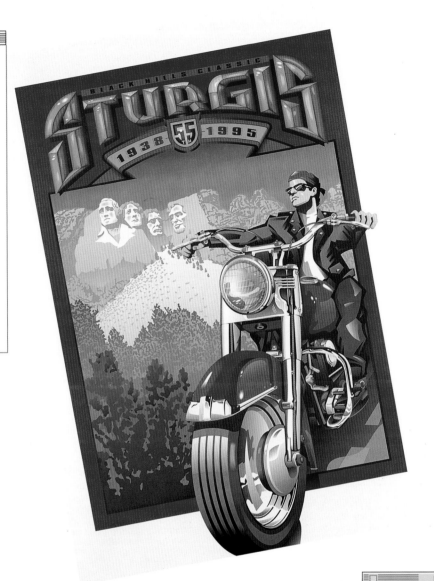

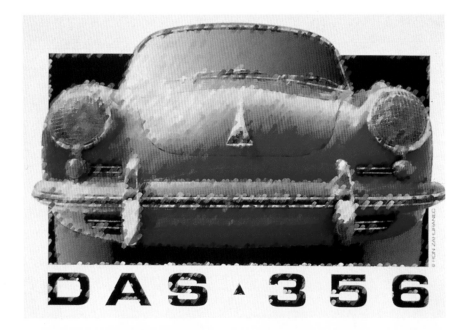

Fine Art

Design Firm
Z Works
All Design
Ron Zahuranec
Project
DAS 356
Client
The 356 Club
Purpose or Occasion
Member T-shirts
Software
Adobe Illustrator, Adobe Photoshop
Hardware
Macintosh Quadra 650

▶ The project consisted of a design and illustration for The 356 Club, a group of Porsche 356 enthusiasts. The design's primary use is on member T-shirts. Since the 356 was created in Germany, the word *the* was changed to its German counterpart *das*, and a very European typeface—Eurostile Bold Extended—was chosen.

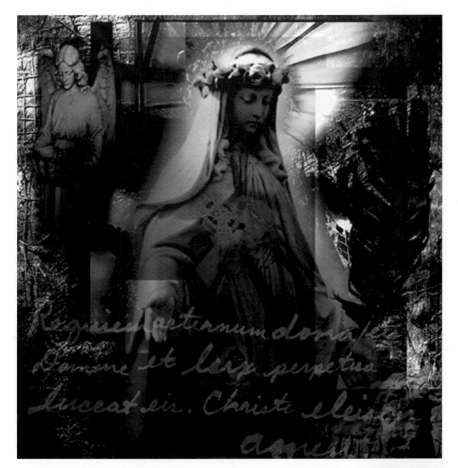

Fine Art

Design Firm
Marcolina Design, Inc.
All Design
Sean McCabe
Project
Personal work
Software
Adobe Photoshop
Hardware
Power Macintosh 8500/120

▶ This personal work was the culmination of an overseas trip to Ireland. The images are composed of various 35-mm photos and objects that were taken on the trip. The final image was composited from scans that were brought into Photoshop, and the text is excerpted from Gorecki's "Misere."

Fine Art

Design Firm
Design Works Studio, Ltd.
All Design
Jason Vaughn
Project
Hand of Sorrow
Client
Design Works Studio, Ltd.
Purpose or Occasion
T-shirt design
Software
Adobe Photoshop
Hardware
Umax 5-900

▶ Intended as a T-shirt design for a summer catalog, a look was needed that would catch the eye of today's generation. An empty and uncertain feeling of sorrow and depression was achieved using a dark color palette and a hand that displays the signs of abuse.

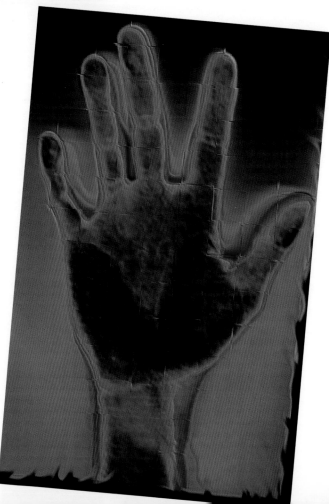

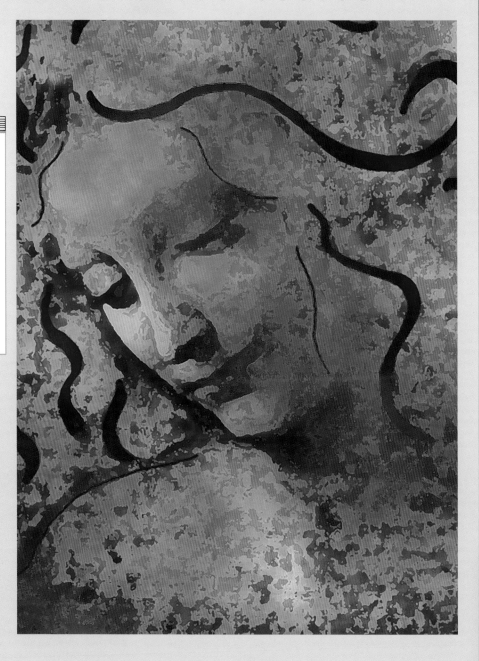

Promotion

Design Firm
Design Works Studio, Ltd.
All Design
Jason Vaughn
Project
Lady of the Sun
Client
Design Works Studio, Ltd.
Purpose or Occasion
Self-promotion
Software
Adobe Photoshop
Hardware
Umax 5-900

▶ Intended for self-promotion, a look was sought that showed a more traditional painting style. The designers needed to show their wider range of talents and move away from traditional graphics. Created in Adobe Photoshop using GE drybrush filter for texture effects, an original from Leonardo da Vinci was altered to give the graphic a more modern feel while keeping a traditional look.

PROMOTION

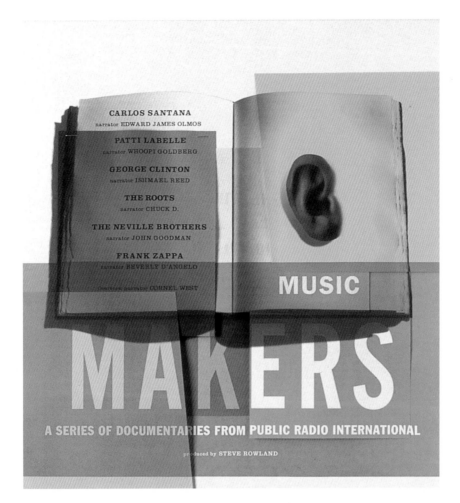

Promotion

Design Firm
Design Guys
Art Director
Steven Sikora
Designer
Richard Boynton
Project
The Music Makers
Client
Public Radio International
Purpose or Occasion
Series promotion
Software
Adobe Photoshop, Adobe Illustrator, QuarkXPress
Hardware
Macintosh Quadra 950

▶ The poster promotes and sells a radio series to PRI affiliate stations. The Music Makers was a six-part series, and the accompanying poster has six flaps, each of which tells about one program in the series.

Promotion

Design Firm
Directech, Inc.
Art Director
Christine Rosecrans
Illustrator
Kevin Gendreau
Project
Website
Client
Microtouch Systems
Purpose or Occasion
Promotion of touch technology
Software
Adobe Photoshop, Lightwave
Hardware
Macintosh Quadra 800

▶ This site incorporates graphics and copy to create environments appropriate to restaurants, casinos, and other industries that utilize touch technology. The site also includes an electronic superstore of Microtouch products.

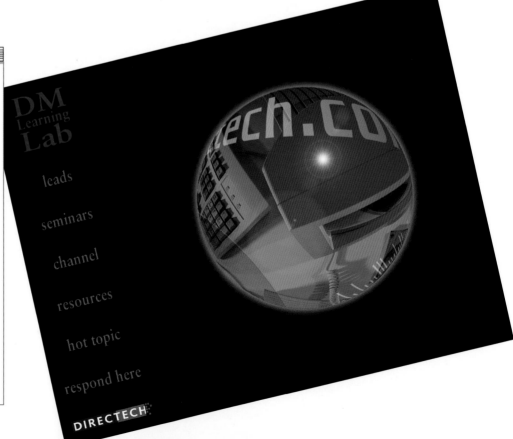

```
┌─────────────────────────────────────┐
│ ▦          Promotion          ▦     │
├─────────────────────────────────────┤
```

Design Firm
Toni Schowalter Design
Art Director/Designer
Toni Schowalter
Illustrator
Stock photos
Project
Holiday CD mailer
Client
Radio Advertising Bureau
Purpose or Occasion
Promote holiday ads
Software
Adobe Photoshop, QuarkXPress
Hardware
Power Macintosh 6100 and 7600

▶ The theme of the twelve days of Christmas is expanded on by using a CD with twelve winning radio spots and a poster with twelve reasons to use radio to advertise. The image was created from a montage created with photo CD images and Adobe Photoshop to modify the color. Use of Quark allowed for consistent production of all the elements. The CD/mailer approach allowed for more display space and generated immediate attention.

Promotion

Design Firm
Schwartz Design
Art Director/Designer
Bonnie Schwartz
Illustrator
Tracy Sabin
Project
Center for Executive Health brochure
Client
Scripps Memorial Hospital
Purpose or Occasion
Promotional brochure
Software
Adobe Illustrator
Hardware
Macintosh 9500

▶ The illustration was created for a brochure directed at business executives that outlines the available health-care services. A positive, light-hearted approach to the graphics was deemed appropriate.

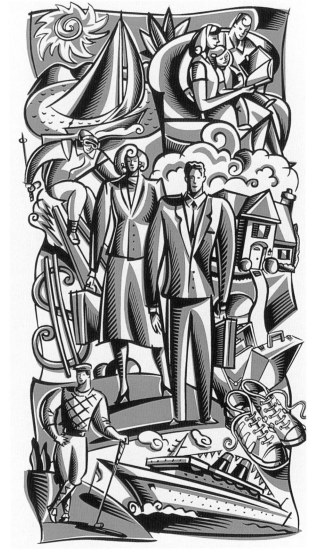

Promotion

Design Firm
Parham Santana, Inc.
Art Director
Elisa Feinman/USA Networks
Designers
John Parham, Dave Wang
Project
Grand Slam Tennis on USA
Client
USA Network
Purpose or Occasion
Sales/promotion kit
Software
Adobe Photoshop, Adobe Illustrator, QuarkXPress
Hardware
Macintosh 8500

▶ This is a sales/promotion kit for cable rights to two grand-slam tennis events on USA Network. The kit is characterized by bold yet elegant style for programming that targets an exclusive demographic. Player images were blurred and silhouetted on metallic and color backgrounds and a simulated foil stamp embossing was achieved using Adobe Photoshop.

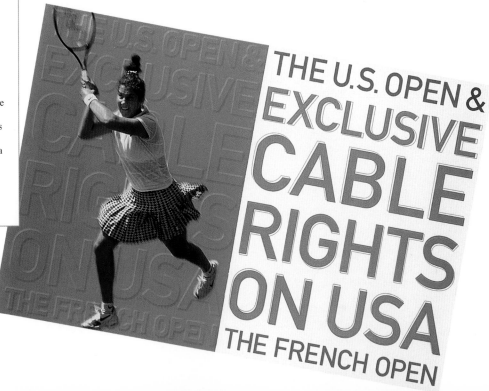

THE U.S. OPEN & EXCLUSIVE CABLE RIGHTS ON USA THE FRENCH OPEN

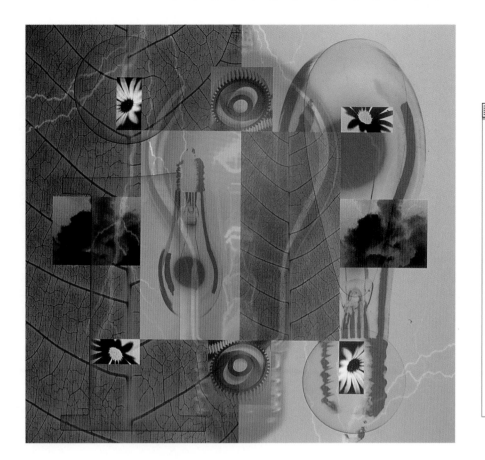

Promotion

Design Firm
Aerial
All Design
Tracy Moon
Project
Impact illustration
Client
Impact Unlimited
Purpose or Occasion
Promotional image
Software
Adobe Photoshop, Live Picture
Hardware
Macintosh 840 AV

► This composite promotional image is designed to inform and excite key audiences about Impact's innovative approach to exhibit design, event planning, and marketing services.

Promotion

Design Firm
Whitney Edwards Design
Art Director
Charlene Whitney Edwards
Designer
Barbi Christopher
Photographers
Comber McHugh, Will Lockwood
Project
Cover for Easton, Maryland
tourist brochure
Client
Easton Business Management
Association
Purpose or Occasion
Cover for tourist brochure
Software
Adobe Photoshop, QuarkXPress,
Specular Collage
Hardware
Macintosh Quadra 950

► The photographs in the collage were chosen from submissions by the Tidewater Camera Club, Easton, MD. The ivy was shot and scanned to a Kodak photo CD and silhouetted in Adobe Photoshop. The old map in the background is a line art scan. All were compiled in Specular Collage and transferred to a layered Adobe Photoshop file. The final product has proven very popular with tourists.

Photo credit: Jordon Photography

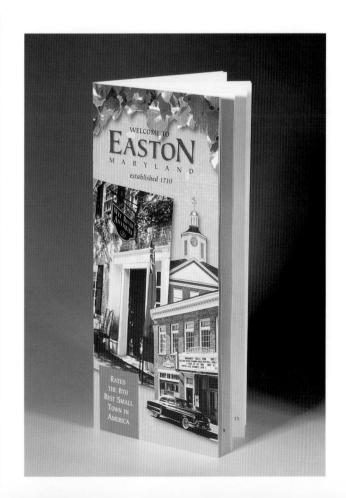

Design Firm
Held Diedrich
Art Director
Douglas Diedrich
Designers
Megan Snow, Sander Leech
Project
Sales sheets
Client
Grand Slam
Purpose or Occasion
Lead generation/fulfillment
Software
QuarkXPress
Hardware
Macintosh 7100 Power PC

▶ A primary image was used to draw the audience in, and an actual-size example of one product was shown on the cover. The electronic file was created in QuarkXPress.

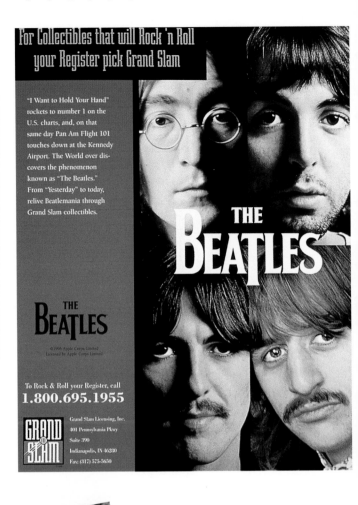

Design Firm
Mix Media
Art Director/Designer
Krystal Mix
Project
National League scoreboard
Client
KMTR (NBC) Eugene, OR
Purpose or Occasion
Nightly television news broadcasts
Software
Adobe Photoshop
Hardware
Power Macintosh 9500

▶ This project consisted of creating an eye-catching, colorful template on which to display daily National League baseball scores. The needs and expectations were straightforward: simplicity, legibility, and consistency with the news' overall graphic format.

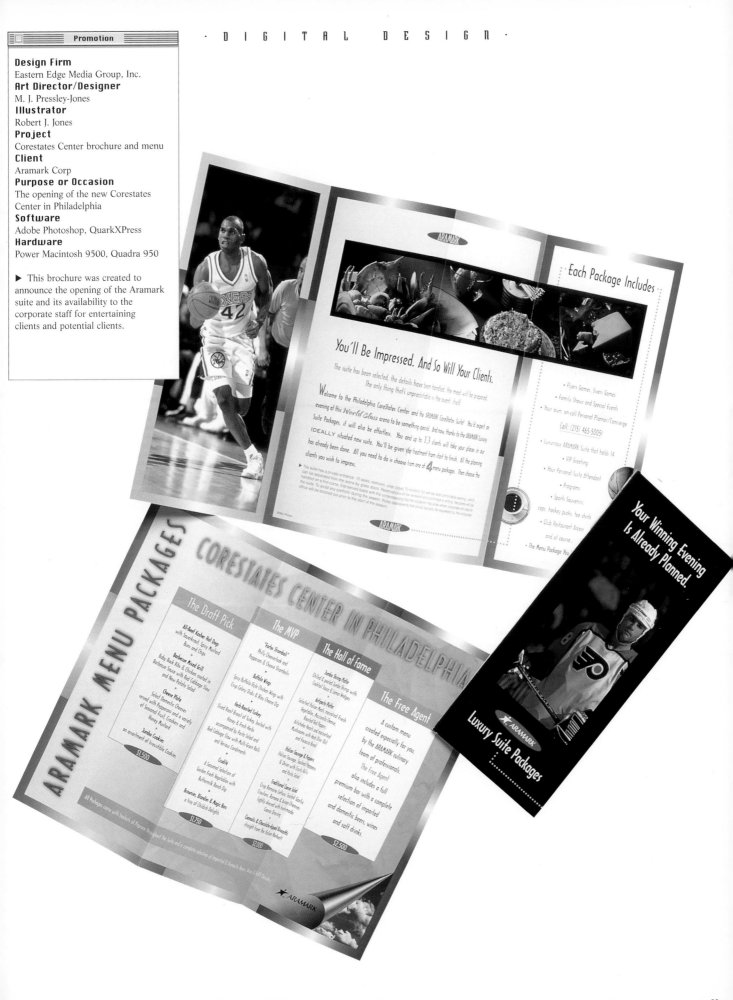

Promotion

Design Firm
Eastern Edge Media Group, Inc.
Art Director/Designer
M. J. Pressley-Jones
Illustrator
Robert J. Jones
Project
Corestates Center brochure and menu
Client
Aramark Corp
Purpose or Occasion
The opening of the new Corestates
Center in Philadelphia
Software
Adobe Photoshop, QuarkXPress
Hardware
Power Macintosh 9500, Quadra 950

▶ This brochure was created to
announce the opening of the Aramark
suite and its availability to the
corporate staff for entertaining
clients and potential clients.

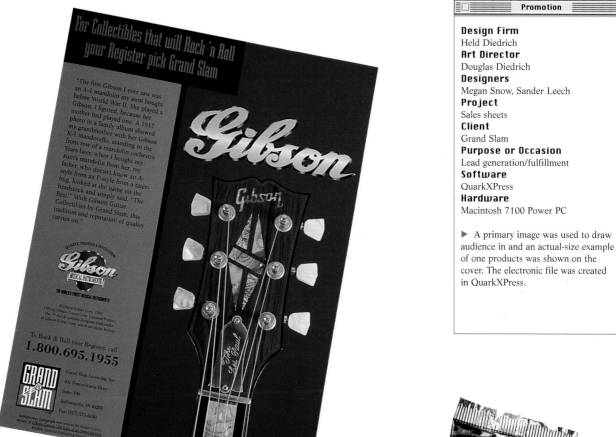

Promotion

Design Firm
Held Diedrich
Art Director
Douglas Diedrich
Designers
Megan Snow, Sander Leech
Project
Sales sheets
Client
Grand Slam
Purpose or Occasion
Lead generation/fulfillment
Software
QuarkXPress
Hardware
Macintosh 7100 Power PC

▶ A primary image was used to draw audience in and an actual-size example of one products was shown on the cover. The electronic file was created in QuarkXPress.

Promotion

Design Firm
Dynamic Duo Studio, Inc.
Art Director
Nancy Gottsman
Designer
Arlen Schumer
Illustrators
A. Schumer, Sherrie Wolfgang
Project
Oracle Trading Cards
Client
Oracle Magazine Interactive
Purpose or Occasion
Promotion of Oracle's website at computer trade show
Software
Adobe Photoshop
Hardware
Power Macintosh 8500

▶ Six comic-book characters were created to interact in a bi-weekly comic strip appearing on Oracle's interactive website (www.oramag.com). To promote it, the client wanted to distribute trading cards at a trade show. Each card was approached as a separate poster and each was handlettered.

ROW. RIDE. RUN. REJUVENATE.

REHAB REGIMENS TO LIVE BY

Promotion

Design Firm
Held Diedrich
Art Director
Doug Diedrich
Designer/Illustrator
Jeff Wiggington
Project
Direct-mail series
Client
BMH Health Strategies
Purpose or Occasion
Direct-mail campaign
Software
Adobe Illustrator, Adobe Photoshop,
QuarkXPress
Hardware
Macintosh 7600 Power PC

▶ This direct-mail campaign was targeted at a variety of audiences. Thematically, the piece was intended to maintain a connection to previous print materials that had been created. Illustrator was used to create the shoe-print image and photos were stock CD images that were converted through Photoshop to duotones. Final electronic files were created with QuarkXPress.

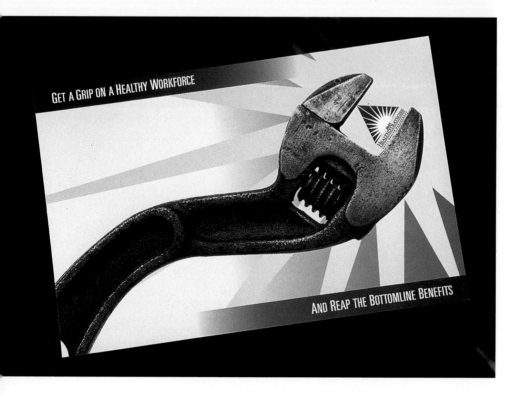

GET A GRIP ON A HEALTHY WORKFORCE

AND REAP THE BOTTOMLINE BENEFITS

Promotion

Design Firm
Held Diedrich
Art Director
Doug Diedrich
Designer/Illustrator
Jeff Wiggington
Project
Direct-mail series
Client
BMH Health Strategies
Purpose or Occasion
Direct-mail campaign
Software
Adobe Illustrator, Adobe Photoshop,
QuarkXPress
Hardware
Macintosh 7600 Power PC

▶ This direct-mail campaign was targeted at a variety of audiences. Thematically, the piece was intended to maintain a connection to previous print materials that had been created.

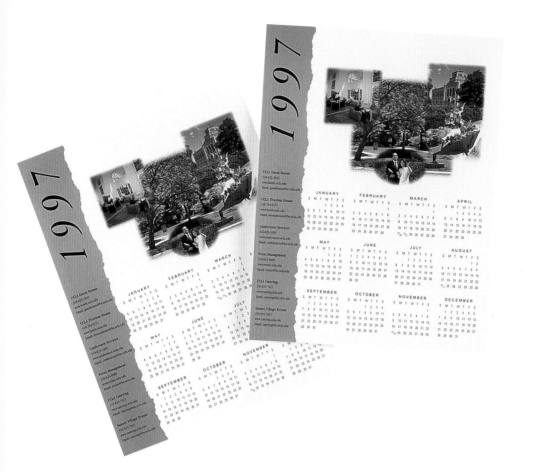

Promotion

Design Firm
Julia Tam Design
All Design
Julia Chong Tam
Project
Calendar
Client
UCLA University of California —
Los Angeles
Purpose or Occasion
Calendar
Software
Adobe Photoshop, Adobe Illustrator,
QuarkXPress
Hardware
Power Mac 8500

▶ Limited by previously chosen photos, the primary challenge was to provide the client with a warm, soft image in the final piece. Additional challenges were the spatial limitations of the 8 1/2" x 11" sheet and a careful approval process involving numerous individuals.

Promotion

Design Firm
Held Diedrich
Art Director
Doug Diedrich
Designer
Megan Snow
Project
Calendar
Client
Held Diedrich
Purpose or Occasion
Self-promotion
Software
QuarkXPress, Adobe Photoshop
Hardware
Macintosh Power PC

▶ This self-promotional piece allowed some creative breathing space. Rather than designing a Christmas card, the designer opted for a calendar so prospective and current clients could be reminded of the firm throughout the year. Some minor image manipulation took place in Photoshop and the final file was created in QuarkXPress.

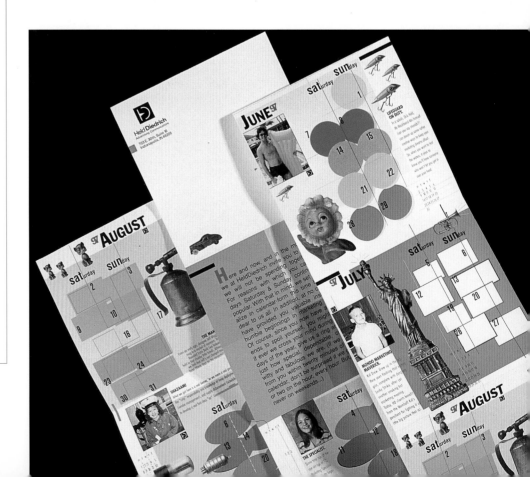

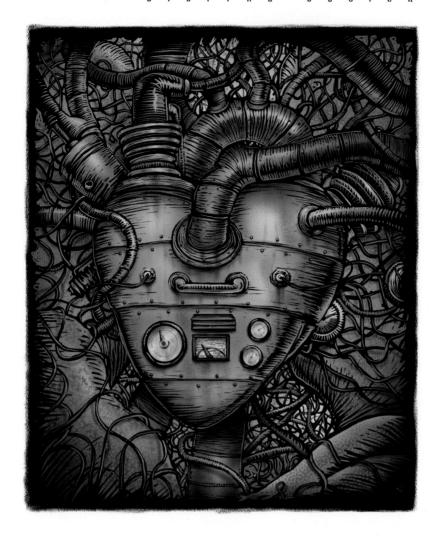

Promotion

Design Firm
Chet Phillips Illustration
All Design
Chet Phillips
Project
Horsepower Heart
Client
Chet Phillips
Purpose or Occasion
Self-promotion
Software
Fractal Design Painter
Hardware
Power Macintosh 7500,
Wacom Art 2 pad/pen

▶ First, black-and-white scratch-board
art was created, and then color was
added with Painter's airbrush tools and
various texturing effects.

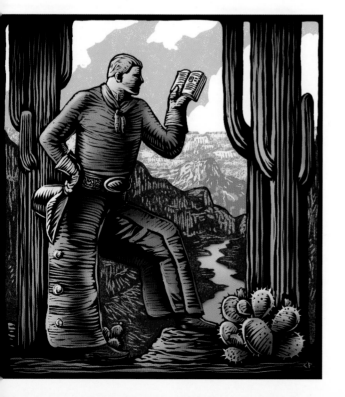

Promotion

Design Firm
Chet Phillips Illustration
All Design
Chet Phillips
Project
The Literate Cowboy
Client
Chet Phillips
Purpose or Occasion
Self-promotion
Software
Fractal Design Painter
Hardware
Power Macintosh 7500,
Wacom Art 2 pad/pen

▶ This promotion was created using
the scratch-board tool in Painter with
color added using gel attributes as a
floater. Black-and-white mountains
were transformed to color using Apply
Screen effect.

Promotion

Design Firm
Silicon Graphics Creative
Art Director
Larry Puppo
Designer
Megan Frost
Illustrator
Rick McKee
Project
Poster
Client
Silicon Graphics, Inc.
Purpose or Occasion
Visionarium grand opening
Software
Adobe Photoshop, Microsoft Softimage
Hardware
Macintosh, Silicon Graphics

▶ A poster was required to advertise the grand opening of the Visionarium, the first Silicon Graphics Reality Center. The image was digitally created and is an example of the intriguing worlds available for fly-through in real-time.

Promotion

Design Firm
Shields Design
Art Director/Designer
Charles Shields
Project
Website advertisement
Client
Shields Design
Purpose or Occasion
Advertise website design capabilities
Software
Adobe Photoshop, Adobe Illustrator
Hardware
Power Computing

▶ This ad was designed for inclusion in a local business publication to let potential clients know that just having a Website is not enough—it has to be noticed. The type was done in Illustrator and imported into Adobe Photoshop, and the shattering box effect around the word "attention" was done in Illustrator with Kai's vector effects. The corner of the web browser was brought into Adobe Photoshop from a screen dump.

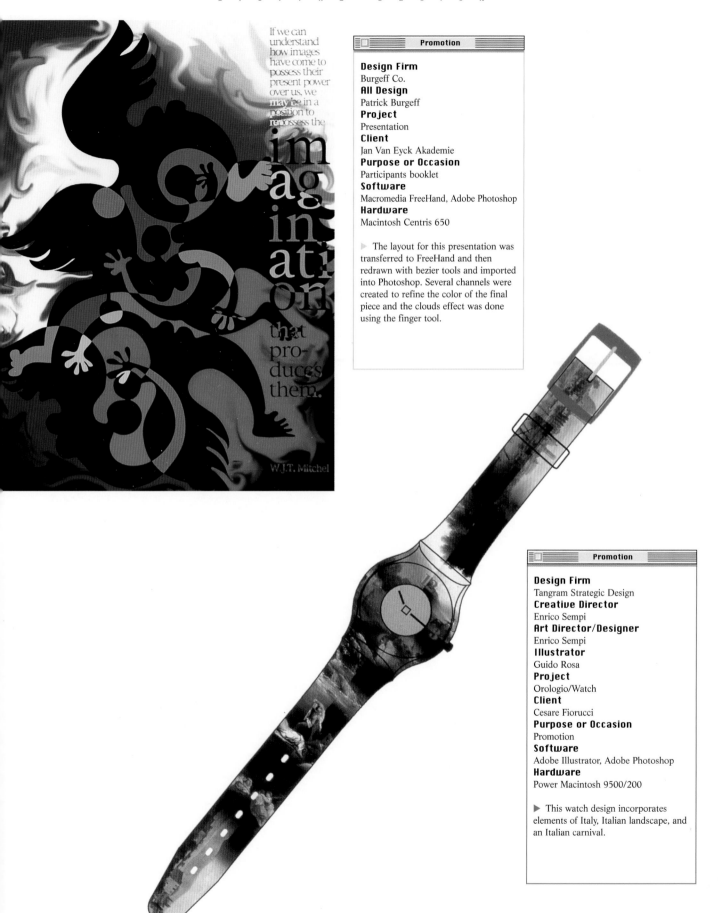

If we can understand how images have come to possess their present power over us, we maybe in a position to repossess the imagination that produces them.

W.J.T. Mitchel

Promotion

Design Firm
Burgeff Co.
All Design
Patrick Burgeff
Project
Presentation
Client
Jan Van Eyck Akademie
Purpose or Occasion
Participants booklet
Software
Macromedia FreeHand, Adobe Photoshop
Hardware
Macintosh Centris 650

▶ The layout for this presentation was transferred to FreeHand and then redrawn with bezier tools and imported into Photoshop. Several channels were created to refine the color of the final piece and the clouds effect was done using the finger tool.

Promotion

Design Firm
Tangram Strategic Design
Creative Director
Enrico Sempi
Art Director/Designer
Enrico Sempi
Illustrator
Guido Rosa
Project
Orologio/Watch
Client
Cesare Fiorucci
Purpose or Occasion
Promotion
Software
Adobe Illustrator, Adobe Photoshop
Hardware
Power Macintosh 9500/200

▶ This watch design incorporates elements of Italy, Italian landscape, and an Italian carnival.

Promotion

Design Firm
Larry Burke-Weiner Photo-Illustration
Design
All Design
Larry Burke-Weiner
Project
Aquarium promotion
Client
Larry Burke-Weiner Photo-Illustration
Design
Purpose or Occasion
Promotion
Software
Adobe Photoshop
Hardware
Macintosh 8100, HP Scanjet II

▶ Photos of sharks were taken at Point
Defiance Zoo in Tacoma, Washington
and then combined with a hallway shot
from the research building at Indiana
University. Lighting was added to the
top of the sharks and walls.

Promotion

Design Firm
Larry Burke-Weiner Photo-Illustration
Design
Illustrator
Larry Burke-Weiner
Project
Promotional card
Client
Larry Burke-Weiner Photo-Illustration
Design
Software
Adobe Photoshop, Fractal Design Painter
Hardware
Polaroid Daylab slide printer

▶ Polaroid transfers were first colorized
and roughed up using Painter. The
brain is a photocopy of a plastic brain
and the X-ray was taken from a
personal archive.

Promotion

Illustrator
Richard A. Bucci
Project
Put That Stuff Back!
Software
Adobe Photoshop, RayDream Designer
Hardware
Macintosh

▶ This scene showing a small robot that made a mess that it must now clean up contains acorns, beads, rocks, cartoons, and other items. Objects were modeled and rendered in RayDream Designer. Post-production work in Adobe Photoshop consisted of background composition and subtle image brightness adjustment.

Promotion

Design Firm
Larry Burke-Weiner Photo-Illustration Design
Art Director/Designer
Tom DeMay Jr.
Illustrator
Larry Burke-Weiner
Project
Illustration about on cheating on the web
Client
Internet Underground magazine
Purpose or Occasion
Illustration showing www cheating
Software
Adobe Photoshop, Fractal Design Painter
Hardware
Macintosh 8100, HP Scanjet II, Polaroid Daylab II slide transfer/duplicator

▶ This illustration about cheating using the web was commissioned by *Internet Underground* magazine. The image was created using Polaroid transfers that were colorized and lit in Adobe Photoshop. The 35-mm prints were roughed up in Painter to look like transfers. Both the book and the background wood texture were scanned.

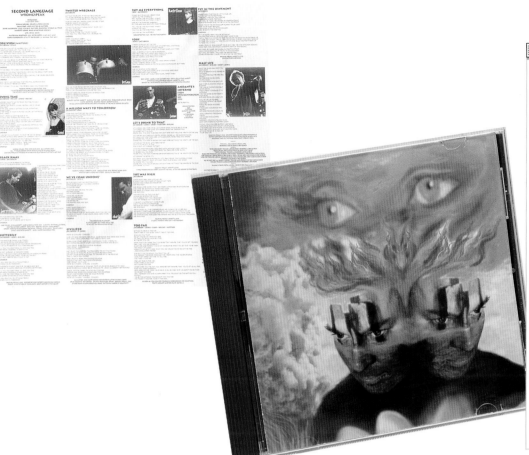

Promotion

Design Firm
Toni Zeto
All Design
Toni Zeto
Project
Wrong Speak
Client
Second Language
Purpose or Occasion
Compact-disc insert
Software
Adobe Photoshop
Hardware
Macintosh

► The main idea for this CD-case cover-art insert was to render a 90s version of 60s psychedelic stream of consciousness. First, a loose acrylic sketch of a forehead dangling as a mobile over the earth surrounded by flames was rendered. The images were then projected onto each band member and photographed separately. All images were scanned into Photoshop, where airbrush and various paint tools were used to combine all the images and finish the cover illustration.

Promotion

Design Firm
Tracy Sabin Graphic Design
Art Director
Linda Weidenbaum
Illustrator
Tracy Sabin
Project
Charlotte Russe shopping bag
Client
Charlotte Russe
Purpose or Occasion
Holiday promotion
Software
Adobe Illustrator
Hardware
Macintosh 9500

► This promotion/shopping bag was designed for holiday shoppers at Charlotte Russe, a women's-wear retailer.

Design Firm
Tracy Sabin Graphic Design
Designer/Illustrator
Tracy Sabin
Project
Tracy Sabin Graphic Design website
Client
Tracy Sabin Graphic Design
Purpose or Occasion
Self-promotion
Software
Adobe Illustrator, Adobe Photoshop,
Adobe PageMill
Hardware
Macintosh 9500

▶ A website for a graphic designer/
illustrator, the main function is to
present a portfolio of work and contact
information for potential clients.

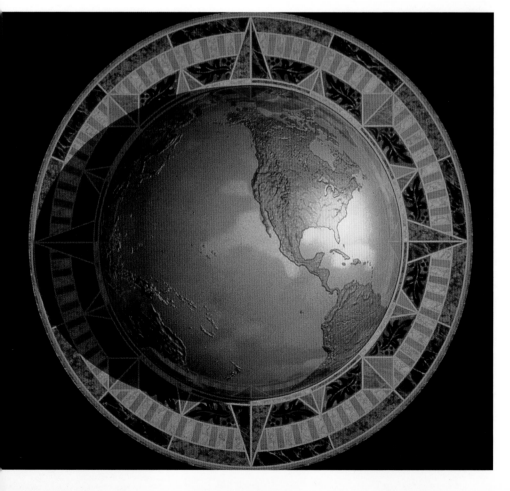

Design Firm
Design Group West
Art Director
Joan Maloney
Illustrator
Tracy Sabin
Project
Globe illustration
Client
Hahn/Trizel
Purpose or Occasion
Illustration for brochures
Software
Strata StudioPro
Hardware
Macintosh 9500

▶ An illustration of a globe is
used throughout the brochure for a
shopping-center developer to reflect
the worldwide nature of the client's
operations. Different sections of the
globe illustration are used and the
precious metal, handcrafted aspect is
indicative of the type of property
development the client strives for.

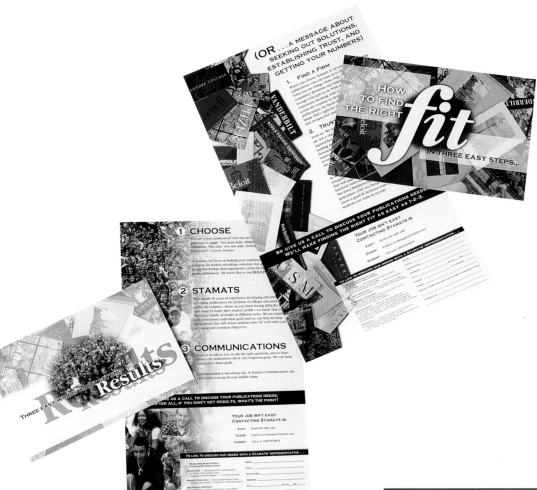

Promotion

Design Firm
Stamats Communications
All Design
Kevin Ostmo
Copywriter
Carol Besler
Project
Three-postcard self-promotion
Client
Stamats Communications
Purpose or Occasion
Self-promotion
Software
Adobe Photoshop, QuarkXPress
Hardware
Macintosh 840 AV

▶ The concept evolved from a series discussions about how to emphasize the essential services Stamats provides — finding the right fit, using a process that works, and getting results. Images were positioned by using the layers feature of Adobe Photoshop and the cloning tool was used to multiply the image and create a crowd shot. Writing and design are balanced to appeal to an institution's decision makers while demonstrating an awareness of the prospective college-student market.

Promotion

Design Firm
Manley Design
All Design
Don Manley
Project
Self-promotional book
Client
Manley Design
Purpose or Occasion
Introduction to new clients
Software
Adobe Photoshop, QuarkXPress
Hardware
Power Macintosh 8500,
Microtech flatbed scanner

▶ Intended as a collector's item, the book represents a personal and professional side that gives the recipient an idea of how the artist works. The book was produced entirely in-house and printed on an HP 600 dpi laser printer. The books are produced 1–15 at a time, as needed, and the response has been great. The unit cost of the piece is three dollars.

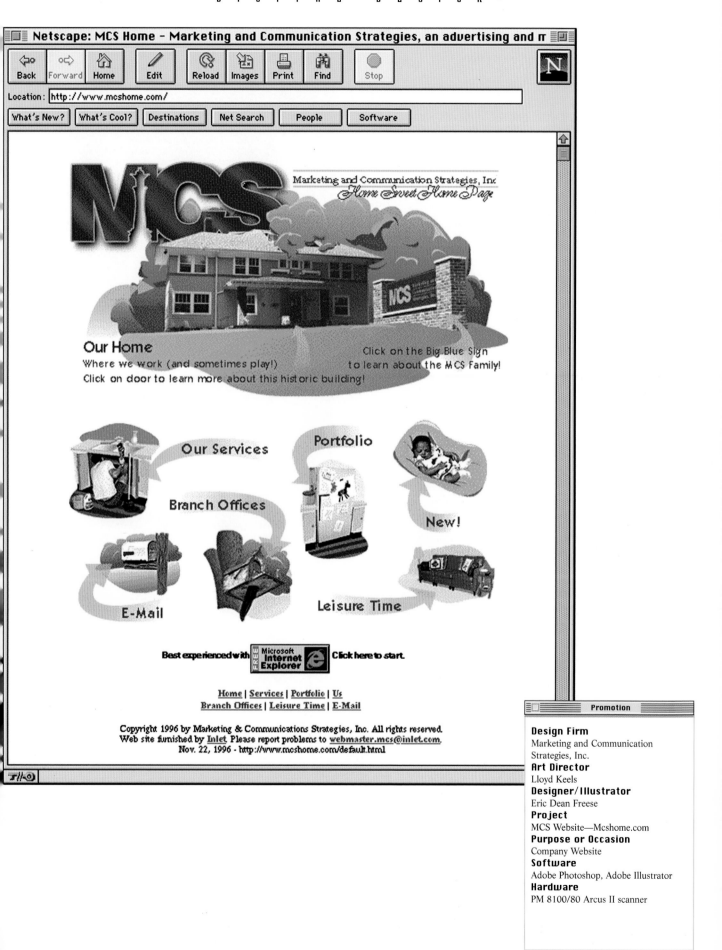

Promotion

Design Firm
Design Guys
Art Director
Steven Sikora
Designer
Scott Thares
Project
Parallel promotion
Client
Parallel Productions
Purpose or Occasion
Promotion
Software
Adobe Illustrator, Adobe Photoshop, QuarkXPress
Hardware
Macintosh 8100 PPC

▶ This swatch book features four photographers and highlights their various specialties.

Corporate Identity

Design Firm
Stamats Communications, Inc.
Art Director
Mike Hunstad
Designer
Adam Blyth
Project
Villanova CD-ROM
Client
Villanova University
Purpose or Occasion
Promotion/marketing
Software
Macromedia Director, Macromedia FreeHand, Adobe Photoshop
Hardware
Macintosh 7100/80

▶ This promotional CD-ROM for Villanova University features an interactive map, catalog, and application.

Promotion

Design Firm
HC Design
Art Director
Chuck Sundin
Designer
Steve Trapero
Project
Our Focus is Your Future
banner and poster
Client
American Society of Health-System
Pharmacists (ASHP)
Purpose or Occasion
Promotion of student forum
Software
Adobe Photoshop, QuarkXPress
Hardware
Power Macintosh 7100

▶ The client wanted something
cutting-edge that would appeal to
college students and promote the
ASHP student forum. Bright colors,
diverse type, and unusual treatment of
photos helped to create the desired
effect, and a special pop-up pocket was
created to hold application forms.

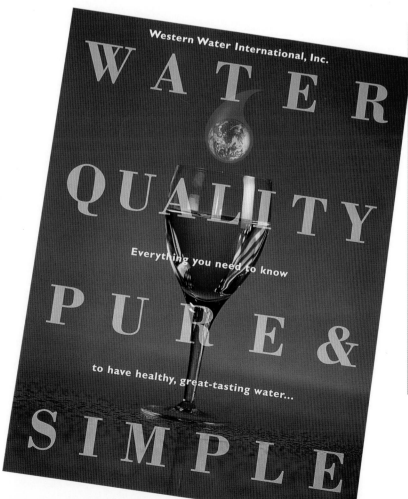

Promotion

Design Firm
Steve Trapero Design
Art Director/Illustrator
Steve Trapero
Designers
Steve Trapero, Aikyoung Ahn
Project
Corporate brochure
Client
Western Water International, Inc.
Purpose or Occasion
Promotion
Software
Adobe Photoshop, Adobe Illustrator,
QuarkXPress
Hardware
Power Macintosh 7100

▶ The client wanted a piece with a
high-tech look to reflect their use of
NASA technology in the systems
they produce. Photoshop was used
throughout to create special effects,
ghosted type, and a globe within a
water drop on the cover.

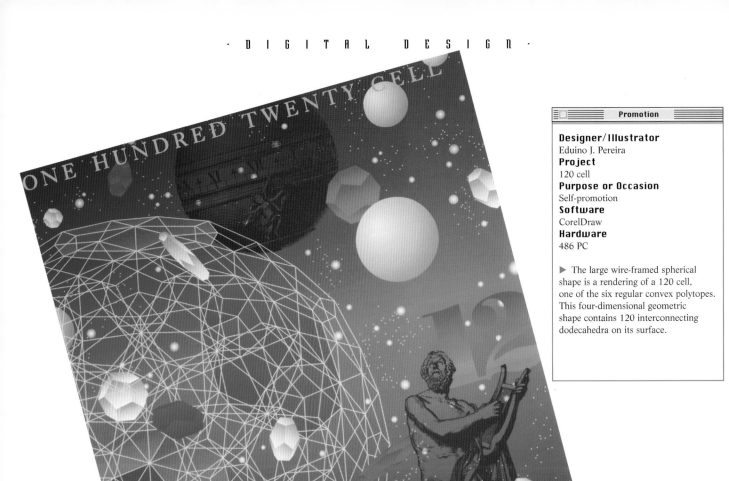

Promotion

Designer/Illustrator
Eduino J. Pereira
Project
120 cell
Purpose or Occasion
Self-promotion
Software
CorelDraw
Hardware
486 PC

▶ The large wire-framed spherical shape is a rendering of a 120 cell, one of the six regular convex polytopes. This four-dimensional geometric shape contains 120 interconnecting dodecahedra on its surface.

Promotion

Design Firm
Gardner Graphics
Designer/Illustrator
Dianne Gardner
Purpose or Occasion
Self-promotion
Software
Adobe Photoshop
Hardware
Pentium PC, scanner

▶ This self-promotional page was designed for inclusion in Seattle chapter of the Graphic Artist's Guild illustration book.

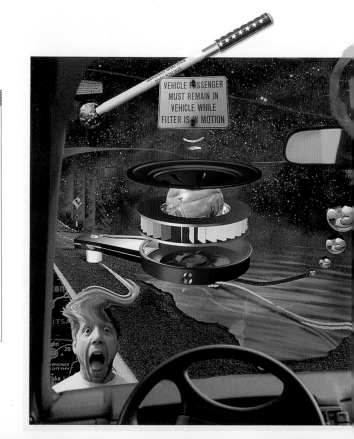

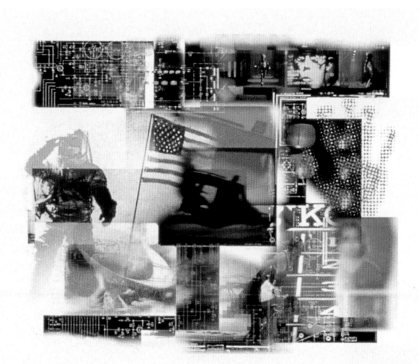

Design Firm
Tangram Strategic Design
Creative Director
Enrico Sempi
Art Directors/Designers
Enrico Sempi, Antonella Trevisan
Illustrator
Guido Rosa
Project
Calendar
Client
Tangram Strategic Design
Purpose or Occasion
Christmas promotion
Software
Adobe Illustrator, Adobe Photoshop
Hardware
Power Macintosh 9500/200

▶ Using a calendar as the base for this promotion, the primary idea was to celebrate Marshall McLuhan through his principal statements.

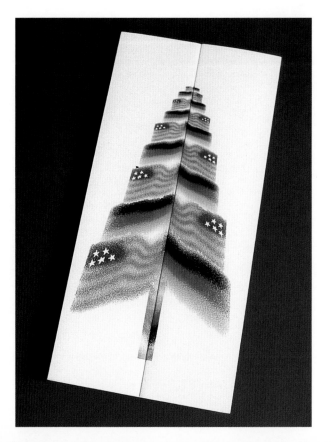

Design Firm
Mohr Design
All Design
Jack N. Mohr
Project
Christmas card
Client
Rias Berlin Kommission
Purpose or Occasion
Christmas card
Software
Fractal Design Painter, Adobe Photoshop
Hardware
Apple Macintosh

▶ This illustration of a German and an American flag was scanned and modified with Painter and then combined in Photoshop. The card's bi-fold cover incorporates the flag imagery as part of a tree, with the left half of the tree using the American flag and the right portion using the German flag.

▶ VH1 programming was packaged as a promotion to advertisers and affiliates. Icons of the era were conceived and photographed to represent a 90s look back at the 70s. Various fashion styles were researched for appropriate photography, iconography, typography, and color palette, and Illustrator was used to render the 70s logo.

Product

Design Firm
Parham Santana, Inc.
Art Directors
Rick Tesoro, John Parham
Designer
Paula Kelly
Photographer
Peter Medelik

VH1 Off-Air Creative Team
Art Director
Dean Lubensky
Project Manager
Mary Russell
Director
Wayne Wilkins
Project
VH1 Presents the 70s
Client
VH1
Purpose or Occasion
Promotion
Software
Adobe Illustrator, Adobe Photoshop, QuarkXPress
Hardware
Macintosh 8100/100

PRODUCT

Product

Design Firm
Mirko Ilić Corporation
Art Director/Designer
Mirko Ilić
Project
Newsletter *Now*
Client
PBC International
Purpose or Occasion
Book on designing newsletters
Software
Adobe Photoshop, QuarkXPress
Hardware
Macintosh 8500

▶ The cover has a trompe l'oiel effect that looks like a regular delivery of a chunk of mail wrapped in a rubberband. As the book is intended for designers, the interior was designed to resemble an on-screen QuarkXPress file.

Product

Design Firm
Puerility Works
All Design
Cesar Ivan
Project
El Paso Art Resources calendar cover
Client
El Paso Arts Resources
Purpose or Occasion
Calendar cover
Software
Fractal Design Painter, Poser
Hardware
486 DX2 66

▶ The graphic was designed to represent several El Paso artists in a landscape bringing the arts together for the El Paso Arts Resources annual calendar. The graphic software Fractal Painter/ Fractal Design Poser was used in addition to a scanner. The Mona Lisa with guitar represents the logo of the El Paso Arts Resources.

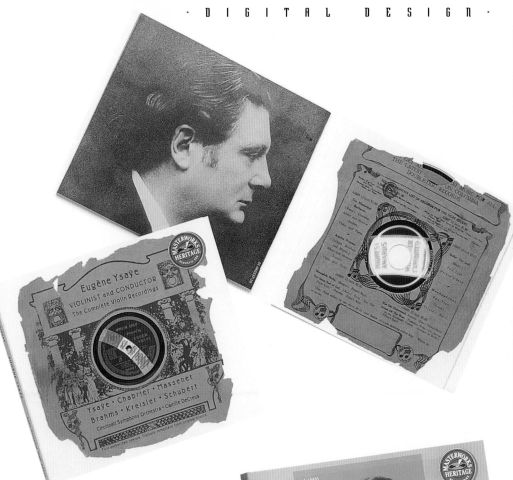

Product

Design Firm
Mirko Ilić Corporation
Art Director
Allen Weinberg
Designer
Mirko Ilić
Project
Eugene Ysaye
Client
Sony Music
Purpose or Occasion
CD packaging
Software
Adobe Photoshop, QuarkXPress
Hardware
Macintosh 8500

▶ Since the compact disc was a rerelease of master works, the designer chose an archeological mood including an image of an existing record sleeve on CD cover. Type was retouched and replaced with the CD's title. The same mood was kept throughout the accompanying book by using a two-color design.

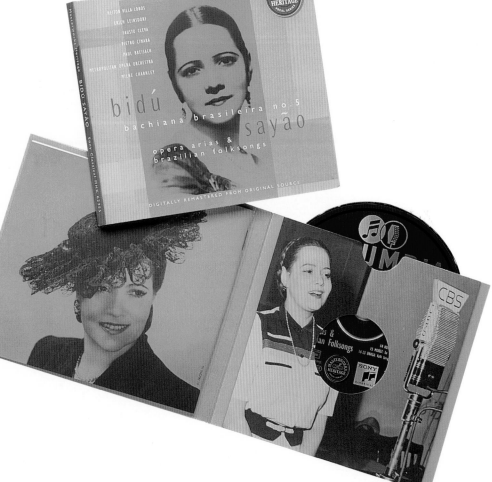

Product

Design Firm
Mirko Ilić Corporation
Art Director
Allen Weinberg
Designer
Mirko Ilić
Project
Bidu Sayao
Client
Sony Music
Purpose or Occasion
CD packaging
Software
Adobe Photoshop, QuarkXPress
Hardware
Macintosh 8500

▶ In order to make the front and back covers of a re-released masterworks catalog attractive, graphical elements were created in Photoshop.

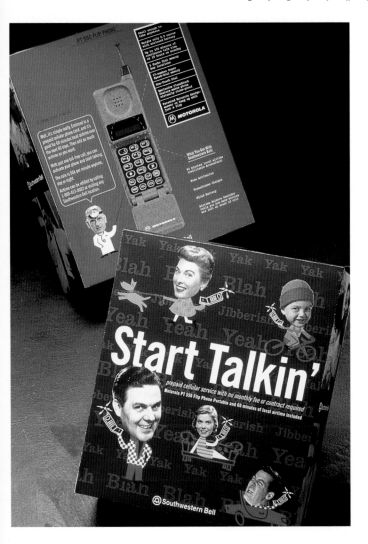

Product

Design Firm
Design Guys
Art Director
Steven Sikora
Designer
Scott Thares
Project
Start Talkin'
Client
Southwestern Bell
Purpose or Occasion
Cellular phone package
Software
Adobe Photoshop, Adobe Illustrator, QuarkXPress
Hardware
Macintosh 8100 PC

▶ The objective was to establish an image of a fun, consumer-friendly cellular phone package for mass-market discount stores.

Product

Design Firm
Design Guys
Art Director
Steven Sikora
Designer
Jay Theige
Project
Start Talkin'
Client
Southwestern Bell
Purpose or Occasion
Cellular-phone package
Software
Adobe Photoshop, Adobe Illustrator, QuarkXPress
Hardware
Macintosh 8500

▶ The objective was to establish an image of a fun, consumer-friendly cellular phone package for mass-market discount stores.

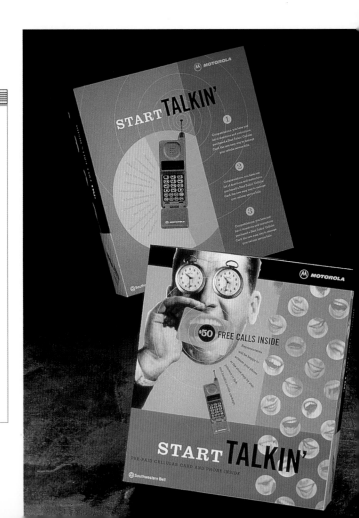

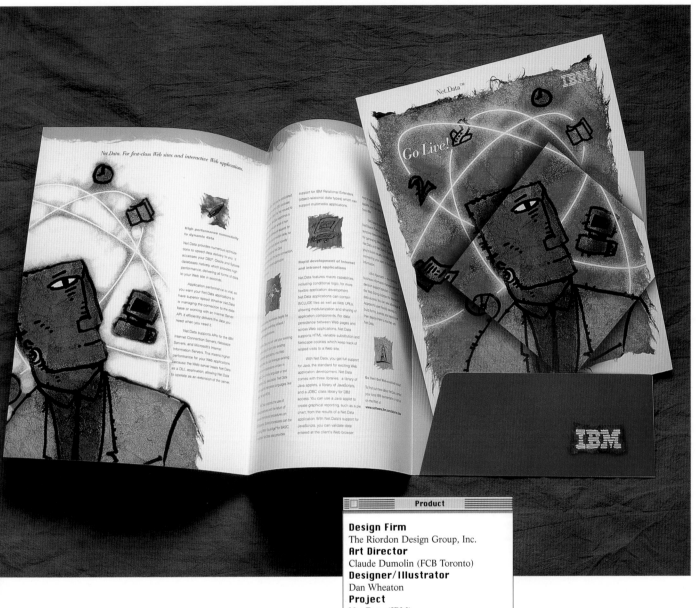

Product

Design Firm
The Riordon Design Group, Inc.
Art Director
Claude Dumolin (FCB Toronto)
Designer/Illustrator
Dan Wheaton
Project
Net Data (IBM)
Client
IBM
Purpose or Occasion
Product brochure and folder
Software
Adobe Illustrator, Adobe Photoshop,
QuarkXPress
Hardware
Macintosh Power PC

▶ The client wanted a cutting-edge
piece that reached out to a particular
audience while maintaining some of the
structure of other corporate pieces
already in circulation. The illustrations
play an important role in creating
excitement within this piece. Rough
sketches were scanned in, manipulated
in Illustrator, and imported into Adobe
Photoshop for coloring and finishing.

Design Firm
Animus Comunicaçao
Art Director
Rique Nitzsche
Designer
Victal Caesar
Project
Maria Santa's CD
Client
Virgin Records
Purpose or Occasion
Merchandising for a CD launch
Software
Macromedia FreeHand, Adobe Photoshop
Hardware
Power Macintosh 8500

▶ The client asked for graphic materials for a CD launch. The designers created a stand-up poster and a dangler to be displayed in stores.

Design Firm
Dog's Eye Creative Design, Inc.
Art Director/Designer
Robert Edmonds
Illustrators
Andrew Currie, Robert Edmonds
Project
"I am Canadian" VIP pass
Client
Molson Canadian/Molson Breweries
Purpose or Occasion
Molson Indy Vancouver
Software
Adobe Illustrator, Adobe Photoshop
Hardware
Power Macintosh 7200/90

▶ The VIP pass was created as an in-pack piece for Molson Canadian eighteen-can cases. It was created to promote both the race and concert event. The guitar/road was illustrated then scanned and manipulated in Adobe Photoshop. The car was created in Adobe Illustrator then imported into Adobe Photoshop where motion blur was added. To add definition, solid outlines and stylized flames were layered back overtop.

Product

Design Firm
FRCH Design Worldwide
All Design
Tim A. Frame
Project
Café Espresso logo
Client
Borders Books and Music
Purpose or Occasion
Logo for espresso bar
Software
Adobe Illustrator

▶ This corporate identity was developed for Borders' espresso-bar area to distinguish it from the bookstore and create a unique brand to be used in ongoing packaging and private-label applications. The intent was to create a contemporary avant-garde look using overlapping imagery and gradations of color.

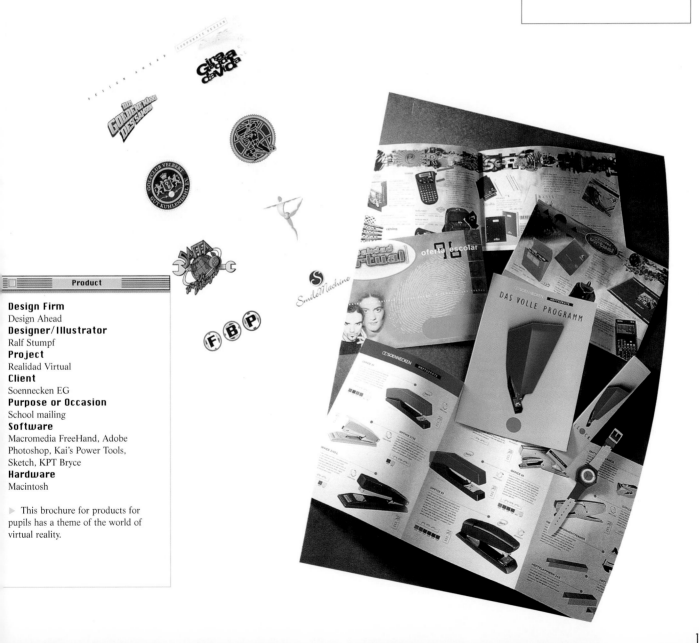

Product

Design Firm
Design Ahead
Designer/Illustrator
Ralf Stumpf
Project
Realidad Virtual
Client
Soennecken EG
Purpose or Occasion
School mailing
Software
Macromedia FreeHand, Adobe Photoshop, Kai's Power Tools, Sketch, KPT Bryce
Hardware
Macintosh

▶ This brochure for products for pupils has a theme of the world of virtual reality.

Product

Design Firm
Tangram Strategic Design
Creative Director/Art Director/Designer
Enrico Sempi
Project
Storia del Rock 5
Client
Giunti Gruppo Editoriale
Software
Adobe Photoshop, Adobe Illustrator, Microsoft Word
Hardware
Power Macintosh 9500/200

► This project involved the design of an international rock history geared for a young market.

Product

Design Firm
Tangram Strategic Design
Creative Director/Art Director/Designer
Enrico Sempi
Project
Nuovo? Rock?! Italiano!
Client
Giunti Gruppo Editoriale
Software
Adobe Illustrator, Microsoft Word
Hardware
Power Macintosh 9500/200

► This is a music book about Italian rock geared for a young market.

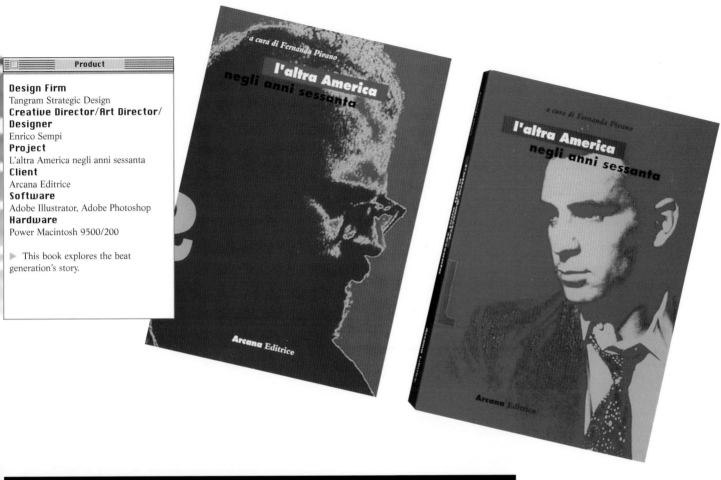

Product

Design Firm
Tangram Strategic Design
Creative Director/Art Director/ Designer
Enrico Sempi
Project
L'altra America negli anni sessanta
Client
Arcana Editrice
Software
Adobe Illustrator, Adobe Photoshop
Hardware
Power Macintosh 9500/200

▶ This book explores the beat generation's story.

Product

Design Firm
Tangram Strategic Design
Creative Director/Art Director/ Designer
Enrico Sempi
Illustrator
Guido Rosa
Project
Washing Powder Consilia
Client
Gruppo SUN
Software
Adobe Illustrator
Hardware
Power Macintosh 9500/200

▶ In developing a series of private label brands, special attention was paid to the positioning of the products because of the image and the quality consciousness of the consumers.

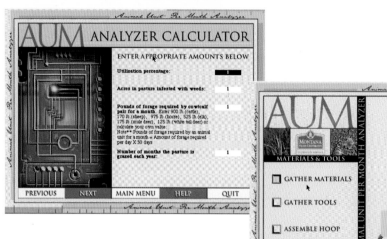

Product

Design Firm
Insight Design Communications
Art Directors/Designers
Sherrie Holdeman, Tracy Holdeman
Project
AUM Analyzer CD packaging
Client
Innovative Computer Enterprises
Purpose or Occasion
Sale Dow Elano, rangeland
management materials
Software
Macromedia FreeHand, Adobe Photoshop
Hardware
Macintosh 7500

▶ This interactive, educational CD
guides ranchers through the process of
determining forage production and
stoking rates, and makes the mathe-
matical calculations that determine the
economic advantages or disadvantages
of managing specific rangelands. The
packaging connects to the austerity and
high ideals of a university while
including rangeland maps to create a
sense of familiarity for the end user.

Product

Design Firm
Marketing Management, Inc.
Art Director
Julie York
Designers
Julie York, Donna Fenley
Illustrator
Daniel Miller
Project
Bestway cookies and crackers
Client
MMI/Jewel-Osco
Software
Adobe Illustrator, Adobe Photoshop
Hardware
Macintosh PPC

▶ Bestway cookies and crackers are
part of a first-quality store brand
program. The full line was constructed
in Illustrator from hand-drawn sketches
with background textures produced in
Photoshop. Final output is four-color
process lithography/flexography.

Design Firm
Marketing Management, Inc.
Art Director
Stuart Simpson
Designer/Illustrator
Roger Higgins
Project
Bestway sauces
Client
MMI/Jewel-Osco
Software
Adobe Illustrator, Adobe Photoshop
Hardware
Macintosh Power PC

▶ Bestway sauces are part of a
first-quality store brand program.
The full line was constructed in
Illustrator from hand-drawn sketches
with background textures produced in
Photoshop. Final output is four-color
process lithography/flexography.

Design Firm
Marketing Management, Inc.
Art Director
Stuart Simpson
Designer/Illustrator
John Horacek
Project
Bestway soda
Client
MMI/Jewel-Osco
Software
Adobe Illustrator
Hardware
Macintosh PPC

▶ Bestway soda is part of a
first-quality store brand program.
The full line was constructed in
Illustrator from hand-drawn sketches
with background textures produced in
Photoshop. Final output is four-color
process lithography/flexography.

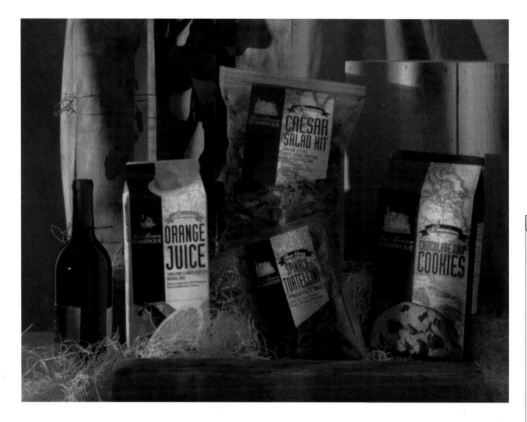

Design Firm
Marketing Management, Inc.
Art Director
Stuart Simpson
Designer/Illustrator
Roger Higgins
Project
La Maison products
Client
MMI Jewel-Osco
Purpose or Occasion
Premium product line
Software
Adobe Illustrator, Adobe Photoshop
Hardware
Macintosh PPC

▶ La Maison products were designed to convey premium quality. The logo was hand-drawn and reconstructed in Illustrator and the background pattern and photo vignettes were manipulated in Photoshop. Final output is four-color process lithography/flexography.

Design Firm
Tangram Strategic Design
Creative Director/Art Director/ Designer
Enrico Sempi
Illustrator
Guido Rosa
Project
Bank promotion
Client
Banca Popolare di Novara
Software
Adobe Illustrator, Adobe Photoshop
Hardware
Power Macintosh 9500/200

▶ This poster that promotes a bank and the services it offers. It translates to: "There is a bank that considers its clients very special."

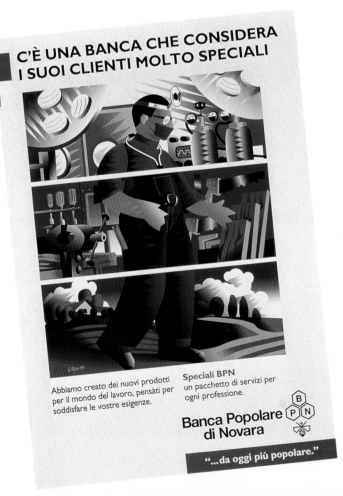

Product

Design Firm
Stamats Communications, Inc.
All Design
Theresa Black
Project
Viewbook cover design
Client
Samford University
Purpose or Occasion
Viewbook for prospective students
Software
Adobe Photoshop
Hardware
Power Macintosh 7100/80

▶ Samford University wanted an elegant, sophisticated look and feel to the viewbook intended for prospective students. The noise filter in Adobe Photoshop was used to create a painted effect on a classic campus photograph.

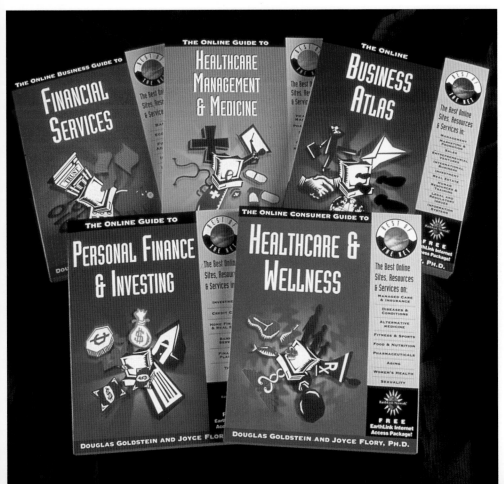

Product

Design Firm
ZGraphics, Ltd.
Art Director
Joe Zeller
Designer
Gregg Rojewski
Project
Best-of-the-Net book covers
Client
Irwin Professional Publishing
Purpose or Occasion
Create an eye-catching book cover
Software
Adobe Illustrator, Adobe Photoshop, QuarkXPress
Hardware
Power Macintosh 7100/80

▶ By using eye-catching cover illustrations, organizing covers and interiors on a strict grid, and using repeating graphic signposts, the *Best-of-the-Net* series is designed to be one of the most user-friendly print guides to the Internet available. Each cover illustration depicts different images, in woodcut-icon form that relate directly to the content of the book.

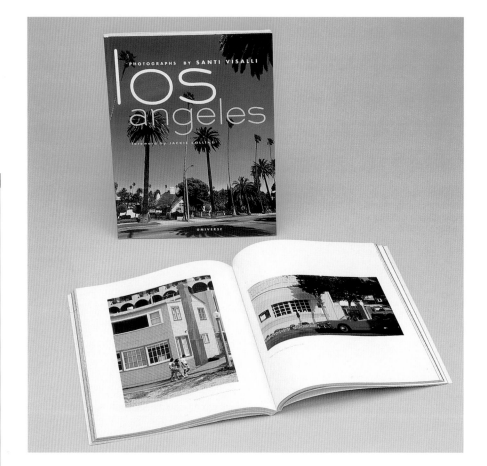

Design Firm
Mirko Ilić Corporation
Art Director
Mirko Ilić
Designer
Nicky Lindeman
Project
Los Angeles
Client
Universe Publishing
Purpose or Occasion
Book about Los Angeles
Software
QuarkXPress
Hardware
Macintosh 8500

▶ As one of the many tourist books about Los Angeles, the piece needed a distinctive look, which was achieved through the positioning of the images.

Design Firm
Held Diedrich
Art Director
Doug Diedrich
Designer
Megan Snow
Project
Capabilities/sales brochure
Client
Performance Dynamics
Purpose or Occasion
Lead generation/fulfillment
Software
Adobe Photoshop, QuarkXPress
Hardware
Macintosh Power PC

▶ The piece was designed to emulate the innovative nature of the client's services—revolutionary techniques used to rehabilitate patients, involving physical therapy, occupational therapy, and exercise physiology. The images were manipulated in Adobe Photoshop and then imported into QuarkXPress.

DAS VOLLE PROGRAMM

HEFTGERÄTE

SOENNECKEN

Product

Design Firm
Design Ahead
Designer/Illustrator
Ralf Stumpf
Project
Launch of new staplers
Client
Soemmeckam EG
Purpose or Occasion
Sales mailing
Software
Macromedia FreeHand,
Adobe Photoshop, Sketch
Hardware
Macintosh, SGI

▶ A brochure and give-away for the
launch of a new generation of staplers.
The main stapler was built in three-
dimensional format and transformed
into an exclamation mark.

Product

Design Firm
Design Ahead
Designer/Illustrator
Ralf Stumpf
Project
Epson Robot
Client
Epson/Kofner and Partner
Purpose or Occasion
Promotion
Software
Sketch, Adobe Photoshop
Hardware
Macintosh, SGI

▶ A three-dimensional illustration of a
robot that later comes out of a sheet of
paper of a new, innovative color printer.

Product

Design Firm
Hornall Anderson Design Works
Art Director
Jack Anderson
Designers
Jack Anderson, Julie Lock, Julie Keenan
Illustrator
John Fretz
Project
Starbucks Mazagran four-pack and bottle packaging
Client
Starbucks Coffee Company
Purpose or Occasion
Product packaging
Software
Macromedia FreeHand, Adobe Photoshop
Hardware
Macintosh

▶ The name Mazagran originated in 1830 in the French Foreign Legion fort city in Algeria. Weary soldiers returning from battle would mix sparkling water with coffee. Illustrations of the arid map, coastline, fort, and soldiers were collected from assorted history books. After extensive research, a customized bottle shape was chosen that would enhance the desirability of the product with focus given to the user-friendly shape.

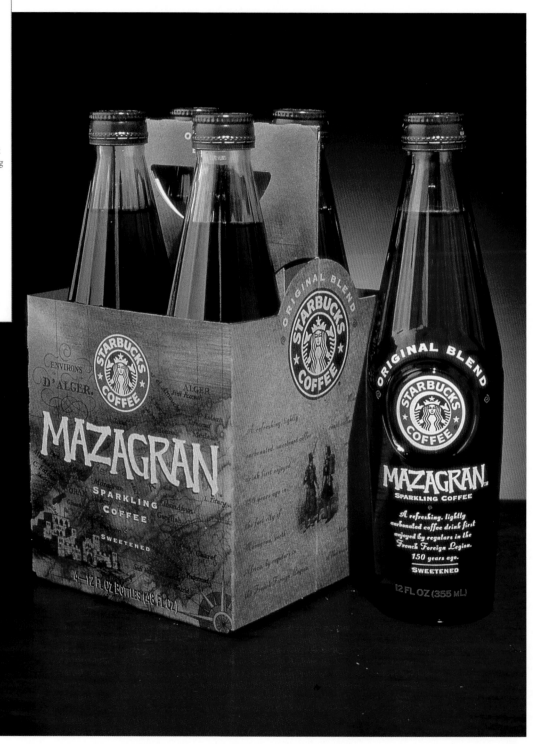

Product

Design Firm
Aerial
All Design
Tracy Moon
Photographer
R. J. Muna
Project
PC•IABP packaging
Client
Datascope Corporation
Purpose or Occasion
Product packaging
Software
Adobe Photoshop, QuarkXPress
Hardware
Macintosh 8500

▶ PC•IABP (Personal Computer — Intra-Aortic Balloon Pump) is a software product that connects sophisticated in-room patient medical devices to doctor's at-home computer through telemetry/modem. Revolutionary and unprecedented for this industry, the packaging needed to clearly and quickly communicate a new, complex product in a visually exciting format.

Product

Design Firm
The Weber Group, Inc.
Art Director
Anthony Weber
Designers
Anthony Weber, Jeff Tischer
Project
Fusion
Client
Vigoro
Purpose or Occasion
New product
Software
Adobe Illustrator, Adobe Photoshop
Hardware
Macintosh 8500/150 Power PC

▶ The Fusion package clearly conveys the product's new, revolutionary shape and all-natural ingredients. The design and its colors set it apart from competitors by being futuristic and revolutionary.

Product

Design Firm
Smith Design Associates
Art Director
James C. Smith
Designer
Carol Konkowski
Illustrator
Dwight Adams
Project
Fudgsicle packaging
Client
Good Humor/Breyers Ice Cream
Purpose or Occasion
Package update
Software
Adobe Illustrator, Adobe Photoshop
Hardware
Macintosh

▶ Richer flavor, creamier texture, indulgence, and a more contemporary feel were the main redesign objectives. This was achieved by using an image that included a rushing river of fudge with a subtle, warm glow casting highlights onto swirling waves.

Product

Design Firm
MartinRoss Design
Designers
Martin Skoro, Ross Rezec
Illustrator
Martin Skoro
Project
PhotoReading book
Client
Learning Strategies
Purpose or Occasion
Publishing book
Software
Adobe Photoshop, QuarkXPress
Hardware
Macintosh 7100

▶ Elements were combined in this cover montage done in Photoshop to give the essence of PhotoReading — a rapid reading-comprehension method that uses the subconscious mind.

Product

Design Firm
Julia Tam Design
Art Director/Designer
Julia Chong Tam
Illustrator
Roy Wieman
Project
Cover for MetaChem catalog
Client
MetaChem
Purpose or Occasion
Catalog
Software
Adobe Photoshop, QuarkXPress,
Ray Dream Designer

▶ Once the color elements were agreed upon with the client, the basic composition was worked out for approval. The three-dimensional program, Ray Dream, was used to create the primary objects that were then opened in Photoshop and combined with stock and custom photography to finish the piece.

Product

Design Firm
Marketing Services — Indiana University
All Design
Larry Burke-Weiner
Project
Voice-mail bookmark
Client
Communication Services —
Indiana University
Purpose or Occasion
Bookmark informing students of
voice-mail options
Software
Adobe Photoshop, Fractal Design Painter
Hardware
Macintosh 8100, HP Scanjet

▶ Using a familiar image of a residential mailbox, the two-color piece was enhanced in Photoshop by adding lighting and ground shadows.

Product

Design Firm
Parham Santana, Inc.
Art Director
Rick Tesoro
Designer
Loriann Reinig
Adobe Photoshop Digital
Adam Osterfeld
Project
Classic TV Christmas collection
Client
CBS Fox
Software
Adobe Photoshop
Hardware
Macintosh 8100/100

► To communicate the nostalgic appeal of the classic TV Christmas collection, archival photographs were given a hand-colored look using Photoshop.

Product

Design Firm
Parham Santana, Inc.
Art Director
Jodi Rovin/BMG Video
Designers
John Parham, Ron Anderson
Illustrator
Derek Beecham
Cover Photographer
Fred Charles
Project
BMG Video catalog
Client
BMG Video
Purpose or Occasion
Annual catalog
Software
Adobe Illustrator, QuarkXPress
Hardware
Macintosh 8100/100

► For a newly formed video division, a collage of the Bertelsmann Building in New York City's Times Square serves to position the company as a creative resource within a media powerhouse.

Product

Design Firm
MartinRoss Design
Designers
Martin Skoro, Ross Rezec
Illustrator
Martin Skoro
Project
Packaging for a Microsoft/
Learn PC project
Client
Microsoft and Learn PC
Purpose or Occasion
Videos and CDs that train people to use
Windows 95 products
Software
Adobe Photoshop, QuarkXPress
Hardware
Macintosh 7100

▶ We needed to portray the Windows
95 product without using the Microsoft
graphics. A Windows graphic was
created through Photoshop as a base
and additional elements were applied
for new product packages.

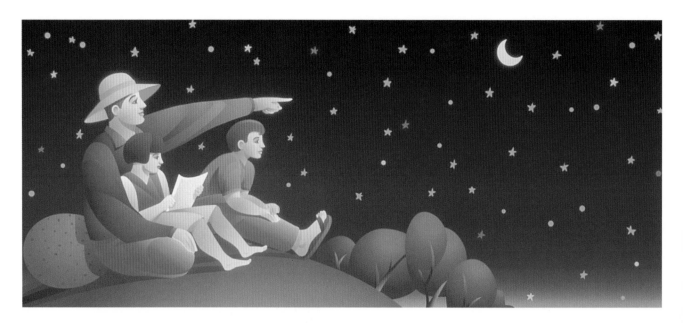

Product

Design Firm
Mires Design
Art Director
John Ball
Illustrator
Tracy Sabin
Project
Literature series illustrations
Client
Harcourt Brace
Purpose or Occasion
Textbook spots
Software
Adobe Illustrator, Adobe Photoshop
Hardware
Macintosh 9500

▶ This project consisted of a series of environmentally-oriented illustrations for use in elementary and grade-school level literature textbooks.

Product

Design Firm
Parker Brothers
Art Director/Designer
Steve Krupsky
Creative Director
Nan Finkenaur
Illustrators
Fritz, Chuck Primeau,
Shannon Kriegshauser
Project
Boggle
Purpose or Occasion
Package redesign
Software
Adobe Photoshop, Strata StudioPro,
Adobe Illustrator, QuarkXPress
Hardware
Macintosh 9500/150

▶ The background textures were composited from several digital stock photos and combined using layer masking in Photoshop. The original colors of the textures, which were blue and aqua, were shifted to red and yellow by swapping channels. The Boggle cubes and tray were constructed in Strata StudioPro and final details were added in Photoshop.

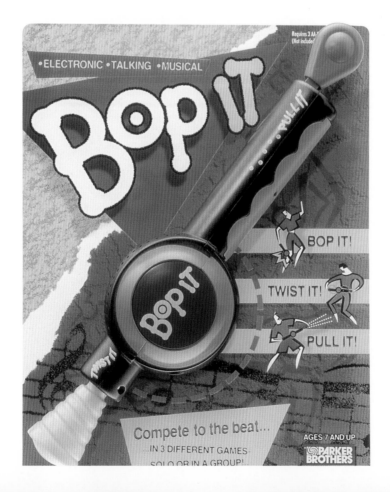

Product

Design Firm
Parker Brothers
Art Director/Designer
Steve Krupsky
Creative Director
Nan Finkenaur
Illustrator
Lisa Henderling
Project
Bop It
Software
Adobe Photoshop, Adobe Illustrator,
QuarkXPress
Hardware
Macintosh 9500/150

▶ The textures for the background started out as low-resolution files in Photoshop and increased to 300 dpi for the final production. The logo was drawn in Illustrator and brought into Photoshop where the diffuse filter was used to roughen up the black outline.

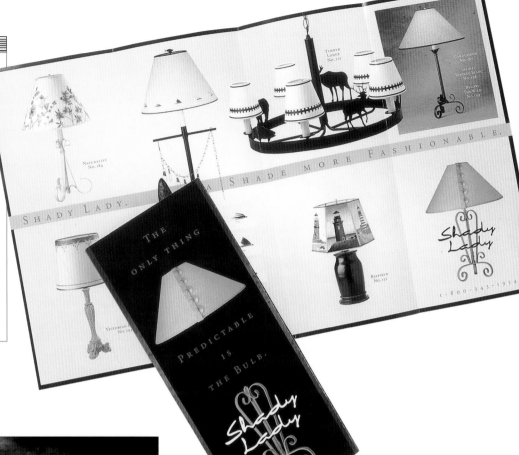

Product

Design Firm
Becker Design
Art Director/Designer
Neil Becker
Project
Brochure for lamp manufacturer
Client
Shady Lady
Purpose or Occasion
Brochure for lamp manufacturer
Software
Adobe Photoshop, Adobe Illustrator,
QuarkXPress
Hardware
Macintosh 8500

▶ This piece was mailed to potential
buyers of lamps and lighting accessories
who were attending a lighting industry
trade show.

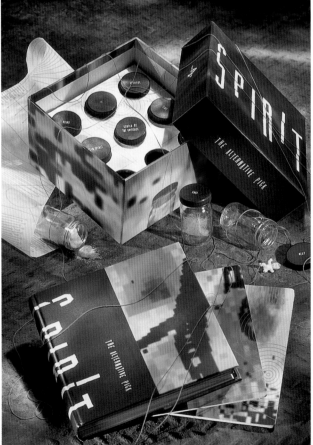

Product

Design Firm
Planet Design Company
Art Directors
Dana Lytle, Kevin Wade
Designers
Kevin Wade, Darci Bechen
Project
Alternative pick logo
Client
Storm Music
Software
Adobe Photoshop, QuarkXPress
Hardware
Power Macintosh

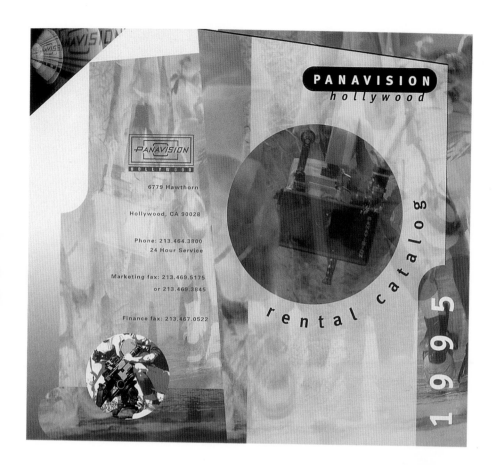

Product

Design Firm
Design Art, Inc.
Art Director/Designer
Norman Moore
Project
Panavision catalog
Client
Panavision Hollywood
Software
Adobe Photoshop, Adobe Illustrator,
QuarkXPress
Hardware
Macintosh 9500/150

▶ Various photographs from previous
advertising campaigns were colorized
and distorted in Photoshop and then
combined in QuarkXPress with
Illustrator type set on a curve.

Product

Design Firm
Allan Burrows Limited
Art Director
Reg Malin
Designers
Debbie Easteal, Reg Malin
Illustrator
Debbie Easteal
Project
Guardian packaging
Client
M. Heyhoe
Purpose or Occasion
Insurance administration software
Software
Fractal Design Painter, Adobe Photoshop,
QuarkXPress
Hardware
Macintosh 8500/120, Wacom graphics
tablet

▶ The subject of insurance is often
perceived as being dry and stuffy,
so a piece was created that would be
visually appealing while effectively
presenting the client's product. For
illustrations and packaging, a totally
digital approach was used with Painter,
Adobe Photoshop, and QuarkXPress.

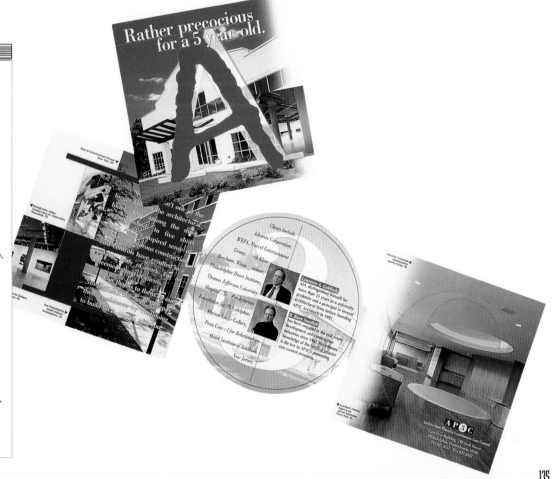

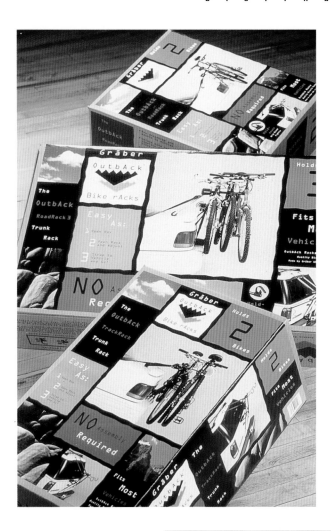

Product

Design Firm
Planet Design Company
Art Directors
Dana Lytle, Kevin Wade
Designers
Dana Lytle, Raelene Mercer
Project
Outback packaging
Client
Graber USA
Software
Adobe Photoshop, QuarkXPress
Hardware
Power Macintosh

Product

Design Firm
Planet Design Company
Art Directors
Dana Lytle, Kevin Wade
Designers
Dana Lytle, Martha Graetinger,
Darci Bechen
Photographer
Mark Salisbury
Copywriter
John Besmer
Project
Saris advertising and catalog
Client
Graber USA
Software
Adobe Photoshop, Adobe Illustrator,
QuarkXPress
Hardware
Power Macintosh

▶ The objective of this catalog and
advertising was to present Saris bicycle
racks and components in a way that
showcased the design of the products.
Although Saris has many functional
advantages over the competition, the
thing that really sets Saris apart is the
appearance of the product line.

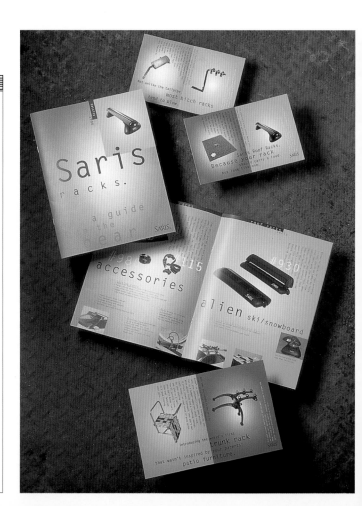

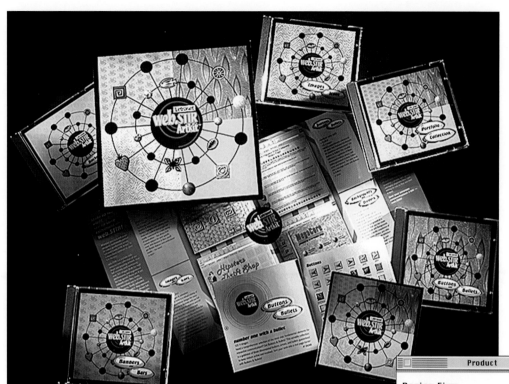

Product

Design Firm
Marcolina Design, Inc.
Art Director
Dan Marcolina
Designer/Illustrator
Rebekah Higgins
Project
Packaging design and
illustration/web.stir art kit
Client
Letraset USA
Purpose or Occasion
Create presence for product
Software
Adobe Photoshop, Adobe Illustrator,
QuarkXPress
Hardware
Power Macintosh 7500/100

▶ The client needed illustrations
and package design that would be
coordinated, eye catching, sum up the
nature of the product, and incorporate
elements from the collection. The hard-
line graphics were created in Illustrator
and then dropped into Photoshop where
the art kit elements logo type were
added. Backgrounds were created with
pattern fills and then colorized.

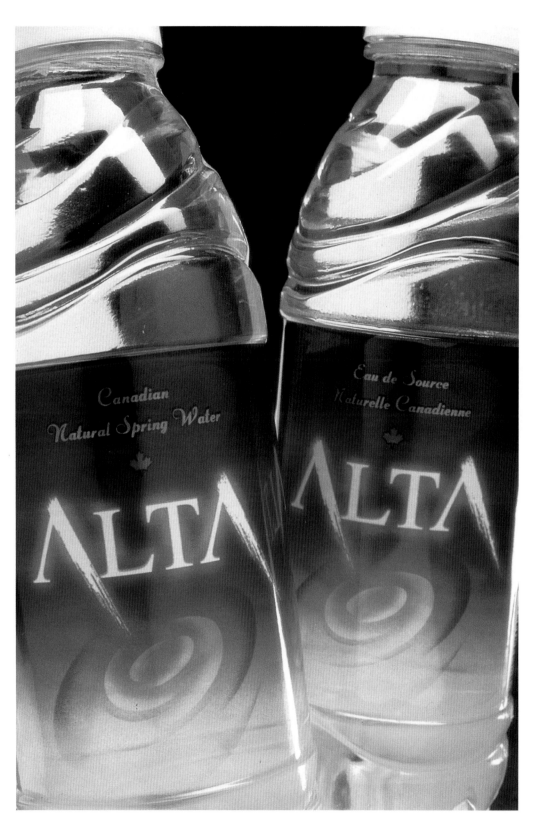

Product

Design Firm
Hornall Anderson Design Works
Art Director
Jack Anderson
Designers
Jack Anderson, Larry Anderson, Julie Keenan
Project
Alta bottle packaging
Client
Alta Beverage Company
Purpose or Occasion
Product packaging
Software
Adobe Photoshop
Hardware
Macintosh

▶ A double glow was used to give an embossed look and feel to the logo application.

Product

Design Firm
Highway One Communications
Art Director
Lee Ann Weber
Illustrator
Adam Cohen
Project
Coca-Cola Co. calendar
Client
Coca-Cola Co.
Purpose or Occasion
1997 customer appreciation calendar
Software
Adobe Photoshop
Hardware
Power Computing Power Tower 180

▶ For the month of August, a hot, southwestern desert-scape was positioned inside a classic-shaped Coke bottle. With the theme of convenience stores, map scans were used and images that evoke a recent New Mexico vacation were put together a very unusual collection.

Product

Design Firm
Highway One Communications
Art Director
Lee Ann Weber
Illustrator
Adam Cohen
Project
Coca-Cola Co. calendar
Client
Coca-Cola Co.
Purpose or Occasion
Customer appreciation calendar
Software
Adobe Photoshop
Hardware
Power Computing Power Tower 180

▶ The client chose January as it is a popular month for Caribbean cruises. A postcard was scanned in, and a handwritten script greeting that resembles a holiday correspondence was added. Using Adobe Photoshop's airbrush abilities, the cruise ship was layered over the Caribbean abstract background. The message in a bottle was requested by the client.

Product

Design Firm
Hornall Anderson Design Works
Art Director
Jack Anderson
Designers
Jack Anderson, John Anicker,
Margaret Long
Project
Corbis software packaging
Client
Corbis Corporation
Purpose or Occasion
Product packaging
Software
Macromedia FreeHand, Adobe Photoshop
Hardware
Macintosh

▶ The client's software packages
needed to portray their contents and
stand out against the competition.
Easily recognizable images taken from
the Corbis archive are included on the
front of the packages, and are not
cluttered, so they remain recognizable
when reduced for use in a catalog
or brochure.

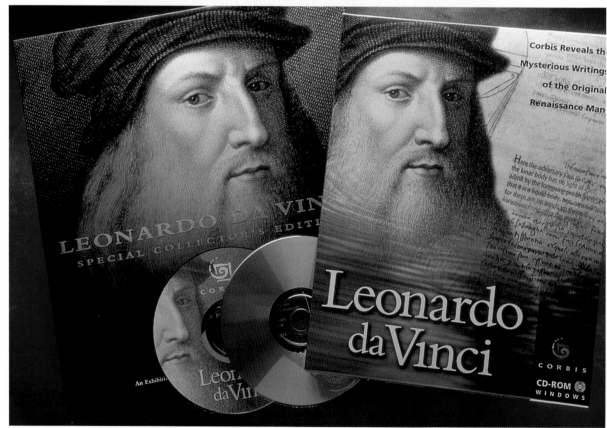

Product

Design Firm
Hornall Anderson Design Works
Art Director
Jack Anderson
Designers
Jack Anderson, Jana Nishi
Illustrator
Mary Iverson
Project
Seattle Chocolates seasonal
spring packaging
Client
Seattle Chocolate Company
Purpose or Occasion
Product packaging
Software
Macromedia FreeHand
Hardware
Macintosh

▶ This box for assorted chocolates
was designed as a seasonal promotional
gift box as well as packaging for the
client's product. Multi-colored, floral
illustrations reflect the theme of spring,
as does the box's bright-yellow bottom.

Product

Design Firm
Marcolina Design, Inc.
All Design
Dermot MacCormack
Project
Fontek Express packaging
Client
Letraset USA
Purpose or Occasion
Packaging for new product
Software
Adobe Photoshop, Spectral Collage,
Adobe PageMaker, Adobe Illustrator
Hardware
Power Macintosh 9500

▶ Letraset introduced a new type
service to its vendors whereby
customers can custom pick fonts and
have them put on disks or a CD-ROM.
This package design contains these
disks as well as a type specifier for
further use. PageMaker was used for
its compatibility with the hexachrome
printing that was used on this piece.

Product

Design Firm
Hornall Anderson Design Works
Art Director
Jack Anderson
Designers
Jack Anderson, Debra Hampton,
Heidi Favour, Jana Wilson, Nicole Bloss
Project
Novell software packaging
Client
Novell, Inc.
Purpose or Occasion
Product packaging
Software
Macromedia FreeHand, QuarkXPress
Hardware
Macintosh

▶ This software packaging retains
the company's corporate colors of red,
white, and black and enables the
packaging to stand out among their
competitors on the shelf.

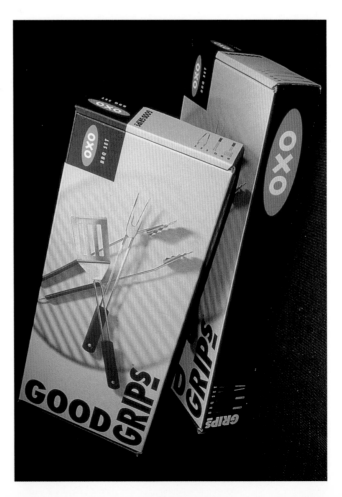

Product

Design Firm
Hornall Anderson Design Works
Art Director
Jack Anderson
Designers
Jack Anderson, Heidi Favour,
John Anicker, David Bates
Project
OXO Good Grips Barbecue
Tools packaging
Client
OXO International
Purpose or Occasion
Product packaging
Software
Adobe Photoshop
Hardware
Macintosh

▶ The natural Kraft-surfaced box was
beneficial in creating a product that
would stand out among its competitors,
which use a slicker treatment and
glossed-box surface. Although rough in
appearance, the closed box treatment
emphasizes an upscale quality through
simplicity. The grill and barbecue tools
were photographed separately and then
merged together in Photoshop.

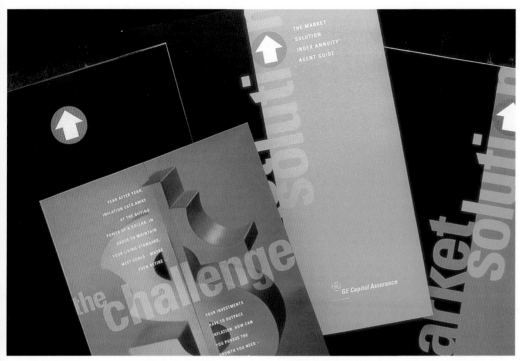

Product

Design Firm
Hornall Anderson Design Works
Art Director
Lisa Cerveny
Designers
Lisa Cerveny, Jana Wilson, Virginia Le
Project
GE Market solutions kit
Client
GE Capital Assurance
Purpose or Occasion
Marketing kit
Software
Adobe Photoshop, Adobe Illustrator,
QuarkXPress
Hardware
Macintosh

▶ This kit highlighting various services
was used in presentations made to
prospective clients.

Product

Design Firm
Hornall Anderson Design Works
Art Director
John Hornall
Designers
John Hornall, Larry Anderson,
Jana Nishi
Illustrator
Jocelyn Cury
Project
Attachmate software packaging
Client
Attachmate Corporation
Purpose or Occasion
Product packaging
Software
Adobe Photoshop, QuarkXPress
Hardware
Macintosh

▶ The client wanted sophisticated, hot
colors to give the packaging a stronger
shelf presence against the competition.
The packaging illustrations were
designed to represent the software's
actual functions. Simple illustrations
were also included to symbolize the
way the software was designed to
simplify the user's lifestyle and business.

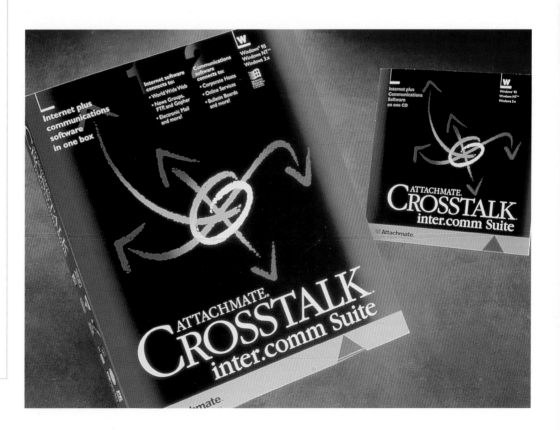

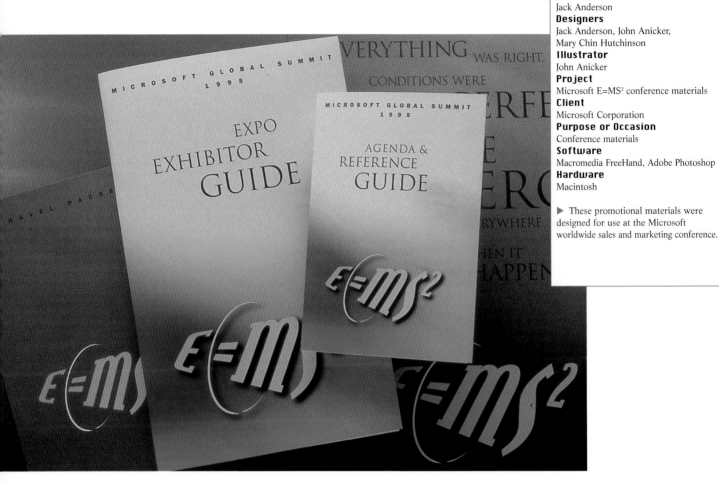

Product

Design Firm
Hornall Anderson Design Works
Art Director
Jack Anderson
Designers
Jack Anderson, John Anicker,
Mary Chin Hutchinson
Illustrator
John Anicker
Project
Microsoft E=MS² conference materials
Client
Microsoft Corporation
Purpose or Occasion
Conference materials
Software
Macromedia FreeHand, Adobe Photoshop
Hardware
Macintosh

▶ These promotional materials were
designed for use at the Microsoft
worldwide sales and marketing conference.

Product

Design Firm
Di Luzio Diseno
Art Director/Designer
Hector Di Luzio
Project
CD Cover/Poster
Client
Todos Tus Muertos
Purpose or Occasion
CD release
Software
Adobe Photoshop, Adobe Illustrator
Hardware
Macintosh Power PC

▶ The key feature of this dual-purpose
CD cover and poster was the inclusion
of several hundred missing individuals
who disappeared during Argentina's
dictatorship. The cover of the CD
"Argentina Te Asesina" (Argentina kills
you) displays the photos arranged in the
form of an Indian face.

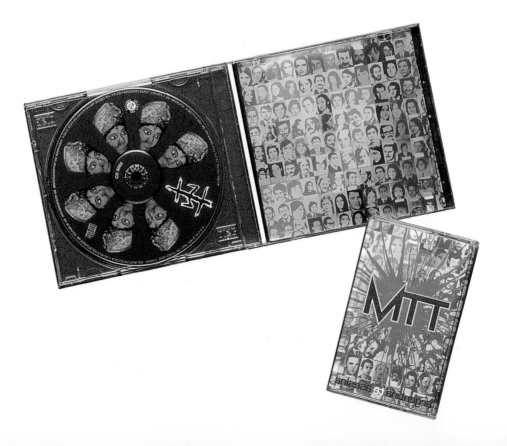

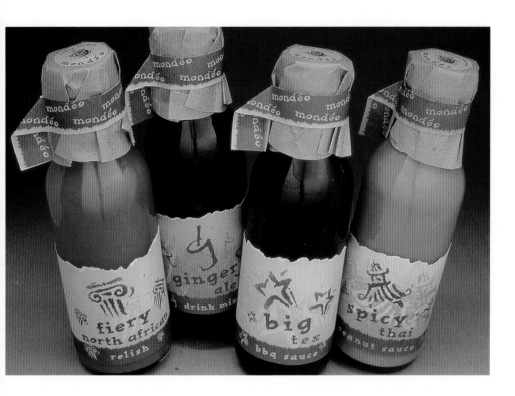

Product

Design Firm
Hornall Anderson Design Works
Art Director
Jack Anderson
Designers
Jack Anderson, David Bates
Project
Mondeo packaging
Client
CW Gourmet
Purpose or Occasion
Product packaging
Software
Macromedia FreeHand
Hardware
Macintosh

▶ Mondeo, a restaurant concept that brings together exciting, authentic flavors from around the world and delivers them in a fresh and fast manner, needed individual bottle packaging for their line of sauces and mixes. An old-world, earthy feel was incorporated into the look and feel of the packaging. This identity symbolizes a fusion of several components successfully working together to support this healthy alternative to the fast-food restaurant.

Product

Design Firm
Hornall Anderson Design Works
Art Director
Jack Anderson
Designers
Jack Anderson, Lisa Cerveny,
Suzanne Haddon
Illustrators
Abe Girvin, Mits Katayama
Project
Jamba Juice posters
Client
Jamba Juice
Purpose or Occasion
Promotional posters
Software
Macromedia FreeHand, QuarkXPress
Hardware
Macintosh

▶ These posters were produced as promotional point-of-purchase posters. Fun, easy-to-read fonts were chosen in addition to the playful, yet sophisticated illustrations. The look needed to appeal to young and old alike as well as being festive and fun without appearing trendy.

Product

Design Firm
Hornall Anderson Design Works
Art Director
Jack Anderson
Designers
Jack Anderson, Lisa Cerveny,
Jana Wilson, Suzanne Haddon
Project
GNA power annuities kit
Client
GNA
Purpose or Occasion
Marketing kit
Software
Adobe Illustrator, QuarkXPress
Hardware
Macintosh

▶ This is the first in a series of
product launches for GNA that will
be used in presentations to potential
clients as a means of representing the
company's capabilities and services.

Product

Design Firm
Design Art, Inc.
Art Director/Designer
Norman Moore
Project
Panavision advertising campaign
Client
Panavision Hollywood
Software
Adobe Photoshop, Adobe Illustrator,
QuarkXPress
Hardware
Macintosh 9500/150

▶ Panavision wanted to get away from
their previous series of serious-looking
ads and present an image that was
more accessible and humorous. Stock
photos and still lifes were composed in
Photoshop and colorized, with final
assembly in QuarkXpress.

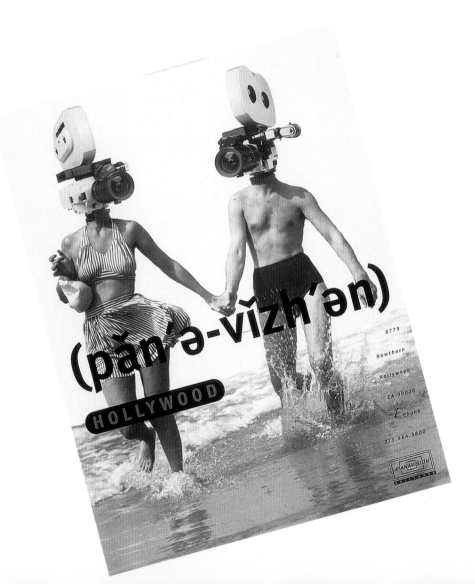

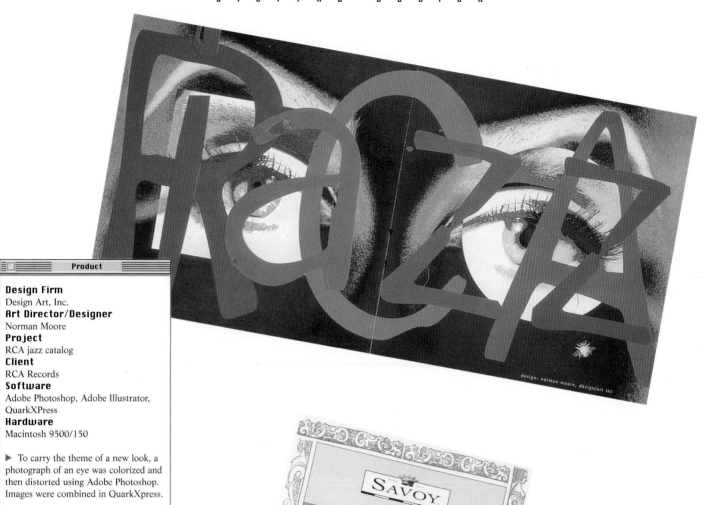

design: norman moore, design/art inc

Product

Design Firm
Design Art, Inc.
Art Director/Designer
Norman Moore
Project
RCA jazz catalog
Client
RCA Records
Software
Adobe Photoshop, Adobe Illustrator,
QuarkXPress
Hardware
Macintosh 9500/150

▶ To carry the theme of a new look, a
photograph of an eye was colorized and
then distorted using Adobe Photoshop.
Images were combined in QuarkXPress.

Product

Design Firm
Becker Design
Art Director/Designer
Neil Becker
Project
Savoy Catalog
Client
Converting, Inc.
Purpose or Occasion
Show new product line
Software
Adobe Illustrator, Adobe Photoshop,
QuarkXPress
Hardware
Macintosh, Microtek ScanMaker II XE

▶ Savoy, a producer of an upscale line
of paper products, needed a catalog to
highlight its new line of paper plates,
napkins, and related items. The design
of the catalog needed to appeal to an
upscale clientele.

Design Firm
Wolfram Research Creative Services
Art Director/Illustrator
John Bonadies
Designers
John Bonadies, Jody Jasinski
Project
Mathematica 3.0 Student
Version packaging
Client
Wolfram Research, Inc.
Purpose or Occasion
New product development
Software
Mathematica, Adobe Illustrator,
Adobe Photoshop, QuarkXPress
Hardware
Power Computing Power
Wave 640/120

▶ The design is a brighter and more
animated subset of the professional
package, utilizing multi-layered
dimensional graphics to illustrate and
communicate the product features.
This sets a visual analogy while
maintaining a strong corporate relationship
to established identity standards.

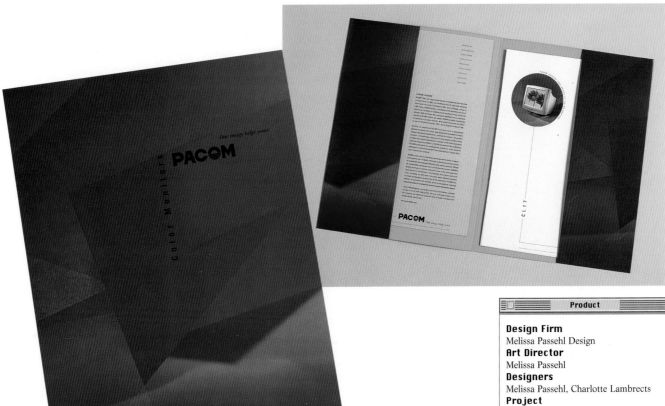

▶ The design objective was to create a visual explosion of color that conveyed the monitor color offered by PACOM. This was achieved through the use of playful color photography.

▶ Black-and-white photographs of Sting from a previously designed album package were combined with design elements in QuarkXPress. Black, red, and yellow predominate because Sting is color blind and sees only those three colors.

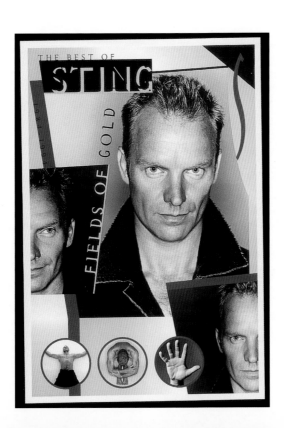

Product

Design Firm
Zappata Designers
Art Director/Illustrator
Ibo Angulo
Designers
Ibo Angulo, Ana Lavalle, Claudio Anaya
Project
CD package — "Now that's what I call music"
Client
EMI Music Mexico
Purpose or Occasion
CD music compilation
Software
Adobe Photoshop, Macromedia FreeHand
Hardware
Macintosh Quadra 840, Power Macintosh 7100

▶ This project was very important because it was the client's first venture into the Latin-American market. The concept was to create something colorful that would make the connection in the consumer's mind to a compilation. The texture was created in Photoshop and placed in FreeHand.

Product

Design Firm
Zappata Designers
Art Director/Illustrator
Ibo Angulo
Designers
Ibo Angulo, Ana Lavalle, Claudio Anaya
Project
CD package — "Everybody loves" collection
Client
EMI Music Records Mexico
Purpose or Occasion
CD music compilation
Software
Adobe Photoshop, Macromedia FreeHand
Hardware
Macintosh Quadra 840

▶ In designing the package for this CD compilation, the main challenge was to unify a collection of photographs that was inherently different. This was achieved through Photoshop by using one color range for each photograph. The collage effect for each photograph was created in Photoshop and then assembled in FreeHand.

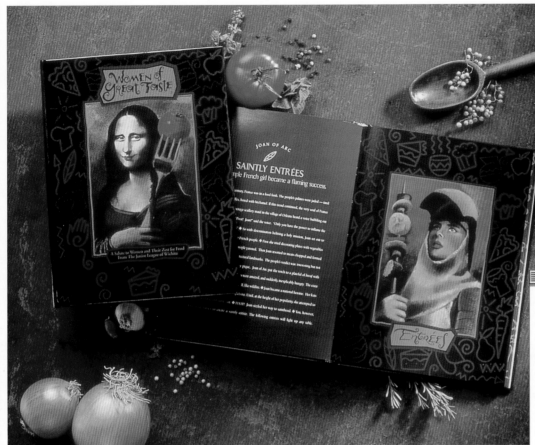

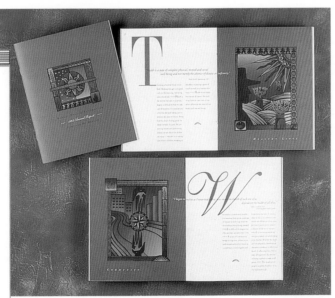

Product

Design Firm
Greteman Group
Art Director/Illustrator
Sonia Greteman
Designers
Sonia Greteman, Jo Quillin, James Strange
Project
Junior League Cookbook
Client
Junior League
Purpose or Occasion
Cookbook
Software
Macromedia FreeHand, Adobe Photoshop
Hardware
Macintosh Power PC

▶ The cookbook was a major success as a fundraiser and promotion. The art and surrounding graphics accompanying the illustration was created in FreeHand and all the illustrations were corrected in Photoshop after scanning.

Product

Design Firm
Greteman Group
Art Director/Illustrator
Sonia Greteman
Designers
Sonia Greteman, James Strange
Project
Kansas Health Foundation annual report
Client
Kansas Health Foundation
Purpose or Occasion
Annual report
Software
Macromedia FreeHand
Hardware
Macintosh Power PC

▶ All illustrations were hand drawn and then recreated in FreeHand where color and blends were added. The initial cap is large to add scale and counterbalance the powerful illustrations. All typesetting was done in FreeHand.

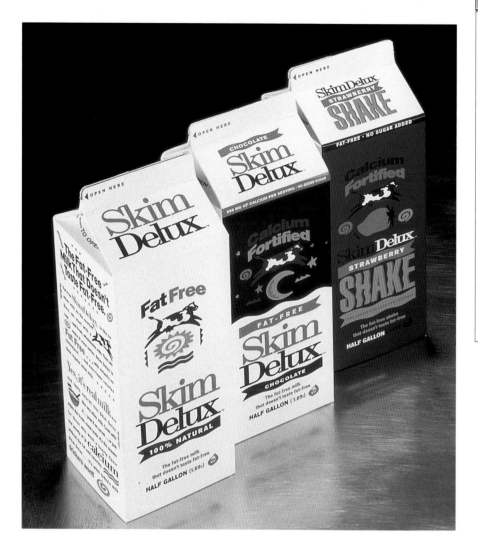

▶ A simple illustration and type treatment was necessary for the surrounding graphics with all art created in FreeHand. The jumping cow remained consistent and was positioned over a representation of whatever the particular flavor of the product was.

▶ All graphics were created in FreeHand with the exception of the major illustration. The illustration was hand-tinted and then scanned in to Adobe Photoshop. Earth tones were used with a smattering of bright color to highlight the product's name.

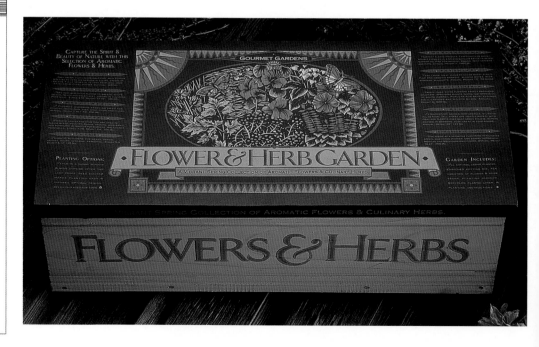

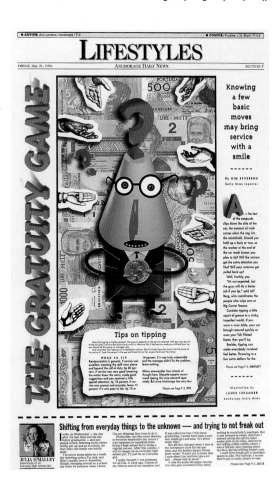

Product

Design Firm
Anchorage Daily News
All Design
Lance Lekander
Project
The Gratuity Game
Client
Anchorage Daily News
Purpose or Occasion
Lifestyle feature section
Software
Raydream Designer, Dimensions, Adobe Photoshop, QuarkXPress
Hardware
Macintosh 9500/132, Apple flatbed scanner

▶ This page was done for an article on tipping with the character's head, body, arms, and questions rendered using Designer. The background of foreign currency was scanned and manipulated in Photoshop, and the quarter was also scanned on the flatbed scanner. The headline was done in Dimensions, then taken into Adobe Photoshop for the cast shadow. All the pieces were then put together in QuarkXPress.

Product

Design Firm
Anchorage Daily News
All Design
Lance Lekander
Project
Battering the Brain
Client
Anchorage Daily News
Purpose or Occasion
Front of features section
Software
Adobe Photoshop, Adobe Illustrator, QuarkXPress
Hardware
Macintosh 9500/132

▶ This feature was designed for a story on concussions. The illustration and headline were done in Illustrator then brought into Adobe Photoshop as paths. There they were converted to selections, and color was added with the airbrush tool. The headline and illustration were then put together in QuarkXPress along with the story copy.

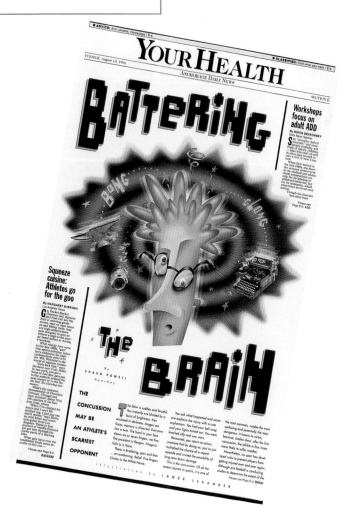

Product

Design Firm
Anchorage Daily News
All Design
Lance Lekander
Project
Get Wired
Client
Anchorage Daily News
Purpose or Occasion
Weekly entertainment section
Software
Adobe Illustrator, Adobe Dimensions,
Adobe Photoshop
Hardware
Macintosh 9500/132 80

▶ This illustration went along with an
article about coffee shops with Internet
connections. The headline, cup, saucer,
and computers were rendered in
Dimensions, the background spiral
buzzsaw pattern was made in
Illustrator. All elements were then
combined in Photoshop.

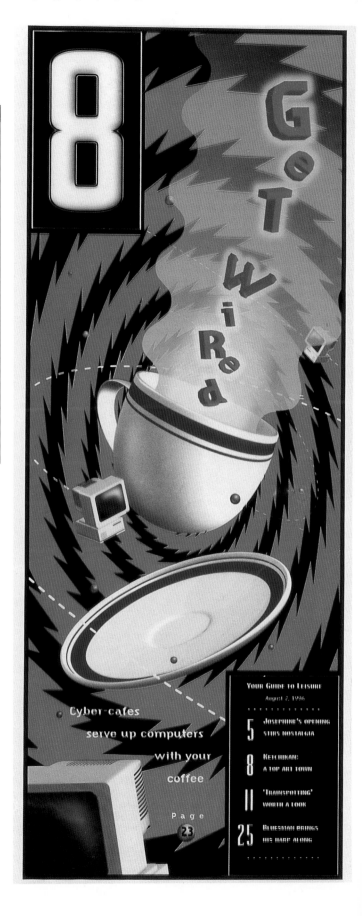

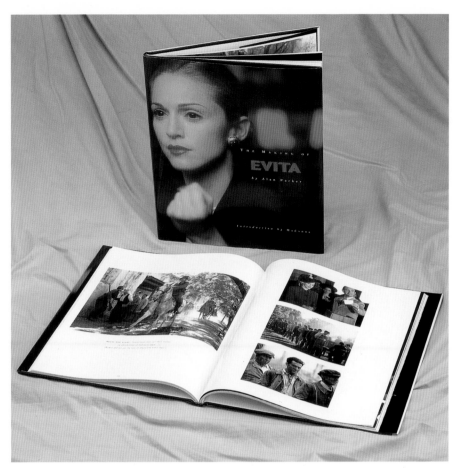

Product

Design Firm
Erbe Design
Art Director/Designer
Maureen Erbe
Photographer
David Appleby
Project
Evita
Client
HarperCollins
Purpose or Occasion
Book
Software
QuarkXPress
Hardware
Macintosh

▶ The purpose of the book was to serve as a piece of memorabilia for the film "Evita."

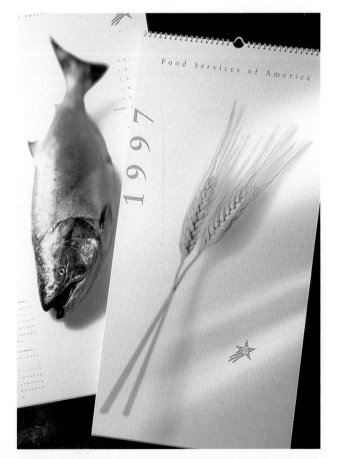

Product

Design Firm
Hornall Anderson Design Works
Art Director
Jack Anderson
Designers
Jack Anderson, Mary Hermes,
Julie Keenam
Project
Food Services of America calendar
Client
Food Services of America
Purpose or Occasion
Calendar
Software
Macromedia FreeHand, QuarkXPress
Adobe Photoshop
Hardware
Macintosh

▶ Having designed the six previous editions of the client's calendar, great care was taken to provide the client with a distinctive piece that was to be used a flagship mailer for existing and potential clients.

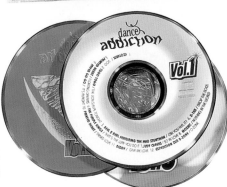

Product

Design Firm
Zappata Designers
Art Director/Illustrator
Ibo Angulo
Designers
Ibo Angulo, Ana Lavalle,
Claudio Anaya
Project
CD package — Dance-addiction series
Client
EMI Music Mexico
Purpose or Occasion
CD music collection
Software
Adobe Photoshop, Macromedia FreeHand
Hardware
Macintosh Quadra 840, Power
Macintosh 7100

▶ The client sought a package that would distinguish this collection of dance music from others currently available. Utilizing a consumer-product theme that keyed to soap, the product stood out and generated positive results.

Product

Design Firm
Hornall Anderson Design Works
Art Director
Jack Anderson
Designers
Jack Anderson, John Anicker, Margaret
Long, Mary Hermes, Jana Wilson
Project
Corbis catalog
Client
Corbis Corporation
Purpose or Occasion
Product/service catalog
Software
Macromedia FreeHand, QuarkXPress
Hardware
Macintosh

▶ The client wanted a piece that would direct people toward their Website. The catalog was intended to serve as a sampling of the kind of images Corbis carries, rather than being a straight catalog of all available items. This was achieved by using an open layout and adding space where appropriate.

Product

Design Firm
Mirko Ilić Corporation
Art Director/Designer
Mirko Ilić
Project
Olympic Dreams
Client
Universe Publishing and Kodak
Purpose or Occasion
Olympic Games
Software
QuarkXPress
Hardware
Macintosh 8500

▶ After seeing this new technology by Kodak for creating multiple images, and given the fact that Kodak is the co-publisher, the designers suggested that this image be used on the cover of the hardcover edition. The actual image contains 28 different images.

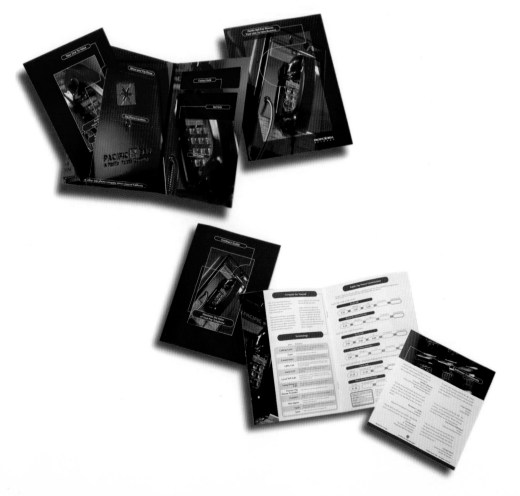

Product

Design Firm
The Focal Group
Art Director
Paulo Simas
Designer
Tamara Tom
Photographer
Jeffrey Michaels
Project
Media kit
Client
Pacific Bell
Purpose or Occasion
Sales brochure
Software
Adobe Illustrator, Adobe Photoshop, QuarkXPress
Hardware
Macintosh 8500/180

▶ To design a sales tool that would inform potential customers of the benefits and features of a Pacific Bell pay phone, the image of a phone was manipulated to resemble a structure. By doing this, something routine is portrayed as something visually striking.

Index & Directory

Aerial
▸20 ▸91 ▸127
58 Federal
San Francisco, CA 94107

Allan Burrows Limited
▸135
Essex House, High Street
Ingatestone, Essex CM4 9HW
United Kingdom

Ira Altshiller
▸71
1384 Union Street
San Francisco, CA 94109

Anchorage Daily News
▸81 ▸153 ▸154
4340 Woronzof Drive
Anchorage, AK 99517

Animus Comunicaçao
▸116
Ladeira Do Ascurra 115-A
Rio De Janeiro RJ 22241-320
Brazil

Becker Design
▸30 ▸31 ▸33 ▸34 ▸134 ▸147
225 East St. Paul Avenue,
Suite 300
Milwaukee, WI 53202

Michelle Bowers
▸70
RFD 1 Box 2491
Plymouth, NH 03264

Richard A. Bucci
▸75 ▸101
83 Dexter Saunders Raod
North Scituate, RI 02857

Burgeff Co.
▸99
Herderstrasse 57
53173 Bonn
Germany

**Lars Busekist and
Vibeke Nodskov**
▸54
Overgaden Oven Vandet 54 A 2
1415 Copenhagen K.
Denmark

Cato Berro Diseño
▸64 ▸65
Eltanislao Diaz 102
1642 San Isidro
Buenos Aires
Argentina

Chet Phillips Illustration
▸97
6527 Del Norte
Dallas, TX 75225

**Copeland Hirthler Design and
Communications**
▸18 ▸22 ▸23 ▸57 ▸59 ▸60
▸61 ▸66
40 Inwood Circle
Atlanta, GA 30309

Corporate Visions, Inc.
▸10
1000 16th Street NW
Washington, DC 20006

Design Ahead
▸14 ▸117 ▸125
Kirchfeldstrasse 16
Essen-kettwig
Germany

Design Art, Inc.
▸41 ▸135 ▸146 ▸147 ▸149
6311 Romaine Street, #7311
Los Angeles, CA 90038

Design Group West
▸103

Design Works Studio, Ltd.
▸46 ▸85 ▸86
2201 University
Lubbock, TX 79410

Design Guys
▸13 ▸52 ▸53 ▸88 ▸106 ▸114
119 North Fourth Street, #400
Minneapolis, MN 55401

Di Luzio Diseño
▸144
Terrero 2981
1642 San Isidro
Aregentina

Directech, Inc.
▸88
450 Bedford Street
Lexington, MA 02173

**Dog's Eye Creative
Design Inc.**
▸116
#201-1110 Hamilton Street
Vancouver, BC V6B 252
Canada

Dynamic Duo Studio, Inc.
▸94
95 Kings Highway South
Westport, CT 06880

**Eastern Edge Media
Group, Inc.**
▸29 ▸59 ▸93
P. O. Box 187
Lansdowne, PA 19050-0187

Erbe Design
▸11 ▸23 ▸32 ▸155
1500 Oxley Street
South Pasadena, CA 91030

The Focal Group
▸157
1188 Bordeaux Drive
Sunnyvale, CA 94089

FRCH Design Worldwide
▸117
444 North Front Street, Suite 211
Columbus, OH 43215

Gardner Graphics
▸108
P. O. Box 69637
Seattle, WA 98188

Gary Glover Illustration
▸78

Greteman Group
▸45 ▸46 ▸151 ▸152
142 N. Mosley
Wichita, KS 67202

GST Internet
▸17
421 Southwest 6th Avenue
Portland, OR 97204

HC Design
▸107
3309-G Hampton Point Drive
Silver Spring, MD 20904

Heart Graphic Design
▶ 43 ▶ 81 ▶ 82
501 George Street
Midland, MI 48640

Held Diedrich
▶ 39 ▶ 92 ▶ 94 ▶ 95 ▶ 96 ▶ 124
703 East 30th Street
Indianapolis, IN 46205

Highway One Communications
▶ 139
252 West 17th Street, Apt. #5B
New York, NY 10011

Hornall Anderson Design Works
▶ 34 ▶ 36 ▶ 37 ▶ 38 ▶ 39 ▶ 40 ▶ 41
▶ 126 ▶ 138 ▶ 140 ▶ 141 ▶ 142 ▶ 143
▶ 144 ▶ 145 ▶ 146 ▶ 155 ▶ 156
1008 Western Avenue, Suite 600
Seattle, WA 98104

The Identica Partnership
▶ 44
1 Olympia News
Queensway, W23 SA
London
United Kingdom

Imaginings Computer Graphics
▶ 76 ▶ 77 ▶ 83
245 South Serrano Avenue, Suite 318
Los Angeles, CA 90004

Insight Design Communications
▶ 50 ▶ 52 ▶ 55 ▶ 79 ▶ 120
322 South Mosley
Wichita, KS 67202

Jim Lange Design
▶ 51 ▶ 55
203 North Wabash Avenue, #1312
Chicago, IL 60601

Julia Tam Design
▶ 96 ▶ 129
2216 Via La Brea
Palo Verdes, CA 90274

Kan and Lau Design Consultants
▶ 50 ▶ 58 ▶ 65 ▶ 67
28/F Great Smart Tower
230 Wanchai Road
Hong Kong

Larry Burke-Weiner Photo-Illustration Design
▶ 101 ▶ 129
832 South Woodlawn Avenue
Bloomington, IN 47401

Larsen Design and Interactive
▶ 47 ▶ 48
7101 York Avenue South
Minneapolis, MN 55435

Louis Nelson Associates Inc.
▶ 16
80 University Place
New York, NY 10003

Love Packaging Group
▶ 16 ▶ 25 ▶ 26 ▶ 27 ▶ 62
410 East 37th Street North
Plant 2, Graphics Department
Wichita, KS 67219

Manley Design
▶ 104
255 Budlong Road
Cranston, RI 02920

Marcolina Design, Inc.
▶ 8 ▶ 31 ▶ 35 ▶ 80 ▶ 85 ▶ 137 ▶ 141
1100 East Hector Street, Suite 400
Conshohocken, PA 19428

Mark Selfe Design
▶ 19
252 West 17th Street, #5B
New York, NY 10011

Marketing Management, Inc.
▶ 120 ▶ 121 ▶ 122
4717 Fletcher Avenue
Fort Worth, TX 76107

Marketing and Communication Strategies, Inc.
▶ 15 ▶ 54 ▶ 105
2218 First Avenue NE
Cedar Rapids, IA 52402

MartinRoss Design
▶ 63 ▶ 128 ▶ 131
1125 Xerxes Avenue South
Minneapolis, MN 55405

McCullough Creative Group
▶ 11 ▶ 53 ▶ 84
890 Iowa Street
Dubuque, IA 52001

McElveney & Palozzi Design Group, Inc.
▶ 10 ▶ 21
1255 University Avenue
Rochester, NY 14607

McGlothlin Associates, Inc.
▶ 68 ▶ 70 ▶ 71 ▶ 72 ▶ 74
5397 Twin Knolls Road, Suite 18
Columbia, MD 21045

Melissa Passehl Design
▶ 40 ▶ 42 ▶ 149
1275 Lincoln Avenue, Suite 7
San Jose, CA 95125

Metropolis Corporation
▶ 57 ▶ 58
P. O. Box 32
Milford, CT 06460

Mires Design
▶ 21 ▶ 132
13476 Ridlen Road
San Diego, CA 92129

Mirko Ilić Corporation
▶ 51 ▶ 62 ▶ 112 ▶ 113 ▶ 124
▶ 157
207 East 32nd Street
New York, NY 10016

Mix Media
▶ 92
3363 West 3470 South
Salt Lake City, UT 84119

Mohr Design
▶ 109
Huettenwegstrasse 28A
14195 Berlin
Germany

Multimedia Asia, Inc.
▶ 28
P. O. Box 18416
San Jose, CA 95158

Parham Santana, Inc.
▶ 29 ▶ 90 ▶ 110 ▶ 130
7 West 18th Street
New York, NY 10011

Parker Brothers
▶ 133
50 Dunham Road
Beverly, MA 01915

Eduino J. Pereira
▶ 108
10837-F Amherst Avenue
Wheaton, MD 20902

Index & Directory

Planet Design Company
▸ 134 ▸ 136
605 Williamson Street
Madison, WI 53703

Puerility Works
▸ 112

Arlene Rhoden
▸ 76 ▸ 77 ▸ 83
753 Summerfield Road
Santa Rosa, CA 95405

The Riordon Design Group Inc.
▸ 12 ▸ 13 ▸ 115
131 George Street
Oakville, ON 40J 3B9
Canada

Schwartz Design
▸ 90
13476 Ridley Road
San Diego, CA 92129

Shields Design
▸ 98
415 East Olive Avenue
Fresno, CA 93728

Silicon Graphics, Inc.
▸ 98
2011 North Shoreline Boulevard
Mountain View, CA 94047

Smith Design Associates
▸ 128
205 Thomas Street
P. O. Box 190
Glen Ridge, NJ 07028

Sommese Design
▸ 63
481 Glenn Road
State College, PA 16803

Randy Sowash
▸ 73 ▸ 74
550 Sunset Boulevard
Mansfield, OH 44907

Stamats Communications, Inc.
▸ 67 ▸ 104 ▸ 106 ▸ 123
427 Sixth Avenue SE
P. O. Box 1880
Cedar Rapids, IA 52406

Steve Trapero Design
▸ 47 ▸ 107
3309-G Hampton Point Drive
Silver Spring, MC 20904

Tangram Strategic Design
▸ 99 ▸ 109 ▸ 118 ▸ 119 ▸ 122
Via Negroni 2
28100 Novara
Italy

Chip Taylor
▸ 78
117 West City Hall Avenue, #608
Norfolk, VA 23510

Toni Schowalter Design
▸ 43 ▸ 64 ▸ 89
1133 Broadway, Suite 1610
New York, NY 10010

Tracy Sabin Graphic Design
▸ 102 ▸ 103
13476 Ridlen Road
San Diego, CA 92129

The Weber Group, Inc.
▸ 127
3001 Washington Avenue
Racine, WI 53405

Whitney Edwards Design
▸ 24 ▸ 91
14 West Dover Street
P. O. Box 2425
Easton, MD 21601

Winner Communications, Inc.
▸ 56
Two Warren Place, 6120 South Vale
Tulsa, OK 74136-4229

Wolfram Research Creative Services
▸ 148
100 Trade Center Drive
Champaign, IL 61820

Zappata Designers
▸ 150 ▸ 156
Lafayette 143 Anzures C.P. 11590
Mexico City
Mexico

Toni Zeto
▸ 102
901 10th Street, Suite #301
Santa Monica, CA 90403

ZGraphics, Ltd.
▸ 123
322 North River Street
East Dundee, IL 60118\

Z Works
▸ 84
11557 Chadwick Road
Corona, CA 91720-9443